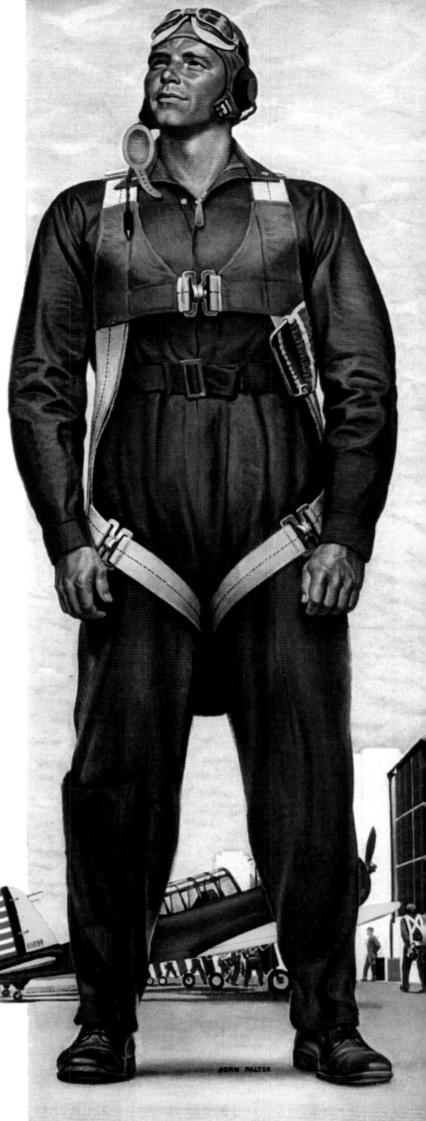

"I have often wondered how one can live without either enthusiasm or passion"

Mermoz

Georges Grod

When Art Kept'Em Flying

To our friend Jean-Michel CHARLIER.

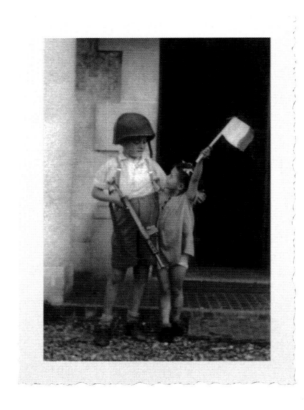

Georges Grod, a child of the Liberation

✪ Introduction

Sometimes love can just take you by surprise and almost unawares. It comes in an instant and leaves you almost unrecognisable to yourself, helpless at first, but happy, oh how happy, and better, to the extent that your very being seems filled with it. This suddenly discovered passion that strikes you like the lightning of a divine revelation, had it always lain in your heart and mind ?

Thus, Georges Grod, a wartime child, had his close encounter of the third kind in those wonderful days when, in a world battered by so much madness, he rediscovered the mirage that stirred every good-willed man and woman and in which they strived to believe, despite what the sordid reality of life had shown to the contrary: this mirage was peace. As a kid, Georges, with curious eyes, marvelled at the sight of all these soldiers that came from the land of the free, a freedom that had in part been exported from France during the lifetime of a certain Lafayette, and which arrived not only with guns and food, but also with their culture of comics, cartoons and Hollywood blockbusters. All of the latter had, of course, been forbidden under the jackboot that tried to crush France during the Occupation. Georges, however, made his discovery in a bin, finding periodicals that opened a paper window on America, this nation that just mobilised its most diverse talents to kick these demons into history and make a more radiant future for the human race. At least that was what they believed. In George's memory, where the man of films and television was already taking shape, the skies of his imagination were filled with clear, impressive images of enemy and friendly aircraft that became more and more numerous from June 1944 onwards.

But, now these planes were there, within reach of his desires. He only had to flick through a magazine to see the famous B-17 Flying Fortresses, the twin-engine B-25 and the P-38, that the German quite rightly nicknamed the "twin-tailed devil". Looking up at the sky, George looked out for these flying machines as soon as he heard the distant throbbing of an approaching squadron, making his heart beat faster as the windows of his house shook. Georges' head was filled with images: he dreamed, as all young boys do, of flying through the skies at the controls of one of these steel monsters that now brought terror to those who had spoiled part of his childhood and destroyed so much innocence around him.

On turning the first page of his first American magazine, George did not realise that he had just started a slow and powerful process that would lead to the fruit of a passion that this book now incarnates. Deep down, you know the story, as we all have a dormant or fiercely alive collecting bug within us, an unconditional love for all that flies, whether this covers the entire history of aviation or one of its most thrilling episodes.

Touched by the grace of the great American illustrators who, for him, had lifted the veil on a sort of forbidden fruit, Georges collected the magazines, gazing longingly at them in a way that is usually reserved for a lover, then, without being unfaithful to them, he undertook new chapters of his existence where his thirst for knowledge made him into a man of cinema and television, one day on one continent, the next on another. By plane ! However, the embers of an old passion were still hot and chance placed one

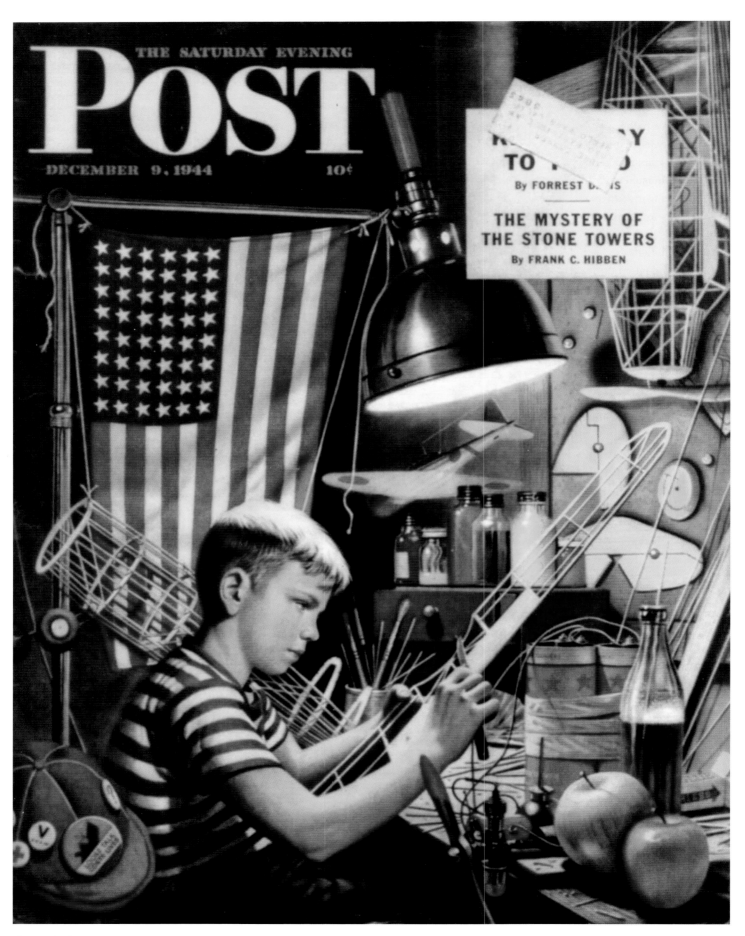

Stevan Dohanos

This artist's two sons' passion for planes, typical of the youth of the day, inspired this cover. How I would have loved to have been in this boy's shoes at the end of 1944 !

The Saturday Evening Post, 9 December 1944.

of these old magazines in his hands. For Georges it was as if he had found a childhood sweetheart years after having thought it had been hidden away forever amongst his fondest memories. He felt a shock, an emotion, a heat. He realised that this passion was not only intact and alive, but had grown deeper with life's patina. Should I write the rest of this beautiful story, which anyway you have already guessed as you are now at the gate of previously secret garden, whose guardian, Georges Grod, now invites you to stroll along its paths.

Georges was unstoppable when talking to me about his passion. Later, the reading of his manuscript ended up with me catching the bug. Like a deep-sea diver, I therefore entered an unusual environment, not one of silence though, but on the contrary filled with noise, a world at war where pencil, ink and the verb often revealed themselves to be weapons as formidable as the fleets of planes, batteries of guns or armoured divisions.

Although the European press, before being partially swept away by the Nazi tide, mobilised the talent of its numerous writers and artists to ridicule the madman in Berlin, it also began adding patriotic advertisements to its pages, exhorting its citizens to carry out their duty. Isolated after the Dunkirk disaster, Great Britain, a nation known for its particularly active and motivated press, certainly put up a better fight thanks to the impact made by these adverts on a population struggling under the effects of the Blitz.

Uncle Sam, standing on the sidelines until that fateful day on 7 December 1941, soon began copying the example of the Old Continent but with his own means, in other words, massive. Indeed, when America takes up a cause and is enflamed by it to such an extent that it forgets its differences, every one and everything mobilises, creating a formidable concentration of willpower for a common cause. Then, there is no such thing as whites and blacks, republicans and democrats, just an American people united for better or for worse, where everyone pulls together for the final victory. During the war, the press played more than ever its role as intermediary in a way that we could qualify as solemn, aware of what was at stake. The press was happy to relay the messages financed by the factory owners, the famous adverts shown by Georges Grod, that exalted, carried along and stimulated the population, reinforcing a nation in its determination.

These pages collected together by Georges Grod, were missing from the general history of the Second World War and more specially that of aviation, a subject nevertheless with many rich facets, sometimes unsuspected. These pages also pay tribute to the illustrators, both famous and unknown who, along with Walt Disney, waged their war alone at their drawing boards and supported by an amazing talent.

As you will soon discover, Georges did not only talk about them with pleasure and respect. It soon becomes obvious that he liked these men for what they accomplished : Fighting evil and even the war with merciless well-sharpened pencils, the great eraser that is the rubber, water colour ammunition and barrels of ink to fuel the train of inspiration. Without doubt, they made a great contribution to peace.

George was filled with a similar enthusiasm and a certain candour, that which forges great convictions. In fact, using these adverts, he chose to remind us of solid values that make up democracies and guarantee their existence or even their survival: liberty, equality, fraternity, solidarity. This is why I like this man and his work that is the result of many years of patient research and which has led to this book.

Bernard Marck

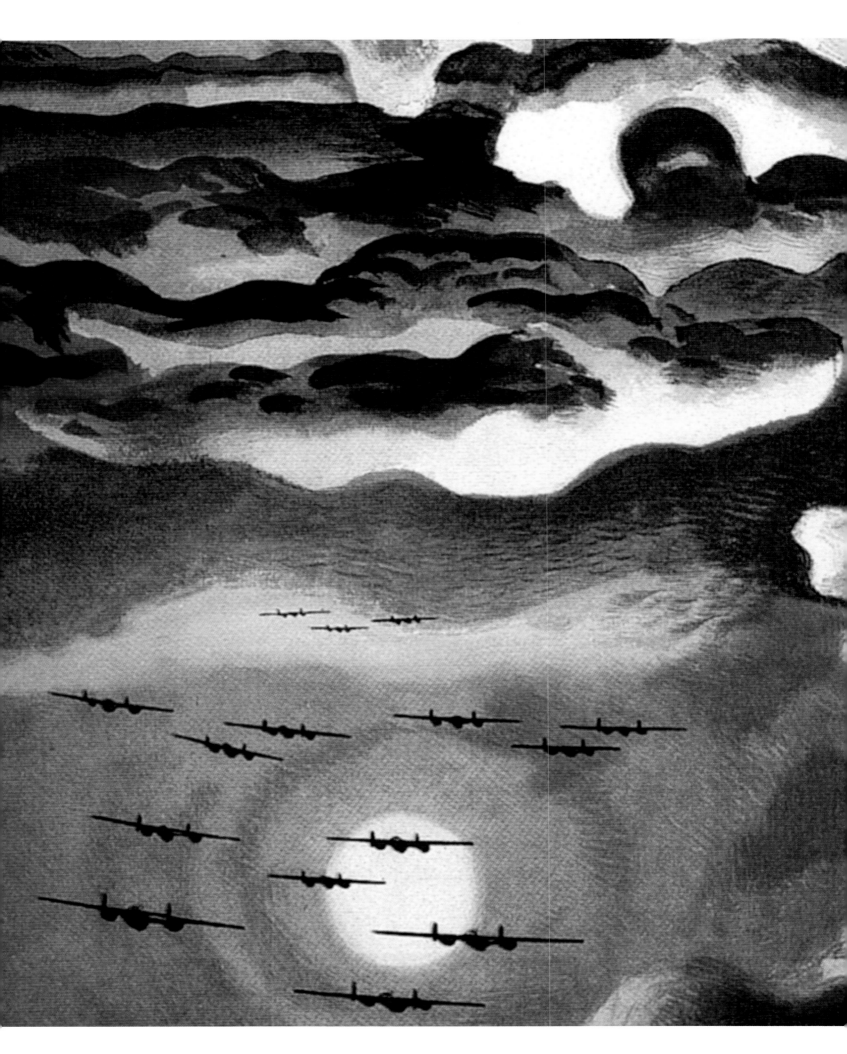

Summary

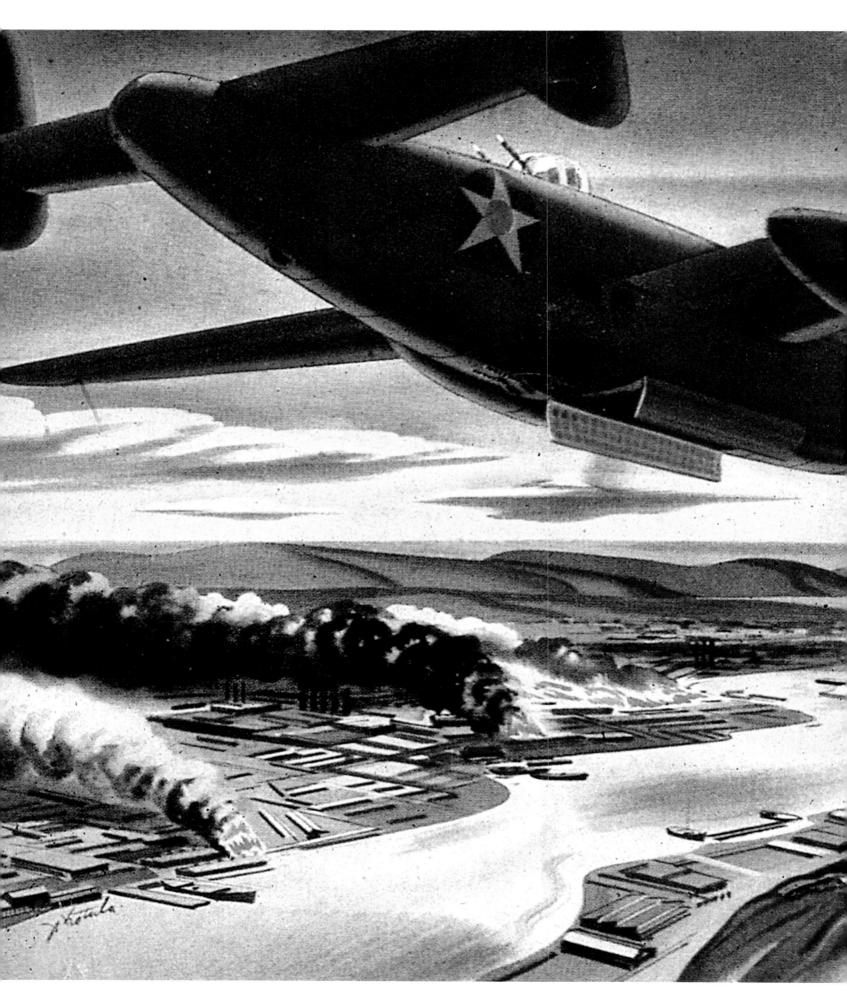

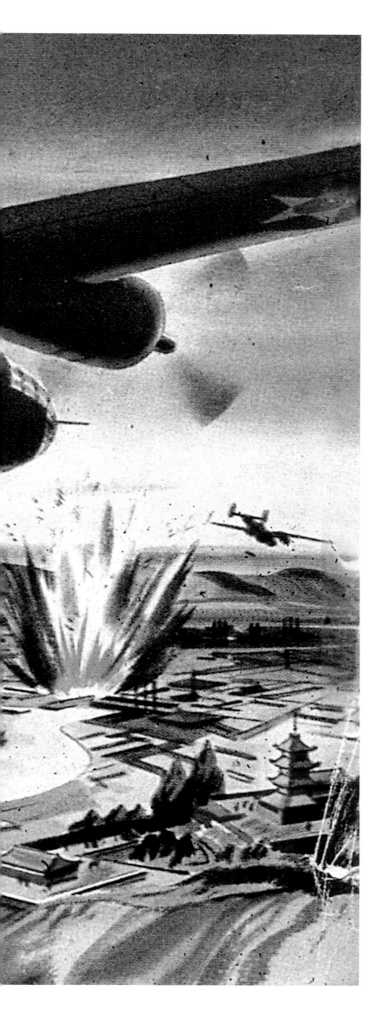

PART ONE

The victory of advertising

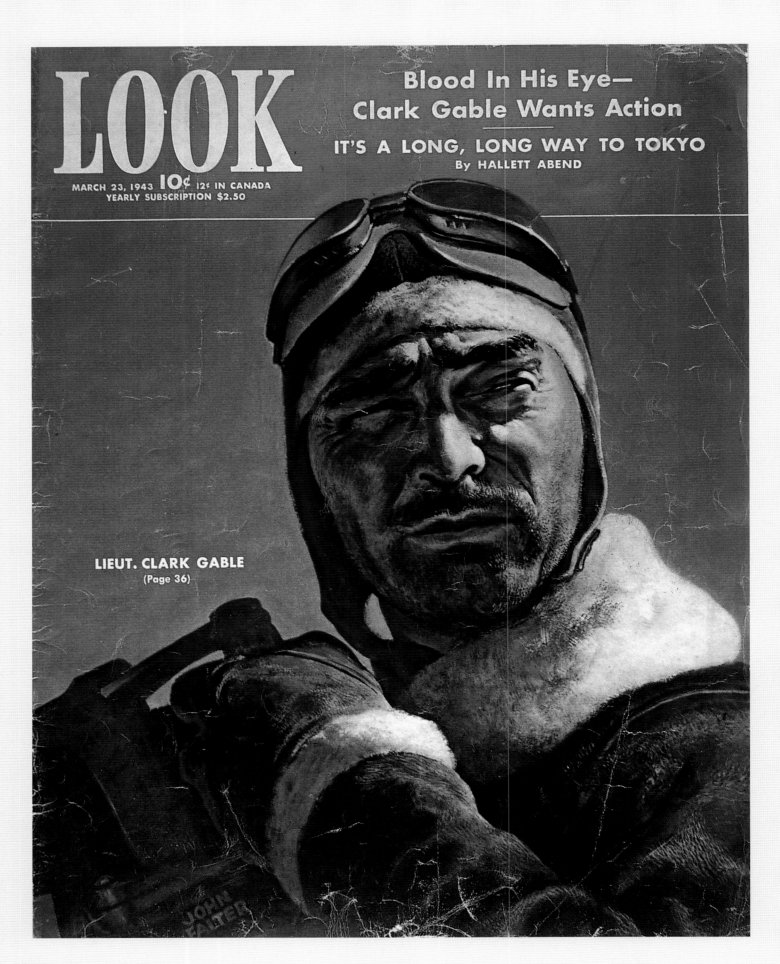

LOOK

MARCH 23, 1943 10¢ 12¢ IN CANADA
YEARLY SUBSCRIPTION $2.50

Blood In His Eye—
Clark Gable Wants Action

IT'S A LONG, LONG WAY TO TOKYO
By HALLETT ABEND

LIEUT. CLARK GABLE
(Page 36)

John Falter

The cover of this magazine has Clark Gable, a lieutenant in the 8th Air Force and director of the propaganda flying film "Combat America".

Look, 23 March 1943.

★ CHAPTER 1

The birth of a...
paper passion

Memories of a far off time, a kid's passion, whose eyes, in a troubled world, were opening on life. The war of 1939-1945 was about to begin. As early as I can remember, famous aviators fascinated me. Their exploits delighted me. Their names were Mermoz, Guillaumet, Saint-Exupéry, Marcel Doret the acrobatic virtuoso, and many others. They had their hour of glory and gave the best of themselves to generations, a fighting spirit where comradeship was one if its first qualities. With their courage they left their mark on an era, creating dreams and, to the young, the desire to equal them. They belong now to legend, but many have totally forgotten them. All that remains are books and a few films or newsreels.

Planes made by Dinky Toys, so accurately made, were particularly attractive to me. They allowed me to go on great flights and amazing adventures. The kitchen table thus became a marvellous aerodrome where I lined up the little planes; I made them carry out incredible aerobatics, just like those of the great aviators Michel Detroyat or Marcel Doret. I also flew all over the world, picking up records for the fastest flights. Even today, I can still feel the intense happiness of those moments.

Then war came and with it long and unhappy years, a war that started with a distraught France suffering a bloody defeat. Although I was very young, I was very much affected by this. Hope, once more, came from the skies, on 17 August 1942, at first an indistinct throb that became that of a horde of giants.

On that day, the American 8th Air Force, based in England, carried out its first B-17 E Flying Fortress raid on Rouen where we lived. Their objective was the warehouses and railways situated, more precisely, at Sotteville-lès-Rouen. This raid was carried out without a single loss for the Allies. This beautiful summer day of 1942 was, for us, the beginning of our deliverance, whilst in the distance we heard the bombs exploding.

A few months before the Liberation, in March 1944, I was now 13 years old and the raids intensified and became deadly. I had taken refuge with friends at Bois-Guillaume, a suburb overlooking the city. Upon hearing the slightest drone, I would run into the garden, or into a neighbouring field to look up at the sky. The allied squadrons sped towards their objectives, making a path through the exploding flak, or chased by enemy fighters. I was filled with a great sadness at the sight of an allied plane going down in flames. At the time I tried to identify the planes with the help of a small German combat

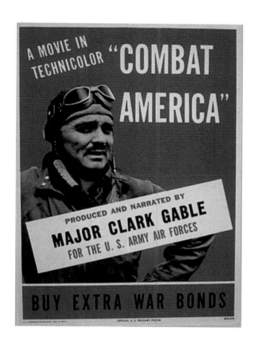

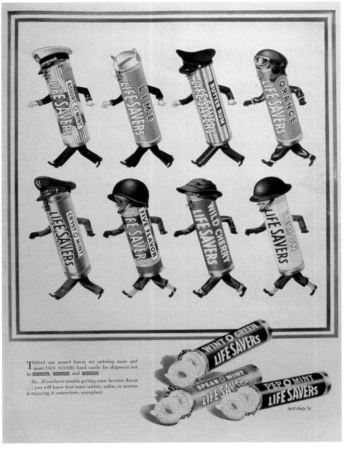

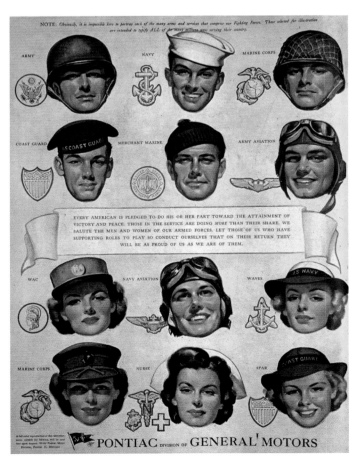

aircraft silhouette recognition booklet (Kriegsflugzeuge), a book that is well known to collectors today. I don't remember how, but I got it from a friend and swapped it for a few Dinky Toys trucks.

As a kid, I watched the fight in the skies with innocence and possibly a lack of concern due to my age, almost as if I were watching an exciting film. At no time did I feel the horror of war, its cruelty or its misery, or even the tragedies being played out in the sky.

At last the great day arrived. 6 June 1944 ! From dawn's first light, hundreds of ships began sending whole divisions and their equipment towards the Normandy beaches. The sky was filled with swarms of C-47s as well as all sorts of Anglo-American fighters and thousands of parachutists descended to the ground. The invasion had begun. The great wait too. A never ending throbbing filled the whole sky. Squadron after squadron, fighters, bombers and transport aircraft sped towards their objectives. No less than 11,000 allied aircraft flew sorties in the biggest operation in history. People spilled out into the streets, despite their fear of bombs, applauding the passing squadrons; my mother both took part in and witnessed the extraordinary events. At Bois-Guillaume, we listened out for news on the BBC, our link with freedom. Naturally, we only managed to catch scrambled pieces of news on our old wireless set, but the most essential news got through anyway: on the other side, men were fighting to help us out of the darkness of the occupation. This old wireless set, therefore, helped us to follow the allied advance, especially once they had set foot on our soil. During this time, nervous Germans patrolled, gun in hand, through the gardens of our suburb. We watched them from behind closed curtains. At this time of danger, I have to admit that there was a heavy tension, a terrible anguish that filled us. Then calm returned once the Germans had left. Above us, P-38 Lightnings circled the sky on the hunt for prey. Up there, as on the ground in each household, impatience reached its height. We could feel that the stakes were high in this battle for our future. Then came the moment of liberation; a huge joy that is forever burned into my memory; a window that opened on hope for the future, even -and above all - for a young boy. At our garden gate, next to the road, I watched, in wonder and fascination as the long American convoys passed by on their way to the front line. I can still see those young, smiling GIs, perched on their vehicles, handing out small nutty chocolate Hershey bars that smelt so good, the taste of which we have long since lost. In the treasure trove of sweets that came with the rations, I especially liked the Chicago-made chocolate covered bars whose names, Mars and Milky Way, still make my mouth water, just like they do for today's kids. The soldiers also gave us rolls of multi-coloured acid drops of different flavours called Life Savers, sweets that are still sold today. Our liberators also gave us tins of an excellent corned-beef whose taste has now disappeared. Amongst the generously handed-out presents were cigarettes that smelt like honey, Lucky Strike, Chesterfield, Camel, Phillip Morris – which, given my young age, I only smelt. My great discovery was Wrigley's Spearmint or Doublemint chewing-gum. I used to keep them for swaps and I also got through a lot myself. I should not forget Coca-Cola, something that was pretty much unknown in France at the time, plus other products whose names escape me now.

After having gone without, we now suddenly had plenty. We also rediscovered feelings that had been stifled by five years of inhumanity.

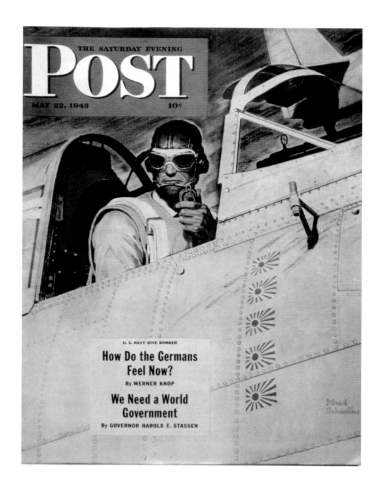

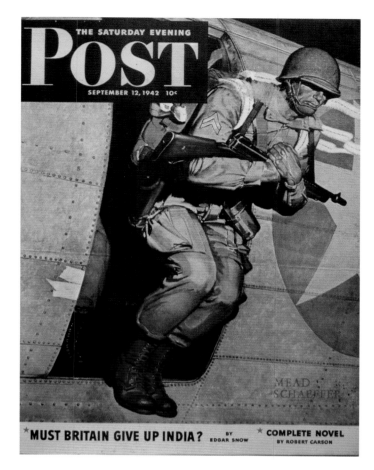

A few weeks later, a big American hospital was set up near our house. I would go walking around there with my dog. It was here that a passion was born, one that would make its mark on my life and give me the joy of discovering a little known period of history via authentic documents, the first of which I found in the......hospital garbage.

At that precise moment I felt a shock, that of a revelation, also shared as it happens by my friend Jean-Michel Charlier, the creator of Buck Danny, the famous Belgian comic strip inspired by Milton Caniff's Terry and the Pirates, a colourful and ever moving universe, filled with fabulous images that we had never seen because of the occupation.

I spent hours, both in wonder at my finds and worried at being caught, flicking through the thick magazines filled with photos and wonderful colour adverts. Luckily, the passion got the upper hand on my shyness and my imagination then took off...

A short time afterwards, enticed by this magical place where I had first experienced the emotions of the collector, I became friends with a sentry, a military policeman who strung together a few words of French. Our conversations were really just gobbledegook. However, enthusiasm usually finds a way around this sort of obstacle and I would talk to him of dogfights that I mimed with my hands as if I were deaf and dumb. I went as far as imitating the sound of the throbbing engines, the dogfights and the planes shot down by the Allies. However, he was not much taken with my stories, but deep down that did not matter much to me, blinded as I was by the admiration I held for him. Indeed, in my eyes, he stood for the whole American Army, the liberators. I felt protected by Uncle Sam, proud and well, happy at having met him and being listened to. One day I showed him a magazine that I had found previously, before asking him if he could find me some more, something that he was happy to do. Over the moon, I left with a heart and head filled with joy, not without thanking him first as if he had given me the best gift possible. With my treasure of five or six different magazines held tightly, I literally flew the kilometre back home, sat myself down at the kitchen table and devoured the famous names: : Life, Saturday Evening Post, Collier's. An aviation magazine especially caught my eye. It was called 'Flying Plus' and had

Two front covers of The Saturday Evening Post illustrated by the talented *Mead Schaeffer*, a friend of *Norman Rockwell*.

(PREVIOUS PAGE)
This is an unusual, even amusing advert that shows the popularity of Life Saver candy within the US Army. These were very popular and were given to children by GIs at the time of the Liberation. This brand still exists today.
Life, 22 February 1943.

· ·

The various branches of the US Army are shown on this Pontiac (a division of General Motors) advert by *Bradshaw Crandell*.
A reproduction of this advert could be ordered from the company for framing.
Look, 27 June 1944.

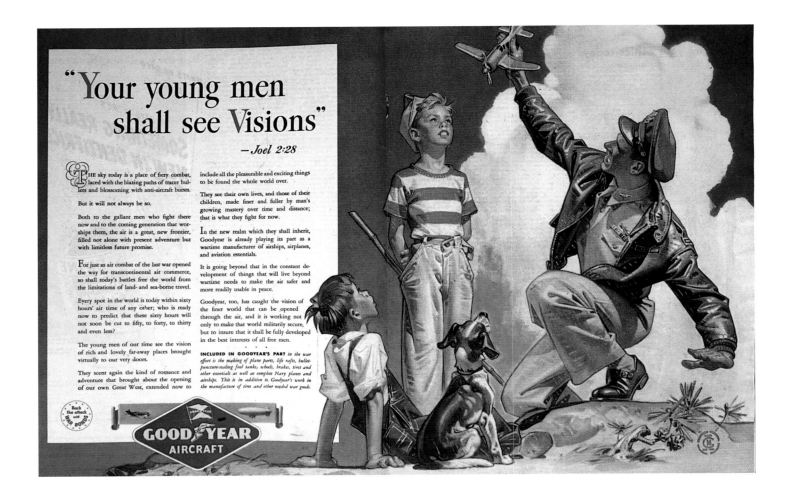

"Your young men
shall see Visions"

—Joel 2:28

(FRONT PAGE ILLUSTRATION)

Joseph Christian Leyendecker

During the Second World War, teenagers were fascinated by the exploits of their flying elders. This advert, signed by the great painter-illustrator Joseph Christian Leyendecker, promotes the quality of products made by Good Year Aircraft.

Collier's, 13 November 1943.

William Arthur Smith

This advert for the Okonite Company, a manufacturer of electric cables, symbolises perfectly the American war effort and industrial strength at the end of 1942.

Adolf should worry…

Magazine United States at War, Navy Army,

7 December 1941 - 7 December 1942.

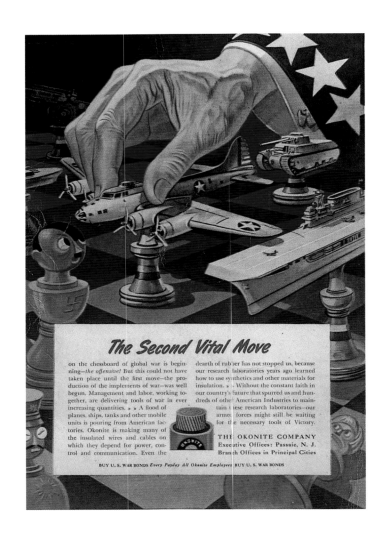

over one hundred magnificently illustrated pages and was full of photos and aeronautical adverts, both in black and white and colour. There was a colour cut-away diagram of a plane, recognition silhouettes and other details. This magazine became my bible. Inspired by what I saw throughout the pages, I spent hours drawing the planes that filled me such enthusiasm, notably the P-51 Mustang and the B-29 Superfortress. Next, I clumsily carved my first models out of pine wood. These were not great, but I liked my mediocre creations, rendered more beautiful by my imagination

In pursuit of lost dreams

Time flies past and memories, even the most precious, end up being quietly covered in dust. I was driven to despair as I had mislaid the magazines to which, as a teenager, I owed a certain enchantment. This was a period lodged between a still present war and a future tinted with hope. I had never forgotten the happy period of the liberation, a time filled with warmth and touched with fraternity. A time where you could meet and admire exemplary men and women.

After my rather average studies, chance, or luck, enabled me to become an assistant director in the film industry. I was just a small cog in a big machine, but I was able to work alongside, know, admire, observe and listen to passionate people such as René Clément and Henri Verneuil, who taught me so much. I also worked for prestigious American directors at a time when the great Hollywood film industry began its decline. The Longest Day remains an intense memory, an important stage, a trip back into a time that had marked me forever. Darryl Zanuck was an extraordinary man, hardworking and tough, but capable of extreme kindness.

The film industry allowed me to travel, to discover other worlds and quench my passion for planes, something that had never left me. I then became a television director and made numerous documentaries. The good thing about documentaries or reports, is that they allow you to meet amazing people. Also, they allow you to quench your passions by making programmes about subjects that you dream of.

I made a series about comic books. This series put me in touch with someone who I was dying to meet : Jean-Michel Charlier. With him, I was able to make a programme about a passionate subject for his great series of "Dossiers Noirs - Les pilotes de la dernière chance"(a programme concerning mercenary pilots in Congo and elsewhere). He was a friend and a role model. Like myself, after the Liberation, he had found American magazines in the garbage of a US Army hospital. Along with a journalist friend, Éric Leguèbe, we had fabulous conversations with the man I called my "good master", one of the best story tellers I have ever met. He spent hours telling us of tales that inflamed him. There was something for everyone. This man was a living encyclopaedia, a man who worked hard and who was driven by a thirst for knowledge. With him, friendship had no boundaries. He was able to understand people of value whose conceptions were totally different to his own. He knew how to listen, analyse the reasons and motivations of people, even those who did not agree with him. We would sometimes go a long time without seeing each other, but when we met again, we would end up celebrating the event. He would greet me by saying, " It's good to see you, dear friend and great artist" and we would end up eating a big meal where I would listen in fascination as he talked of his latest projects. This man should have had several lives. When my time comes, oh how I would like to see him in the next world.....He regretted not having done enough. He left us too soon. He bubbled over with ideas.

My meeting with Nicholas Hulot for his weekly 'Ushuaïa' programme (a French nature and adventure programme) was more than positive. I put together the images of French aviation from the 1930s. I became fascinated with this period. I looked for, and found, a large amount of documentation and, above all, discovered the photos of the men and women who I had admired during my childhood and for whom I had retained a great affection.

Georges Grod and a friend
on the set of a medium-length film on the history of fashion, produced by Darryl Zanuck in 1968.

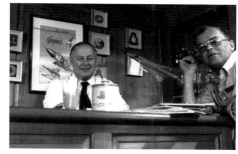

With *Jean-Michel Charlier*.

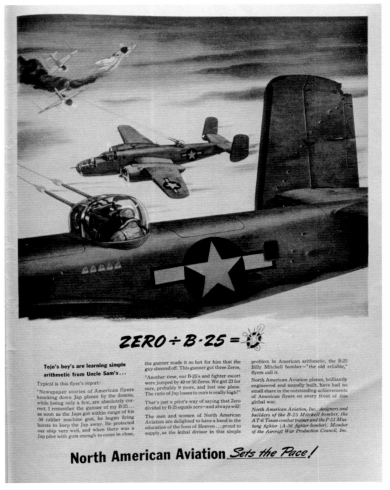

ZERO÷B-25 = ...

This North American advert uses part of a report, one amongst many, written by a B-25 Mitchell crew. It highlights the difficult task of the machine-gunners at their combat posts in the tail turrets and who, nevertheless, manage to fend off the Japanese fighters. All the determined crew members know what they have to do and that their lives depend on the skill of each man. I have not been able to identify the artist.

Life, 7 February 1944.

This was also the case for a few American aviation films from the Second World War, such as the surprising colour "Combat America" directed by Clark Gable. I am grateful to Nicolas Hulot for having accepted to show such images to the public. This unknown footage was seen and enjoyed by more people than I could have imagined. Apart from him, no modern day producer would have accepted to show such films on television and this is a shame for those of us who are fascinated by historic adventures. The greatest gift that he gave me was the filming of a programme in a Flying Legend B-25 Mitchell. The film was a souvenir flight, a tribute to all the young aviators who had gone through hell in the skies. Flying in such an aircraft filled me with an intense emotion; I even felt the presence of all those dead men. Through the throb of the engines, I could hear the faint melodies of Glenn Miller. I was shrouded in an atmosphere of nostalgia. Well done my dear Hulot for having brought back the past for a few moments. A country, a world, that forgets its past, that loses its roots, loses its soul; it lacks points of reference and, therefore, examples to follow. Without an identity, a past, how can one embrace the future ? I saw once more, with the same emotion, the American magazines that I had discovered at the Liberation and that had enchanted my youth.

It was towards the end of the 1970s, with my wife Jade, that we began, sadly a little late, to become dedicated antique-hunters, focusing more on a period rich in all sorts of discoveries: the years 1925-1930. The idea of finding these American magazines dates from this time. It was triggered during an "old paper" show at the Bastille. On a stand covered with old magazines, after looking through piles of magazines, by pure luck I came across a few old Life magazines from 1944.

For the first time, after many years, I rediscovered my childhood. Feverishly, I began flicking through the magazines and memories flowed back, suddenly very present in my memory. Time had erased nothing, when suddenly, upon turning a page, my eyes fell upon an image, or to be more precise, an aeronautical advertisement the style and illustration of which had enchanted me so many years before; a North American Aviation advert drawn by Reynold Brown. Nothing had changed; talent travels through time ! I stared at this advert in the same way as I had before. This advertisement, published on 13 March 1944, showed a Mustang flying above the clouds after just having shot down a Me 109. I had not see it at the time as I lived in occupied France and these magazines could not, of course, be bought. But everything was there, just like at the time of my first pictorial emotions at the time of the Liberation. The shock was just the same as before.

This was the starting point of a passionate hunt, but for which one had to be patient. In fact, it took me ten years to find approximately five hundred magazines such as Life, Collier's, Saturday Evening Post, Look and many others, and it is still not finished !

A collection is never complete. In France, however, they were not easy to find, a few turned up here and there, in flea markets or collector's shows. But, I still retained the hope of finding a nice pile of time-preserved and complete magazines during one of my suspense filled rambles. It was in London, during filming, that I came across the embryo of my collection, in the 'Vintage Magazine Shop' near Piccadilly Circus. With my work barely finished, I rushed down into the basement of this shop, a huge place brimming with shelves of messily stacked magazines. Here I found piles of Life, Saturday Evening Post, Look, and so on, from the period that interested me. I spent

hours flicking through them, putting to one side the magazines that held my treasure, my grail: the precious adverts.

This said, finding which magazines had published these aviation adverts was not easy and took some detective work. One had to know an address where one could ask for information. The answer came after I had contacted the cultural services of the American embassy. They very courteously gave me the address of The American Library in Paris that had a complete collection of Life magazines as well as others that had been published during the period that interested me. I was given a kind welcome and there was no problem in accessing these documents. I sat myself down at a work table and, with several volumes of bound magazines in front of me, began a fascinating search throughout the pages, something which notably allowed me to put together a list of adverts. After several such visits to the library, I ended up having a fairly good idea of what had been published in major magazines and this list turned out to be rather long. Often, the same adverts appear in several major magazines with an interval of one or two weeks. Magazines such as Liberty, The American Magazine, News Week... offer an assortment of adverts different to those published in other magazines, even though they are for the same advertising subject. The reconstitution of a complete original series created by an advertiser is an impossible mission. One can only have a general view of published advertisements.

After having gathered together a large selection of these adverts, the desire to find out who the illustrators were seemed to me to be the logical next step. All of the signatures meant nothing to me, be they those of Dean Cornwell , Falter and many others......

In Paris, the collector of old American adverts can find the adverts that he or she is looking for, depending on the periods and chosen themes, in various places; along the quaysides of the Seine, in some shops or in paper collector's shows. However, these adverts are cut out of the magazines and filed by theme so that they can be sold separately: Coca-Cola, aviation, cigarettes, cars....In the United-States, a lot of dealers sell in this way, something that in my eyes is only justified in the case of damaged magazines of which nothing much can be done, or those that are missing pages. As for myself, I respect history and prefer to keep magazines as they are. A connoisseur will value such an item, photos or news items illustrated by talented artists.

Sadly, blind commercialism threatens these links to a marvellous adventure that took place in a not so distant past. In my hunt for great advertisement illustrators for this book, I could not do anything else other than bend to the law of the market. These dealers should at least make an effort to indicate in the margin the source of their cut out adverts. They do not , however, and only mention the year it was published. At this rate, in a few years time we will not be able to find any original magazines; they are already becoming collector's items and the few complete magazines that one might find will reach high prices. Only well-off collectors will be able to build a collection. Luckily, we can rely on groups of collectors fascinated by this period and whose passion is intact. They do not especially collect these magazines but, via their research in other fields, help to prevent this important period being forgotten by future generations.

One museum particularly interested me, this being the Mémorial de la Bataille de Normandie at Bayeux, a remarkable

Reynold Brown

MUSTANGS RAISE HELL IN HEAVENS
Under this title, this North American Aviation advert takes us into the heart of a victorious, high altitude dogfight with German fighters.
Life, 13 March 1944.

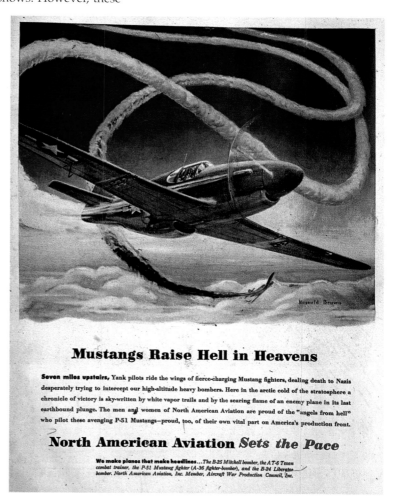

Mustangs Raise Hell in Heavens

Seven miles upstairs, Yank pilots ride the wings of fierce-charging Mustang fighters, dealing death to Nazis desperately trying to intercept our high-altitude heavy bombers. Here in the arctic cold of the stratosphere a chronicle of victory is sky-written by white vapor trails and by the searing flame of an enemy plane in its last earthbound plunge. The men and women of North American Aviation are proud of the "angels from hell" who pilot these avenging P-51 Mustangs—proud, too, of their own vital part on America's production front.

North American Aviation *Sets the Pace*

We make planes that make headlines...The B-25 Mitchell bomber, the A T-6 Texan combat trainer, the P-51 Mustang fighter (A-36 fighter-bomber), and the B-24 Liberator bomber. North American Aviation, Inc. Member, Aircraft War Production Council, Inc.

ANNUAL OF ADVERTISING ART

1943 and 1944 editions.

These annuals, published by the New York Art
Directors Club are a mine of precious
information. Indeed, each advert shows the
names of all those involved in its making.
(agency, art director, editor, photographer or
illustrator)

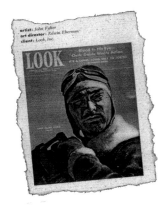

museum due to the quality of its items on display, the seriousness of its research, the credit of which goes to Dr. Jean-Pierre Benamou and his team, not forgetting the historian Georges Bernage for the competence and accuracy of his books. All deserve the utmost praise.

At Sainte-Mère-Église and the Airborne museum, Yves Tariel was in charge of the marvellous reconstitution of the Skytrain Pathfinder Argonia. The plane did indeed fly on 6 June 1944 with the 439th TCG of the 9th Air Force, dropping paras of the 506 PIR-101st Airborne Division. No documents were found concerning this plane and, therefore, the decision was made to give it the livery of a leader aircraft. A tribute to this great moment in history.

Passionate aero model makers, either on their own or in clubs, are historians in their own right. They recreate aeronautical scenes to the slightest detail and often go to great lengths in their historical research, consulting magazines and specialist bookshops in what is usually an indispensable prelude to recreating a scene. The success of the Paris model kit show is proof of the interest of a wide section of the public in model kits. Well done Monsieur Barrau ! For those fascinated in US planes bearing the white star, I am reminded of Eddie Rosier who, under his magnifying glass, makes real pieces of art of an incredible precision. With his splendid reconstitutions, the planes and people are of the utmost accuracy; soon he will add 1/48 scale magazines such as Star and Stripes, Yank, and Varga pin-ups from Esquire magazine. Another friend, Renaud Pouge, a very skilled model maker, is fired by a fascination for D-Day planes and makes superb kits. All of these talented model kit makers thus help perpetuate a past that could fall into oblivion.

Militaria collectors of all periods and subjects help conserve an important part of history. They are the guardians of a past rich in action, suffering and hope. The chosen subjects are extremely varied and include, personal items, badges, equipment,

uniforms, vehicles, various accessories, planes and so on. I would like to express my gratitude to these collectors, most of whom are unknown. They provide a wealth of unexpected information for future historians, especially as their knowledge in a precise field is often impressive.

I should mention the exemplary work of Gérard and Frédéric Finel for their book 'Rappelez-vous 44' (Remember 44) . For the 50th anniversary of D-Day, they wrote the most intelligent book that I have ever read. I enjoyed the way it was put together, the choice of texts, illustrations, the documents shown and the format. This book should be in every school library so that future generations will be able to understand this period.

Luck sometimes leads one to good things. The end of 1993 led to me meeting someone who would help me complete my documentation and at last bring my studies to a conclusion.

Jean-Luc Beghin is a member of the American Society of Aviation Artists. Thanks to him, I was able to write to two artists who had made numerous wartime illustrations and adverts, Jo Kotula and Ren Wicks.

Via letters I was able to verify and obtain direct information on their lives and careers. These two men wrote to me with this information with a warmth, a kindness and a spontaneity that is rare these days. What I liked the most about them was that they were still young at heart and had a boundless energy. They seemed surprised that someone could be interested in their work from another age.

Jean-Luc is, like me, an avid collector of objects, magazines, documents, photos, books and eye-witness accounts. We hold the same respect for these men and women who served during those historic years.

We both lived through the Liberation. Throughout our lives, we have been fascinated by the allied side of these events, thanks to the archives of the Second World War. One of the goals of his collecting is to write a book about the GIs in Europe.

Our meeting enabled us to discover things and enrich our knowledge via exchanges of authentic documents that turned out to be very useful in our research.

ANNUAL OF ADVERTISING ART
1943 and 1944 editions.
Some of the inside pages.

A COLLECTION THAT LEADS TO OTHERS…
When hunting for antiques, it is fun to find period objects that are directly related to the adverts.

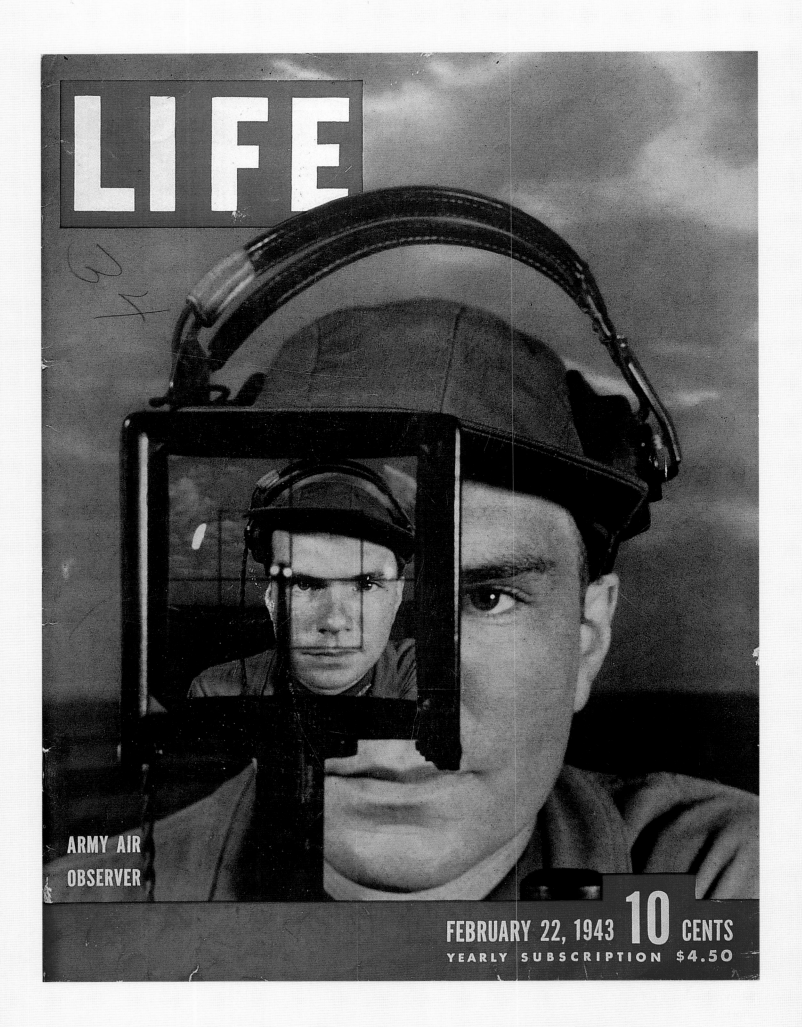

LIFE

ARMY AIR
OBSERVER

FEBRUARY 22, 1943 **10** CENTS
YEARLY SUBSCRIPTION $4.50

Front cover of **Life**, this is without doubt the most commonly found magazine in European collector's fairs. Photo *Dmitri Kessel.*

★ CHAPTER 2

Discovering the magazines

Life, the remarkable news magazine of more than one hundred pages, was filled with articles backed up by numerous quality photographs covering various topics such as the events of the time, the progression of the fighting, the life of military personnel on all fronts, famous people of the day, civilian life, the industrial effort, technological progress, movies and so on. In other words, a flow of varied articles that were worth reading and well set out. Apart from these detailed articles, the magazine also had full page advertisements, twenty of which were in colour, of great illustrative quality and hard hitting ! Take for example, those made by North American, the constructor of the famous T6 Texan , B25 Mitchell and P51 Mustang. Magnificent illustrations by talented artists such as Kramer or Reynold Brown, showed off these aircraft in action.

The Saturday Evening Post was a magnificent magazine whose front pages bore great quality paintings by a host of talented artists such as Norman Rockwell, Mead Shaeffer, Rabut and so on. This hundred page plus magazine included articles illustrated with photos that were often in colour, covering a realm of subjects, all interlaced with adverts drawn by the greatest talents of the day: Stahl, Baumgartner, John Falter, Bingham. Despite the obvious attraction of the magazine, I preferred, however, Flying, not forgetting Collier's, a weekly magazine that closely resembled The Saturday Evening Post. I could only string together a few words of English, but that hardly mattered as the pictures spoke for themselves.

All these adverts portrayed the vitality of a people; to sum up, for the kid that I was, they represented America. All the artists, painters, illustrators and photographers pursued a common goal, that of motivating a people, portraying the heroism and creating one, close-knit family. They had a grasp of the stunning illustration, the movement and the detail. They had to strike people's imagination, their sensitivity, create a dynamism. This was with one goal in mind, to be the best in all fields.

A whole host of products had to be shown off, as well as the contribution, or even the mobilisation of companies, from the smallest to the biggest, in the great national war effort.

OVERSEAS EDITION FOR THE ARMED FORCES DISTRIBUTED TO THE U.S. ARMY BY THE SPECIAL SERVICES DIVISION, A. S. F., TO THE U.S. MARINE CORPS BY "THE LEATHERNECK" AND TO THE NAVY BY THE BUREAU OF SUPPLIES AND ACCOUNTS, U. S. NAVY NOT FOR SALE

This type of insert on the front page is characteristic of the free editions that were given to US military personnel stationed overseas. Sadly they do not have any adverts.

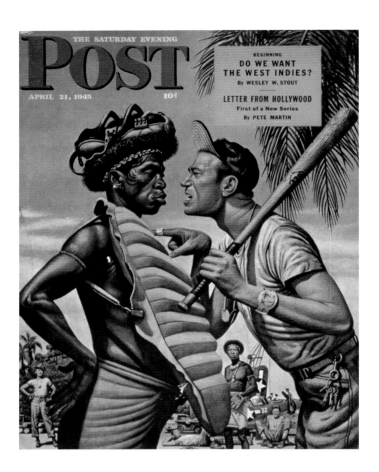

THE SATURDAY EVENING POST.

21 April 1945 issue,

illustration by *Stevan Dohanas*.

...

22 April 1944 issue,

illustration by *Mead Schaeffer*.

All of these firms were important, all manufacturing, under the gaze of Uncle Sam, very present in many adverts between 1942 and 1945, the impressive range of items that would allow them to win the war. The result of this springing into action revealed itself to be as impressive as the colossal effort that only the industrial might of the United-States was able to produce. With 16 million Americans in uniform, serving on various fronts strung out between Europe and the Pacific, 123 million of their fellow Americans, men, women and teenagers, worked in the factories. Throughout the war, they would produce 296,429 aircraft of all types. As for the artists, cut off in the silence of their studios, they used their imagination to visit every hotspot in the world, before

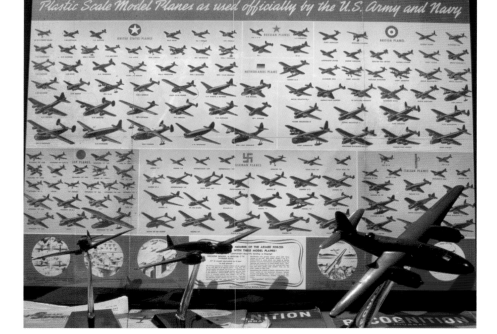

This page shows us three "Cruver" 1/72 scale kits (a British Spitfire, a German Focke Wulf 187 and an American B-26 Marauder).
The background decor is the advertising poster for the Aristo-Craft brand, distributed by this company and portraying the various allied and enemy aircraft at the end of the war.

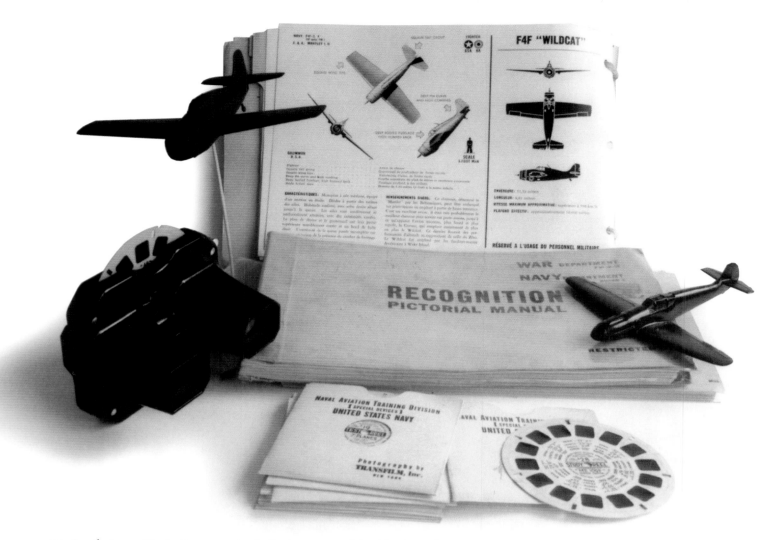

creating their war illustrations, one day in the icy waters of the Aleutians, the next deep in the New-Guinea jungle, where, in the suffocating heat, the men were tormented by clouds of mosquitoes.

Such illustrations often meant that the artist had to first produce a series of preparatory sketches, an indispensable prelude to make sure details were correct and to avoid any mistakes. According to the chosen subject, male and female models would pose in exactly the same way as the subjects in the illustration would, before first being photographed or sketched. These first sketches, or photos, would then be spread out on a table next to the artist, or pinned to his drawing-board and used to make a rough sketch. Alongside this, the artist would also use a great amount of documentation in order to correctly draw the countryside, decor and clothing, as well as the architecture that varied according to the country where the scene took place. Some illustrators had the indispensable monthly National Geographic Magazine that could provide a real source of inspiration with its numerous black and white, as well as colour photographs. Quality articles allowed illustrators to reconstitute precisely a chosen place, wherever it was located in the world, then recreate the exact atmosphere and its particularities in the most precise detail.

Cellulose aircraft silhouettes, made for machine-gunners, anti-aircraft personnel and fighter pilots for enemy and friendly aircraft recognition, were perfect for the artist when drawing one plane or another, whether on the ground or in the air and from all sorts of angles. These 1/72 scale silhouettes were generally made by Cruver (the best known of the companies under contract with the army). From a few metres away, the model would look like a real aircraft at a distance of several hundred metres.

More than 220 model kits of enemy and allied aircraft were made during the Second World War.

Towards the end of 1944, civilians were also able to purchase these same models, but made this time by Aristo-Craft and distributed and sold by Polk's Model Craft Hobbies in New York. Today, these models are extremely rare and almost impossible to find; they are much sought after by collectors.

Seen here is a "View Master" and the discs that show plane silhouettes from various angles, as well as the best known silhouette manual and 1/72 scale Cruver models of a ME 109 and a Wildcat. These items helped illustrators to create very realistic drawings.
Below, one of the discs.

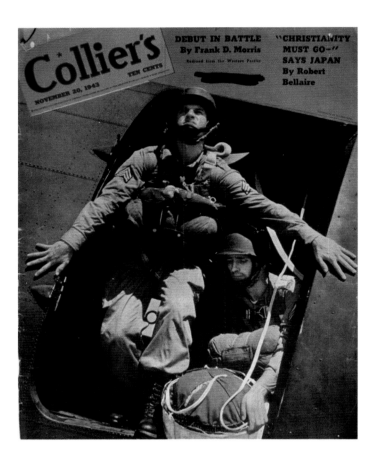

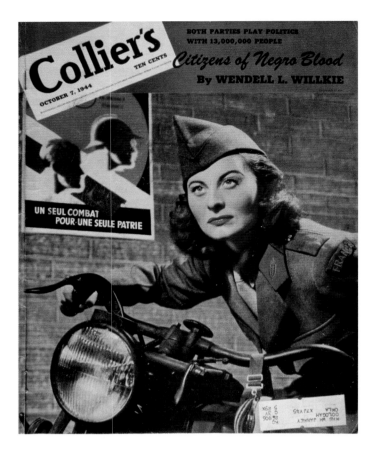

Enemy and allied aircraft recognition manuals, sold to spotters or issued to military personnel, were also very useful to illustrators looking for inspiration or some minute detail. The three-view profiles and silhouettes in action were, therefore, part of important items to be kept at all time near the pencils, pastels or tubes of paint.

Most of the documentation, however, came from the press. Articles published by aeronautical magazines such as Flying, Air News, Skyways and Air Trails, were a great source of accurate information. Also, the great weeklies such as Life and Look published articles that were illustrated with often magnificent photos portraying new aircraft, the various combat squadrons in action, the men, various items of equipment and a myriad of details that could help render the setting of the chosen subject more realistic. Naturally, there was also a necessary close collaboration with the press services of the US Army Air Force, US Navy and US Marine Corps. However, one should be careful, as the artists, when making their extremely realistic illustrations, had to be careful not to show too much, hiding a technical element or a given place in order to not give anything away to the enemy. Thus, serial and code numbers do not appear on aircraft promoting the company's products. In any case, the rough sketches and the final illustration had to pass the censor before obtaining authorization for publication.

To avoid these contingencies and losing time in administrative paperwork, the artists preferred using agents, to cite two, Barry Stephens in Chicago and James Monroe Perkins in New York. Some independent artists, like Dean Cornwell, Albert Dorne and Peter Helk, who were all well known, totally looked after their own interests (fees, work conditions, getting the work in on time).

In New-York, the Rahl Studio gathered together a team of artists such as Paul Rabut and Ben Prins, and artistic directors who acted as a link between their artists and numerous clients. To them fell the responsibility of the product offered by the agency, until its acceptation by the client. Arthur Surin showed Fred Ludekens around as artistic director when he worked for Nash Kelvinator with the Geyger Cornell agency.

As for Newell Jinc and John Older, they depended on Wynn Bedford, still in the role of artistic director with the DP Brother's Co Inc agency and a very big client, General Motors.

In their workshops, these artists used their own techniques according to their temperaments: charcoal, Indian ink, water-colours, gouache, tempera painting or in oils.

With talent and a steady hand, they lifted the veil on the everyday life of pilots, crews, ground-crews and technicians in all braches of the army. A few, skilfully harmonized brushstrokes sufficed to introduce the American public to the Pacific theatre of operations or the skies over Germany. They hid nothing in their work, from the terrible dangers, the anxious faces, death, or that particular look of relief, or even happiness, that lit up the faces, still marked by stress and fatigue, when returning from a difficult mission for example.

The gathering together of all these adverts has allowed us to see how things evolved, especially with the aircraft and their capabilities, and also the men's state of mind as the fighting progressed. After often fastidious research, carried out for a given company, the artist had to achieve the most perfect realism and show the utmost precision in the subject at hand. The talent, personality, without omitting originality, experience and sensitivity of the illustrators came together in a precise portrayal of an event that one could be forgiven for having believed it was traced from a photograph. We can, therefore, see the seriousness of these artists, the importance of their work and the efforts they went to with their rough sketches and research.

A few specialists aside, most artists did not only deal with aviation subjects. They worked on promoting several companies in various manufacturing fields that were working flat out to supply the formidable war machine. According to the multitude and variety of themes covered, the big companies even used several illustrators, of whom, some revealed themselves to be better at one type of subject or who preferred to remain in a precise field. With Coca-Cola, for example, Saul Tepper was able to show the Allies in an aeronautical atmosphere where friendship was perfectly expressed. At the same time, his fellow artists became veritable project-managers for a brand and launched long series of advertising. This was the case with Paul Rabut who portrayed the various branches of the army in action for Western Electric, and also the great watercolour artist Baumgartner, who undertook a magnificent series for Martin-Aircraft. As for James Bingham, as well as his precious aviation adverts, he also put his immense talent to work with, for example, remarkable locomotive art for Pennsylvania Railroad.

This research aimed at awakening a fighting spirit within the reader, they also had a more insidious objective in making people realise that their responsibility or their participation, however small, was of great importance in the well-oiled and terribly efficient organisation of the huge industrial machine.

If many readers picked up this inferred message in a positive way, many others were only attracted by the purely artistic aspect of these illustrations and, therefore, they became sought after items, leading the companies to hand them out for free on demand, more often in the form of posters that could be framed and which soon decorated the bedrooms of kids who dreamed of their elders' aerial exploits. In 1943, the aeronautical company Douglas, offered an colour photograph advert portraying a C-47 Skytrain at dawn. The text is attractive for

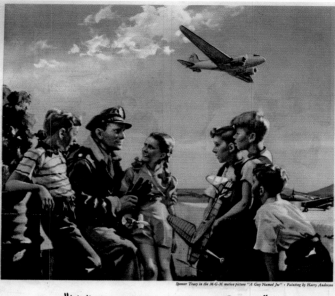

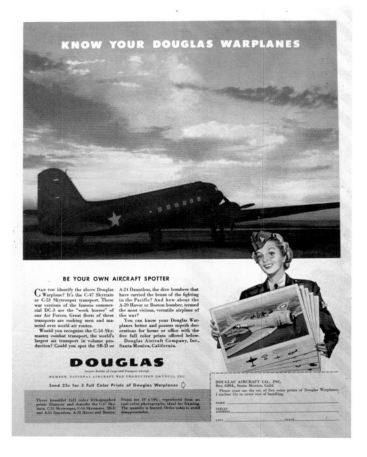

those who are fascinated by the aircraft made by his company: "Be your own aircraft spotter".

At the bottom right hand side of the advert, also painted in colour, is a young woman in uniform, holding five posters of several planes made by Douglas. It is a large colour photo of a SBD Dauntless that appears in three views. This series also includes the famous C-47 Skytrain and the C-53 Skytrooper, two versions of the famous DC-3 ; the C-54 Skymaster and the A20 Havoc. It would appear that there are several series of this poster with different photos.

North American produced, in a similar style, a series of posters of magnificent colour photographs, this time of aircraft on the assembly line: the T6 Texan, B-25 Mitchell and P-51 Mustang. Under the photo are three views of the plane. The press illustrations, made for the Alcoa Aluminium advertising campaign by Glenn Grohe and Gicha, could be asked for in poster form by the companies, who then framed them and placed them on view in the offices. We could mention other examples.

Generally, the texts of the adverts took the form of press articles in a style that closely resembled that of the reporters of the day. They related a precise event that included all the ingredients needed to get a message across: one or two soldiers in a dangerous, or even dramatic situation, who, thanks to their training, skill, but also the quality of their equipment, manage to emerge unscathed. At times these would be accompanied by a press cutting, the name of the newspaper that published it and the date, giving the whole things a touch of truth. This was the case with a John Falter advert that appeared in Life on 12 June 1943 for the Grapefruit Company.

In more than one way, these adverts follow the chronology, the course and the progress of American aviation during the Second World War. They sometimes complete the books written by historians and allow us to take a different view of events. The action really takes place under our eyes and is presented like an historic panorama; it is a glorious comic strip or an adventure film, made from real events, or at least close to the truth.

(FOLLOWING PAGE)

...BETWEEN DOGFIGHT HE GUZZLED GRAPEFRUIT JUICE...

1942, somewhere in the Pacific, a 5th Air Force airfield comes under attack by Japanese planes. Daylight has just broken. This painting by the talented artist, *John Falter*, takes us into the midst of the action.

Pilots and ground crew rush towards the planes. A P-39 Airacobra soon takes off to get to grips with the enemy, whilst the anti-aircraft guns blaze away.

However, a pilot, next to his P-40, guzzles down his grapefruit juice, a drink rich in vitamin C, the "victory vitamin". In a few seconds, filled with energy, he will join the fight.

This scene portrays perfectly the heroic climate in which these men lived. The press article dates from 9 November 1942 and talks of a Japanese attack on an American air base, thus making this advert realistic

Life, 12 April 1943.

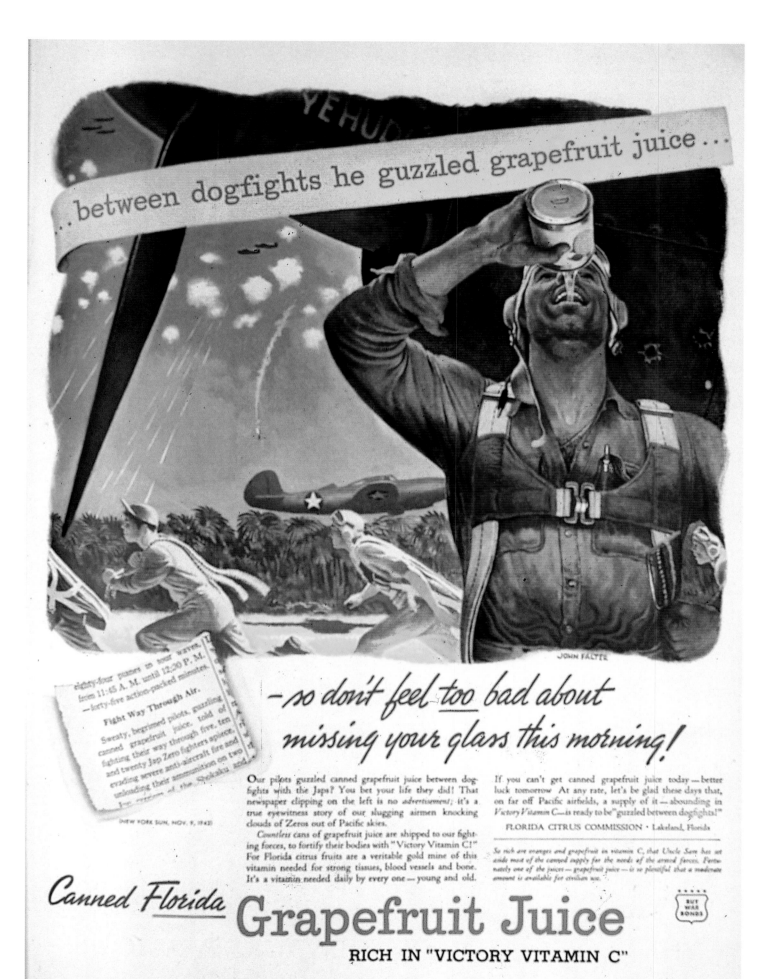

...between dogfights he guzzled grapefruit juice...

— so don't feel _too_ bad about missing your glass this morning!

Our pilots guzzled canned grapefruit juice between dogfights with the Japs? You bet your life they did! That newspaper clipping on the left is no *advertisement*; it's a true eyewitness story of our slugging airmen knocking clouds of Zeros out of Pacific skies.

Countless cans of grapefruit juice are shipped to our fighting forces, to fortify their bodies with "Victory Vitamin C!" For Florida citrus fruits are a veritable gold mine of this vitamin needed for strong tissues, blood vessels and bone. It's a vitamin needed daily by every one — young and old.

If you can't get canned grapefruit juice today — better luck tomorrow. At any rate, let's be glad these days that, on far off Pacific airfields, a supply of it — abounding in *Victory Vitamin C* — is ready to be guzzled between dogfights!"

FLORIDA CITRUS COMMISSION · Lakeland, Florida

So rich are oranges and grapefruit in vitamin C, that Uncle Sam has set aside most of the canned supply for the needs of the armed forces. Fortunately one of the juices — grapefruit juice — is so plentiful that a moderate amount is available for civilian use.

Canned Florida Grapefruit Juice

RICH IN "VICTORY VITAMIN C"

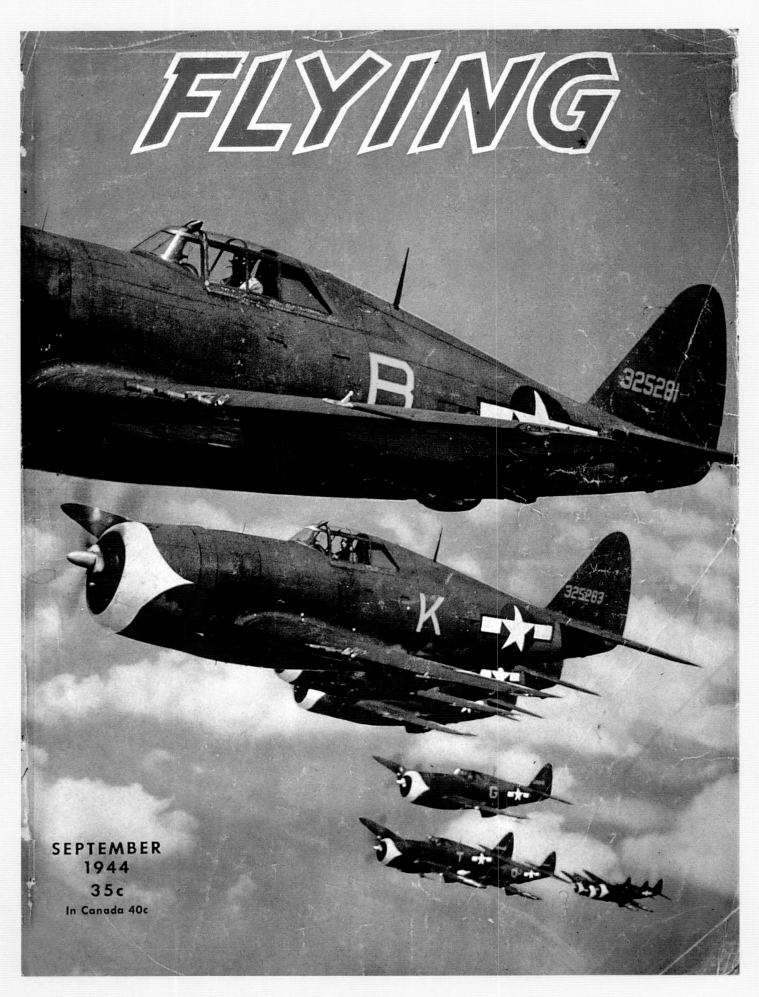

FLYING

SEPTEMBER 1944
35c
In Canada 40c

Republic P-47 Thunderbolt fighters in flight. **FLYING, September 1944.**

✪ CHAPTER 3

In the frontline: Flying (1942-1945)

During this period, young people had a great admiration for pilots and their undeniable courage and exploits that were often held up as examples. Amongst them was Gregory Boyington, a larger than life character who inspired the television series Baa Baa Black Sheep (later, Black Sheep Squadron) made in the comic strip style of the day often with a touch of truth. Another man who inspired the great master of American comic strips, Milton Caniff, was Phil Cochran who, in the series Terry and the Pirates, became Flip Corkin. An article published in an American magazine described him as being the scruffiest colonel in the United-States Army. For his adoring men, he was simply Phil. This simplicity was well deserved. When asked to talk about his wartime exploits, he would only say 'I'm no more a hero than any other'. After having fought in North-Africa with his P-40 Warhawk named Shilalha, he founded the First Air Commando in Burma where he flew a P-51 A Mustang. In March 1944, he organised the transportation of Wingate's Chindits behind Japanese lines. Thus exploit was the inspiration behind the film, Objective, Burma !, with Errol Flynn. For many aviation fans who lived through the war or who had been involved, Flying was without doubt the best aviation magazine covering the events of this period. The monthly magazine was 22 x 29 cm in size, had on average 160 pages and was published by William B. Ziff and B. G. Davis in large numbers – 140 000 in 1943, 250 000 in 1944. The front page bore a colour photograph of a plane supplied by the various branches of the USAAF, the US Navy, the aviation companies or by specialists such as Rudy Arnold or Harold W. Kulick, to whom aviation fans owe a great deal of high quality documentation. The outside back cover was given over to the large Lockheed company with an excellent series illustrated by Ren Wicks who was the artist for aircraft made by this company. Some illustrations of planes such as the twin-engine Hudson, Vega Ventura and Lightning are of absolute perfection.

A drawing made in tribute to Colonel Cochran, alias Flip Corkin in the comic strip "Terry and the Pirates". A drawing specially made for **Life** by *Milton Caniff*.
9 August 1943.

CURTISS WARHAWKS.

June 1944 issue,

photo *U.S. Army Air Forces*.

. .

CURTISS C-46 COMMANDO.

July 1944 issue,

photo *U.S. Army Air Forces*.

. .

PIPER, AERONCA.

May 1943 issue.

For the Curtiss company in 1942-43, Lloyd Howe undertook a series that immortalised the famous P-40 as it fought the Germans in Africa and with the Japanese in Burma. These excellent illustrations paid tribute as much to this legendary aircraft as to the men who fought during these dark times. The great artist, Ben Stahl, illustrated a surprising series dedicated to the P-39 Airacobra for Bell Aircraft. These adverts placed side by side in the style of a comic strip, portrayed the entire history of this aircraft. Thanks to the realism of the drawings, that largely contributed to the success of the advertising campaign, we can see how the P-39 evolved in all its variants and on all fronts, even that in the East where, bearing the Red Star, it excelled at the hands of Soviet pilots.

As for Franck Soltes, employed by Curtiss Electric Propeller, he left us original illustrations, some of which portray scenes that are of particular interest to the model kit and diorama enthusiast. One of his illustrations that was published in Flying in July 1944, shows a Wildcat having a propeller blade replaced on a Pacific atoll in 1943 where the unit was based at the time.

A long colour series glorified the Wright Aircraft Engine company with its beautiful illustrations, portrayed in the industrial atmosphere of the day. Amongst this impressive series of black and white adverts, we note another large grouping of drawings made by two talented aviation artists between 1942 and 1945 :

Heaslip showed us the various types of aircraft in use with the US Air Force, via Aerols, a company that made suspension systems for undercarriage, the qualities of which the artist promoted.

As for Clayton Knight, he illustrated products made by Boots and almost all of the issues concerning this period show all types of aircraft and men in battle.

To make itself known to the public, Aeronca chose the L3 Grasshopper whose capabilities were shown via well drawn comic strips. A grasshopper, named Abel and drawn by Walt Disney himself, soon gave a personal touch to the aircraft and before long, was hopping from one advert to another in all sorts of situations.

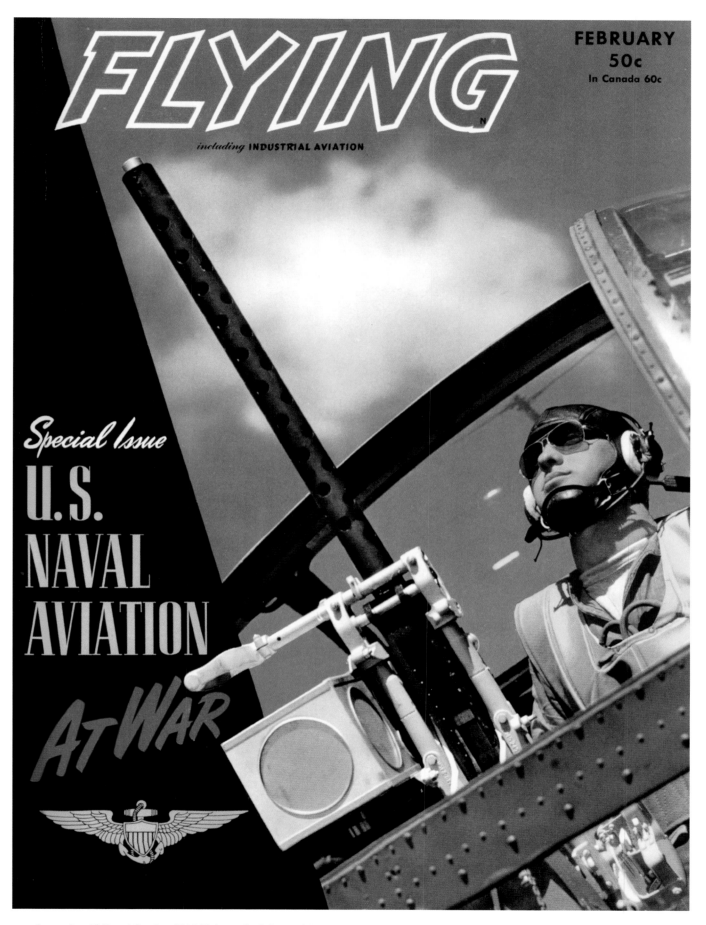

FEBRUARY
50c
In Canada 60c

FLYING

including **INDUSTRIAL AVIATION**

Special Issue
U.S. NAVAL AVIATION
At War

Between September 1941 and October 1944, **Flying** edited six special editions devoted to the Second World War. Three of these portrayed the US Navy, two the USAAF and one the RAF. A seventh special edition looked at the USN and the Korean War. These rather well filled issues had, on average, 330 pages with one or several colour photo booklets. However, the number of colour adverts is no higher than that found in a normal edition. There are many black and white photos, printed on good quality paper, as well as an equally impressive number of black and white adverts, with, of course, numerous well illustrated articles on all of the aeronautical problems of the time. Photo *U.S. Navy*.

BOEING FLYING FORTRESS
(B-17G)

Engines: Four 1,200 h.p. Wright Cyclones
Wing span: 103 ft. 9 in.
Length: 74 ft. 9 in.
Height: 19 ft. 1 in.
Top speed: over 300 m.p.h.

Gross weight: over 65,000 pounds
Service ceiling: over 40,000 feet
Armament (.50-cal.): 13 guns
Crew: 6 to 10
Wing loading: 38.5 lbs. sq. ft.

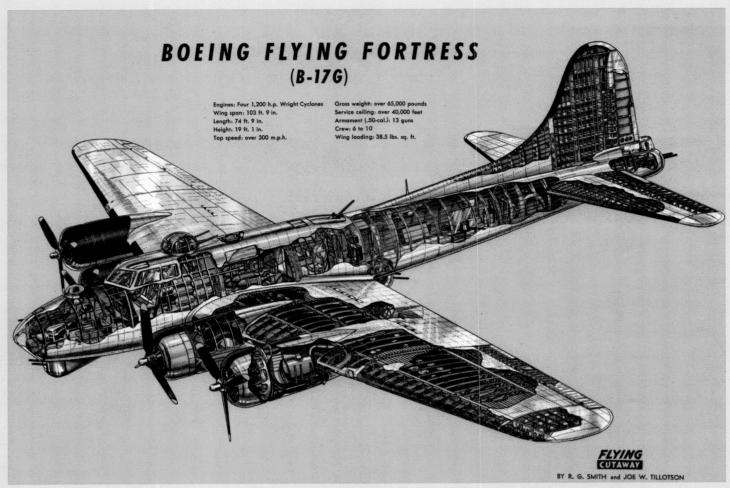

FLYING CUTAWAY

BY R. G. SMITH and JOE W. TILLOTSON

REPUBLIC THUNDERBOLT
(P-47D)

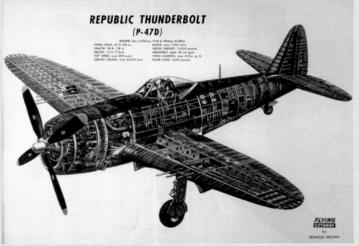

LOCKHEED LIGHTNING
(P-38J)

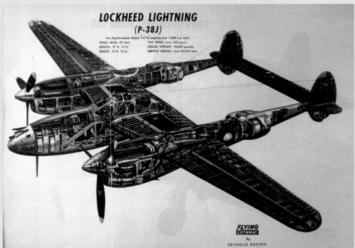

GRUMMAN HELLCAT
(F6F-5)

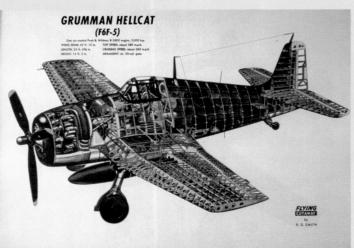

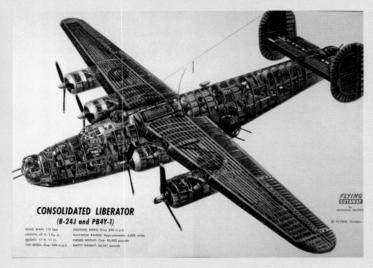

CONSOLIDATED LIBERATOR
(B-24J and PB4Y-1)

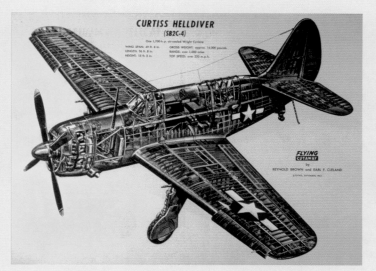

CURTISS HELLDIVER
(SB2C-4)

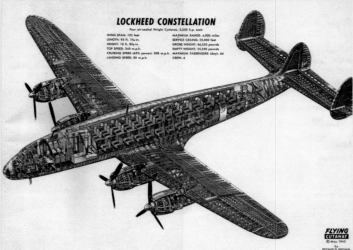

LOCKHEED CONSTELLATION

FLYING IN 1945
A LIST OF CUTAWAYS

FLYING
CUTAWAY

Month	Aircraft	Illustrator
JANUARY	B-17 G Flying Fortress	R.G. Smith & J.W. Tillotson
FEBRUARY	P-47 D Thunderbolt	Reynold Brown
MARCH	F6 F5 Grumman Hellcat	R.G. Smith
APRIL	P-38 J Lockheed Lightning	Reynold Brown
MAY	Lockheed Constellation	Reynold Brown
JUNE	Curtiss Commando (civil)	R.G. Smith & R.J. Poole
JULY	Vought Corsair F4 U1 D	R.G. Smith & R.J. Poole
AUGUST	Airsedan (civil), advert	Kotula
SEPTEMBER	Curtiss Helldiver SB2 C4	R.Brown & E.F. Cleland
OOCTOBER	B-24 J Liberator	Reynold Brown
NOVEMBER	Fairchild Forwarder	R.G. Smith & R.J. Poole
DECEMBER	none	

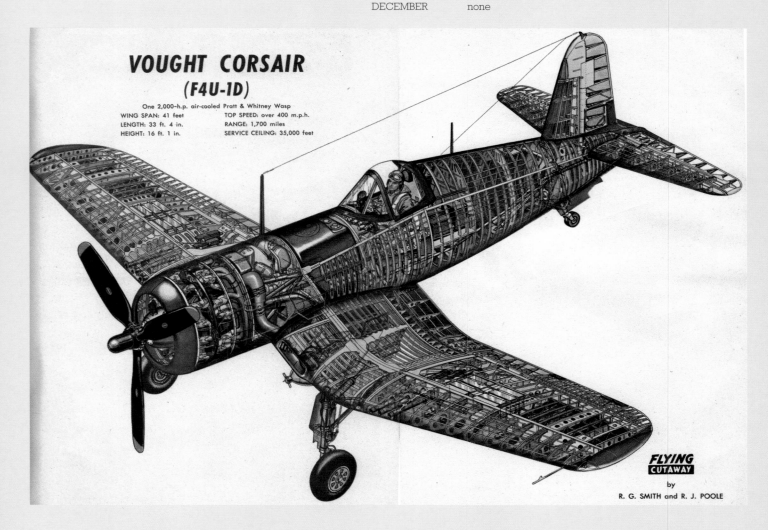

VOUGHT CORSAIR
(F4U-1D)

One 2,000-h.p. air-cooled Pratt & Whitney Wasp
WING SPAN: 41 feet
LENGTH: 33 ft. 4 in.
HEIGHT: 16 ft. 1 in.
TOP SPEED: over 400 m.p.h.
RANGE: 1,700 miles
SERVICE CEILING: 35,000 feet

FLYING
CUTAWAY
by
R. G. SMITH and R. J. POOLE

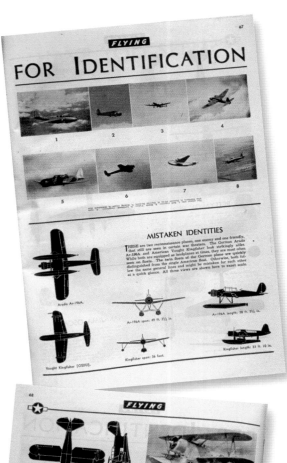

The Piper Cub L4 Grasshopper appeared in adverts that were also very well drawn. We can follow it through numerous theatres of operations where it served. This time, its constructor used a small bear cub wearing a USAAF forage cap as its symbol.

Eddo Float Gear, that made floaters for the navy, placed adverts in magazines that were illustrated by Rodewald and made to look like press articles, promoting the exploits of the Kingfisher, the observation and above all, the perilous rescue of pilots who had crashed into the sea.

This is a brief look at the aviation adverts published in this magazine. There were a great many. There was also a multitude of fascinating articles talking of events, technological progress and the men and women united in the war effort, all accompanied by quality photos and drawings. The black and white photographs, taken by talented photographers and printed on thick paper, evoked the climate and atmosphere especially well.

There was enough in the magazine to captivate me:

"Have You Seen", a series of illustrations detailing the aircraft involved in the conflict. "Mistaken Identities" compared the silhouettes of allied and enemy aircraft, allowing one to note the characteristics of planes that could be mistaken for each other. "For Identification" literally took a plane to pieces in each issue in order to render its identification easier. This page was placed before the three view section that showed in photographs the various aircraft serving on all fronts.

We now arrive at the two main parts where, for many enthusiasts, the most interesting sections of the magazine that made its mark on generations of aviation fans lay.

In March 1943, the publisher introduced booklets of colour photographs which continued up to December 1945. We have noticed, when talking with friends who knew Flying, that this great idea was a huge success. It perhaps helped make this magazine the best selling aviation periodical, making it the reference point ahead of other very good magazines. December 1945 saw a major change with the appearance of colour two-page aircraft cut-away diagrams. Ten were published up to November 1945. These distinctive drawings showed the internal structure of the aircraft, sometimes to the tiniest detail and can be considered as being veritable works of art. These were a great success and Reynold Brown was without contest at the top of the artists' hit parade. His works of art, the P-38 J Lightning, B-24 Liberator and P-47 Thunderbolt, bear testimony to his skill.

In March 1942, **Flying** magazine started a section that became popular and which contributed to the magazine's success. This was called "For Identification 100 Mistaken Identities" and showed planes from three angles allowing for the identification of friendly and enemy planes.

...

INTERCHANGEABILITY KEEPS 'EM FLYING

This *Soltesz* illustration shows mechanics changing the propeller of a F-4F-Wildcat at Henderson Field, Guadalcanal in 1943. This is a good picture for model kit and diorama makers. At the bottom left hand side, we can see a crate containing the propeller parts, an original item to make for this model.

Flying, July 1944.

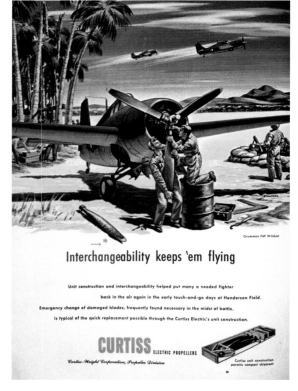

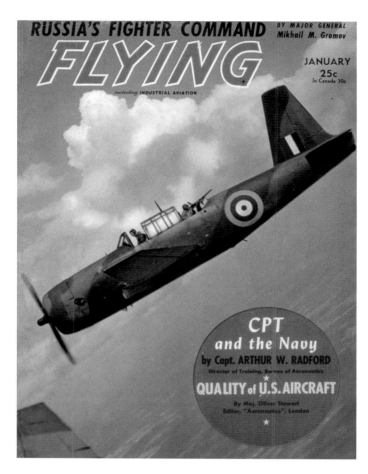

Clockwise:

BT-15 Photo *U.S.A.A.F.*, **October 1942** / A-31 Vultee Vengeance, **January 1943** / Avenger, **June 1944** / Avenger, **November 1944**.

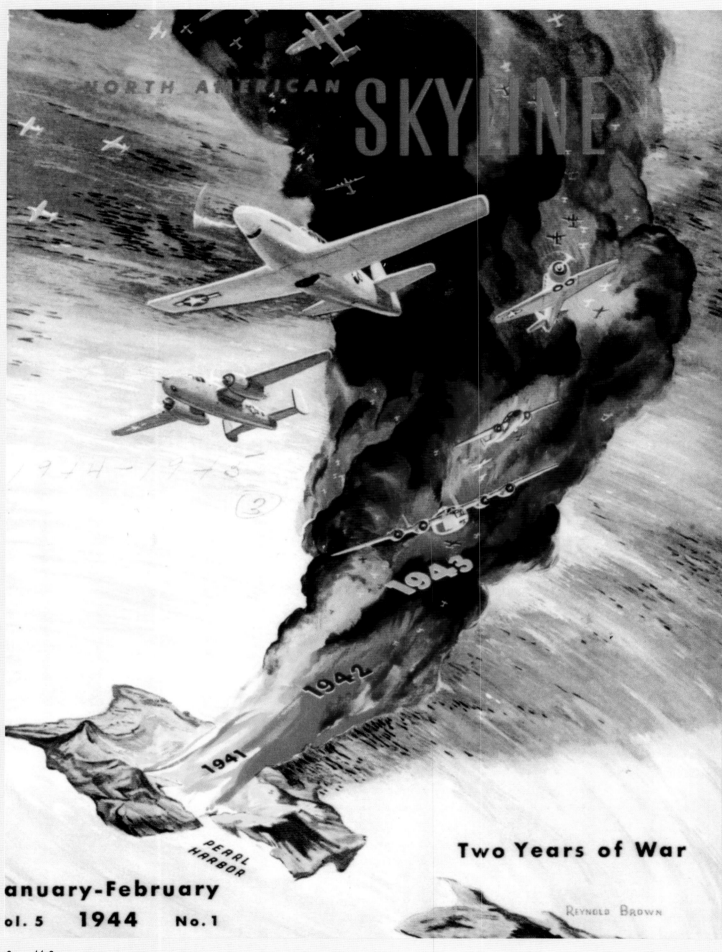

Reynold Brown

TWO YEARS OF WAR

This issue of **Skyline** is naturally largely given over to the P-51 and B-25, made by North American Aviation Inc.

★ CHAPTER 4

Aviation companies publish their own magazines

The aircraft factories made their own publications, aimed mostly at highlighting the entire production process, the workforce, various sections involved in designing the aircraft, then the assembly lines producing numerous aircraft and the multiple components necessary in this process.

These very well made aviation magazines contain much of interest. The articles cover many subjects, company events, the life of engineers, technicians and workers, the new planes and the test pilots. Other sections of the magazine look at family life, the nursery schools, leisure activities, the various associations, festivities organised for the personnel, the various events held to boost morale, life on various fronts and the exploits of the aviators showing the quality of the equipment made in the factories.

These in-house periodicals made by various companies worked like real magazines and were edited and made by small, highly motivated teams that comprised of a chief-editor, a few journalists, photographers, illustrators and secretaries. Some of these publications reached a level of quality that was on a par with the best selling magazines.

"Plane Talk" for Consolidated Vulte Aircraft Corporation is a perfect example. This was a two-monthly magazine printed on thick paper to a 20 x 30 cm format and comprising of approximately 34 pages. The back cover bore a quality colour illustration, a photo or a painting. The articles concerning this company covered a range of subjects: news from the frontlines, maintenance, a description of life in the factories, areas of production, leisure... The highlighting of various articles rested on numerous black and white or colour photos, or illustrations painted by talented little known or amateur artists.

Amongst those who contributed to this magazine, we should note the name of the photographer Ivan Dmitri who took remarkable colour photographs and who worked for various publications: American Legion, en Guardia, a propaganda magazine written in Portuguese in the style of Victory and The Saturday Evening Post.

We should take special note of the 17 April 1943 number where he published a good colour report on an air base in Labrador. On 5 February 1944, this magazine carried an excellent article with colour photos on the Liberators and their crews in the American desert based units.

We owe to him the book, "Flight over to everywhere", covering flights all over the world at war and published in 1944 by Wittlesey House-MC Graw Hill Book Company Inc., New York-London. This book, with its numerous black and white and colour documents is a remarkable account of transport aviation during the war. The colour photos were also used, as it happens, for the advertising campaign based on "The national and international American Airlines Inc", and were published in magazines

Super-Fighter
THE **MUSTANG**

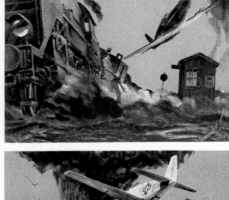

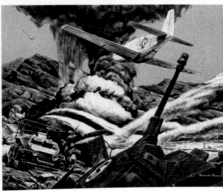

EVER since the P-51 Mustang went into action for the first time on May 10, 1942, with the R.A.F, there has been need for a single book to present the combat-production story of this great plane.

Such a book is scheduled to make its appearance soon in book stores and on newsstands. It is *Super-Fighter: The Mustang*, edited by the editors of Air News Magazine and published by Phillip Andrews Publishing Company, through Duell, Sloan & Pearce, Inc., of 270 Madison Avenue, New York 16, New York.

Popularly styled for general readership, the book is authoritative and comprehensive. It explains in basic terms the intricate pattern of engineering, production, flying, and tactics that has caused the Mustang to be described by more than one authority as "the most outstanding airplane in the world today."

Priced at one dollar, the book is profusely illustrated by Reynold Brown of North American whose work is well-known to *Skyline* readers.

Reynold Brown
Skyline, March-April 1945.

such as The Saturday Evening Post of 30 September 1944 and Fortune of April 1944.

Plane Talk was a very good aviation magazine that went well beyond its advertising objective.

Skyline, a two-monthly 22 x 28 cm format magazine of approximately 34 pages, published by North American Aviation Inc. and printed on good quality paper, bore a colour photo or drawing on its front cover whilst the back cover had a colour advert.

It was a good magazine with varied news articles that included quality black and white photos.

During the war, the excellent artist-illustrator Reynold Brown, revealed to us, via his series covering North American aircraft, an important aspect of his numerous talents.

In the January 1943 issue, volume 4 - n° 1, we can see, over two pages, the beginnings of the P-51 Mustang's exploits, in RAF livery.

The March-April 1945 issue shows us other remarkable illustrations of the P-51 in action taken from a book created by the publishers of Air News, Phillip Andrews Publishing Company and Duell Sloan & Pierce Inc. of New York. This book is like a bible that is to be kept piously by the fans of this prestigious aircraft. Indeed, it has many spectacular Reynold Brown illustrations as good as those of the best North American adverts. The May-June 1945 issue, illustrated by the same artist, allows us to view the evolution of the Mustang throughout important missions, between 10 May 1942 and 8 May 1945. We also owe to him the powerful images of the Mitchell B-25 in action, seen in its various versions and highlighted by the magazine. There is no need to point out that Skyline, of course belongs to the category of very good aeronautical magazines.

Douglas Airview, another quality monthly magazine 22 x 29 cm in format, comprised of approximately 40 pages. The front page was in colour as well as the back page that bore a company advert. The contents were very varied and in the style of a best selling magazine, with articles on the fighting and wartime events, the manufacture and quality of the planes, the life of the employees, sport, fashion and not forgetting

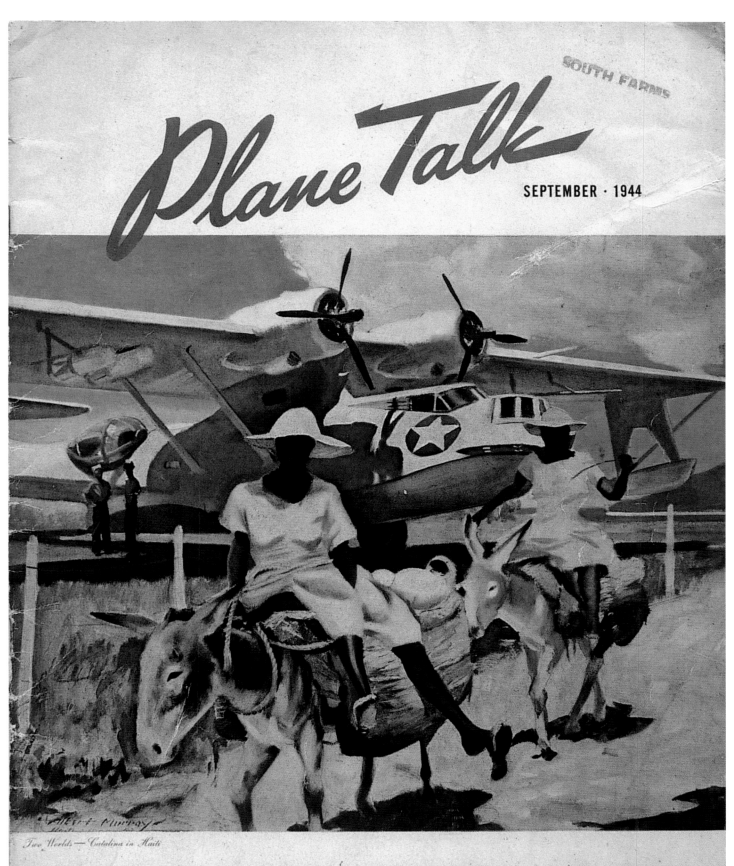

Plane Talk

SEPTEMBER · 1944

Two Worlds — Catalina in Haiti

**Why We Need Airpower for Peace · Demobilizing Our Aircraft Industry
Liberator Men in China · Medical Brief for World Travellers · Hot Stuff for Liberators**

PLANE TALK

September 1944.

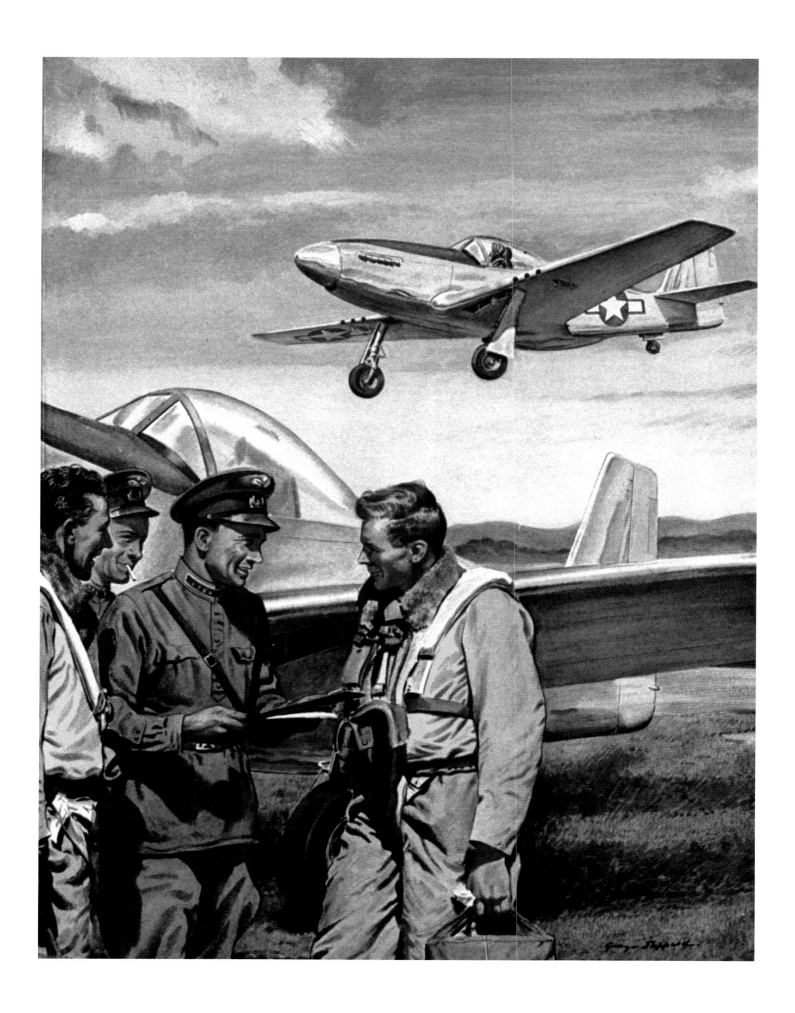

George Sheppard

The saga of the P-51 Mustang, flying on all fronts (seen here in Russia and India) was the favourite subject of the Skyline artists.

recipes and leisure. One of the things that stands out is that several issues included colour photos and that the August 1944 issue showed the dawn of 6 June 1944 with a flight of DC-3 aircraft towing Waco gliders over the channel, a remarkable photo due to the talent of Clyde Provosha.

Although they were similar to each other in their layout, these magazines all had something specific to the company that published them. Thus, the pages of the two-monthly Curtiss Fly Leaf hold priceless treasures for the enthusiast of the P40, C-46, Helldriver and so on. The magazine had a 21 x 27 cm format with approximately 32 pages, a colour front page and the traditional company advert on the back that was also in colour. This magazine was full of black and white, and sometimes colour photos, covering a wealth of subjects. Well illustrated pages portrayed the life of the company, introduced the planes, the men and women and news, all of which was accompanied by the illustrations of the in-house artist Lloyd Howe.

All the aviation companies published their own staff newspaper or magazine, differing in their articles and the choice of the latter, illustrations, photos and lay-out. All of them are of great interest to those of us who are fascinated with the period. They are little known today and only a small number of copies have survived and do not really interest collectors, historians or the enthusiast. However, these magazines helped boost the morale of a whole nation, making it aware of its responsibilities and filling it with an iron resolve and courage. They were the bond that joined together these men and women, ordinary or specialist workers, technicians, engineers, test pilots or those delivered the aircraft.

This illustration taken from **Skyline**, shows the indispensable human element needed to keep the American war machine running. Typical of "Home Front" propaganda, we can see a pilot, workers of both sexes and an engineer.

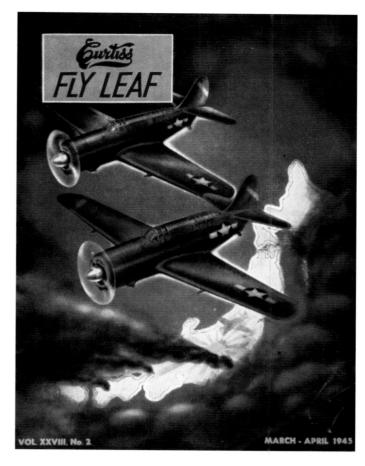

Some examples of magazines published by other aeronautical firms.

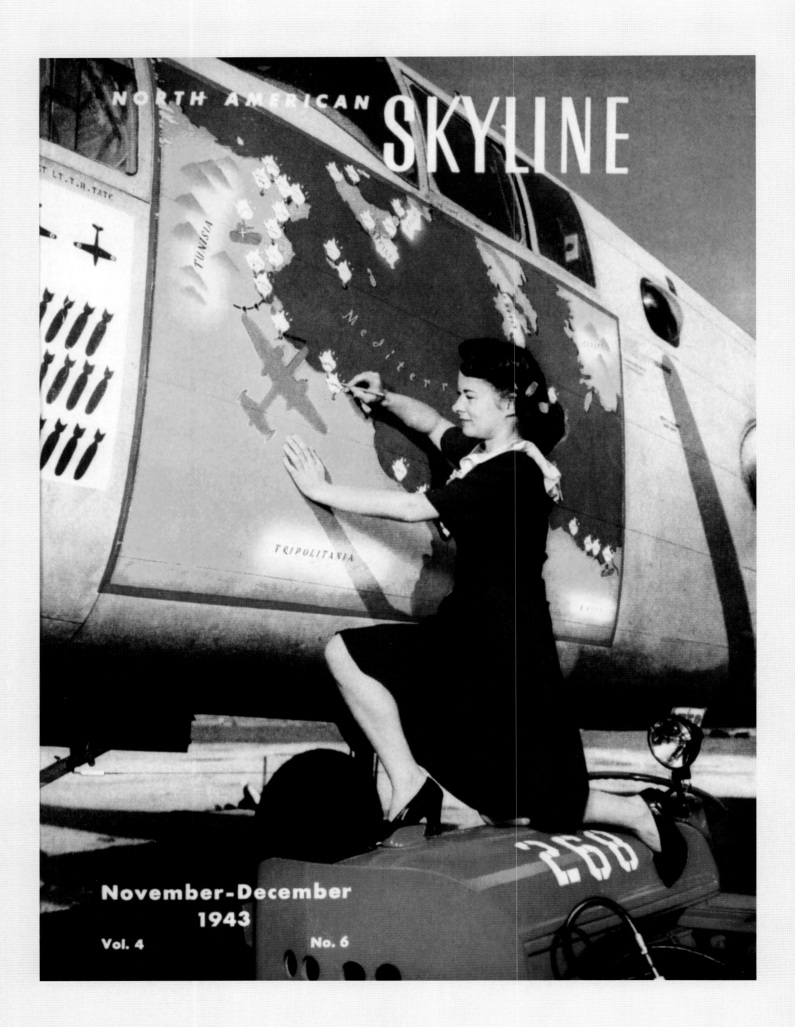

NORTH AMERICAN SKYLINE

November-December
1943

Vol. 4 No. 6

⭐ CHAPTER 5

The mobilisation of pencils and brushes

When one thinks of war, the mind invariably conjures up images of uniforms, tanks, bombers or fighters and ships bristling with guns; then others follow or blend in with them, terrifying scenes of fighting, victories, or defeats, parades and mourning...

However, one should not lose sight of one if the most important aspects of any conflict, that of the home front where the civilian populations, in most cases, suffer to various degrees: rationing, a loved one away at war, the loss of a relative and not forgetting, the constant fear of being bombed or reprisals.

The America of 1941, although it did not really live in fear of an invasion, suddenly lost some of its innocence when Japanese aircraft launched a sneak attack on its fleet anchored at Pearl Harbor. The ignominy of this attack, carried out in a period that would be rich in treachery of all sorts, was enough to enflame American public opinion and provided it with a desire for revenge identical to that which filled the first convoys of French soldiers in 1914.

But a flame, however brightly it burns, only does so if one knows how to fan it. But, the United-States were not entering a localised battle in a precise sector of the planet. Their entering into the war gave it a worldwide character. As a consequence, it was likely to last a long time.

From this point on, all means were used in order to ensure that the mobilisation of men and companies in uniform was accompanied by a constant civilian mobilisation.

The American army and the factories that supplied it relied, therefore, on the most formidable intermediary, the press and the film industry, exhorting the population and stimulating its patriotism, thanks to the talents of Hollywood film directors and artists such as Walt Disney whose fame had already reached Berlin and Tokyo. Magazines and companies employed illustrators of all styles, who had, throughout the years, to make sure the Americans received the strong message that would guarantee that they pulled together in the enormous war effort.

Curiously, there are few women amongst these talented artists, but this did not prevent the fairer sex showing a real strength in risky jobs such as ferrying the aircraft, or in physically difficult jobs on the assembly lines, a hardiness that sometimes left the tough foremen speechless.

Thus, in their way, the artists fought alongside the Marines, infantrymen, the US Air Force or the US Navy. Week after week, or month after month, they produced their war panoramas, heroic actions or just pictures that paid tribute to the war effort at home, all of which was carried out under the piercing eye of an implacable censorship. It was a case of not giving too much away, not allowing the enemy to pick up anything of interest. Such a lesson is quickly learned.

(PREVIOUS PAGE)

A young woman paints the control panel of a B-25 of the 12th Bombardment Group, deployed in the M.T.O. (Mediterranean Theater of Operations) back in the U.S.A. on a war bond tour.

Its crew was made up of four members of the group's four squadrons, as well as a Canadian machine-gunner.

The fuselage also bears the 78 mission markings, the "Silver Star" and the "Air Medal", decorations won by the unit.

This B-25 was accompanied on the propaganda tour by the B-24 D Liberator "The Squaw" of the 98th Bomber Group.

SKYLINE, November-December 1943.

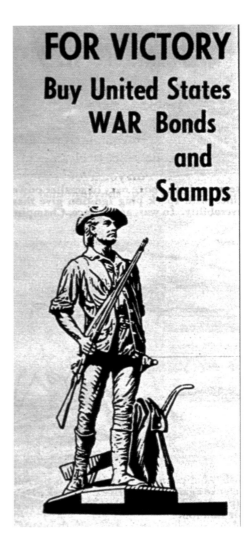

FOR VICTORY
Buy United States WAR Bonds and Stamps

Patriotic, wanting to take part, even in a small way, to the huge war effort that was about to get under way and which involved the whole nation, the American people stepped up to the task.

Walt Disney and the host of illustrators threw themselves, in their own way and with finesse, into the great fight, with just the right degree of accuracy in the brushstroke when it came to painting a plane, emotion or humour.

Before the war, in an America lacking in heroes, they had invented Superman and Mickey Mouse. From 1941 onwards, it called upon these invincible characters that made its heart beat and who would help it regain its honour and ultimately peace.

From now on, the Japanese and the Nazis would have to watch out !

Nevertheless, all wars need the wheels of industry to turn and to get things up and running quickly. It requires steel, precious metals and costly alloys. For firms to slow down their production rate is out of the question; on the contrary, they are asked to accomplish the impossible, something akin to running a marathon at the speed of a 100 metre sprinter ! Such a daring challenge costs a lot of money and government grants or bank loans are not enough. In such circumstances they generally turned to the public. Help us and we will win. Above all, your children will return from the war more quickly. These were simple, but efficient arguments that had to convince Americans to put their hands in their pockets. More effective than an austere poster pasted in every street corner, the press, radio and indispensable film industry hammered home the message to the American people, resulting in an incredible rise in production in all domains, be it the navy, aviation or land forces. America reacted to the stain on its honour and retained its drive until the Japanese surrender, not only because of its generals or admirals' strategies, but also because of the skill and talent of its artists and actors.

The war bond drive is typical of the campaigns launched by the American government to make the public participate, in this case by asking them to put their hands in their already stretched wallet. Boring administrative posters made way for those that touched a patriotic or republican sensibility, and created by the skilled hands of the great artists, or the word of the movies. This initiative paid off, as proven by the war bonds. Also, America showed its appreciation by creating the "E for Excellent" label.

The Japanese attack on Pearl Harbor on 7 December 1941, triggered this public mobilisation that had one aim: to save, contribute financially to the war effort and buy war bonds to ensure the final victory.

In almost all of the adverts published in the press, the illustrations are accompanied by texts and logos to highlight a product; in principle, a short and repetitive slogan finishes off the job of galvanising the reader.

A short time after Pearl Harbor, saw the appearance of a character in adverts, a pioneer from the previous century, Minute Man. He symbolised the roots, the birth, courage, tenacity and will to win of the American people. This character can be seen, amongst others, at the bottom of the John Vickery illustrated Cadillac adverts.

The Oldsmobile branch of General Motors showed, in a series of adverts, various squadron insignia placed at the entrance to airbases. In each of these adverts, a small insert showing a battle scene incited people to buy war bonds using slogans such as:

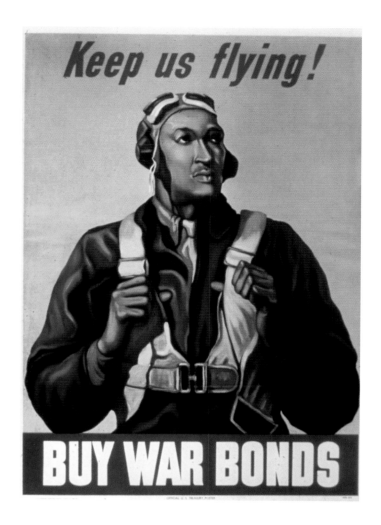

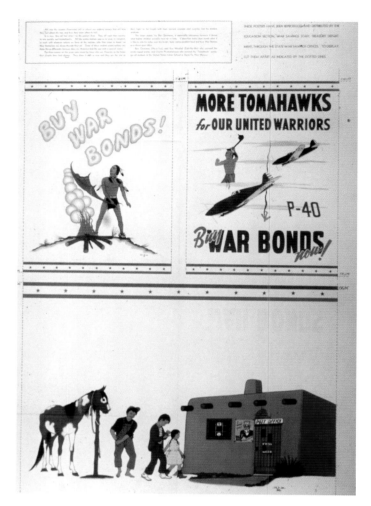

"Remember the men who are fighting for you", and "They're fighting for us, and counting on us".

Camel used a small red, white and blue shield to encourage people to buy war bonds. This was a powerful, well orchestrated form of propaganda that could mould the way people thought, one where well chosen and constantly repeated words struck the imagination. It was a discreet, but omnipresent form of propaganda that was used throughout the dark days until the moment of victory. This campaign, the organisation of which was perfect down to the last detail, had to result in total success. All over, people could purchase war bonds, in the banks, post offices, cinemas, shops, street corners and even in the workplace. There were over 70,000 selling points for war bonds and over a million for savings stamps. However, the most efficient means remained that of directly asking people to buy bonds. Thus, more than six million volunteers all of the huge country sold bonds to people from every social background.

Money saved in this way allowed people, once the war was over, to improve their living and social conditions.

Also, each radio station made a free contribution of its time and talents, using every programme to day and night to exhort Americans to prove their faith in freedom by buying war bonds (RCA, in its adverts for wireless cabinets, mentioned these programmes). Movies, new reels, short, as well as long films, brought the war to the American people and asked them to buy defence bonds.

Marlene Dietrich, Charles Boyer, Bing Crosby and a hundred other stars toured the country for free. The government did not have to spend a cent ! Kodak, in several magazines, published an advert on aviation documentaries filmed in 16 mm colour, notably "Midway incident" , "Eagle of the Navy", and "Aleutian emplacement", made by the great directors of the time such as John Ford or William Wyler.

Special War Bond drives were aimed at the so-called American racial minorities that were already fighting a tough war on two fronts, that of civic rights and that of the war.

Books for collecting war bond stamps.

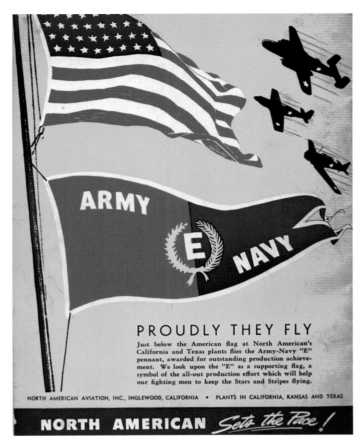

PROUDLY THEY FLY
Just below the American flag at North American's California and Texas plants flies the Army-Navy "E" pennant, awarded for outstanding production achievement. We look upon the "E" as a supporting flag, a symbol of the all-out production effort which will help our fighting men to keep the Stars and Stripes flying.

NORTH AMERICAN AVIATION, INC., INGLEWOOD, CALIFORNIA • PLANTS IN CALIFORNIA, KANSAS AND TEXAS

NORTH AMERICAN *Sets the Pace!*

PROUDLY THEY FLY
Outside back cover of the **November 1942 issue of North American Skyline.**

The press, newspapers and, above all, the best selling magazines that were so numerous at the time, were used during this campaign to get people to buy defence bonds. Books praised great Americans, dead and alive, in their struggle for freedom and justice, ideals now symbolised by the defence bonds. Millions of posters were pasted in shop windows, trains, hotel lobbies and tens of thousands of walls and advertising hoardings, talking of savings, patriotism, freedom and security. The greatest painters and illustrators had for name, Norman Rockwell, with his haunting series of posters "The Four Freedoms", Walt Disney, Dean Cornwell, John Falter, Albert Dorne...

Songs were written on the subject and were soon blaring out from juke-boxes. Some, such as "Any bonds", "Buy bonds", or "Dig down deep", were soon at the top of the hit parades. Shows and appearances were put on at every level, from high society to the working classes, in public places or in private, from the town to the farmstead, for ten or a thousand people. America was filled with neighbourhood groups that discussed the campaign. War heroes, such as the crew of the B-17 "Memphis Belle", became the voice of the eleven million men and women in uniform, making the population realise the meaning of the word SACRIFICE. America realised that the sacrifices it was being asked to make were nothing compared to that of blood and that it could spare a few dollars for the boys !

In towns and villages, tanks and planes were put on public display. Battleships, planes, tanks and even small jeeps were christened with the names of the most generous villages. Thanks to the defence bonds, America achieved a unity of minds and action. By giving every citizen the chance to take part in future progress it gave Americans of all ethnic, social and religious backgrounds something where they could all get along and cooperate with each other.

"E" for Excellence

Whereas the Americans dug deep into their savings to turn gold and silver into a martial steel for the weapons industry, the latter increased its output to such a rate that there was nothing miraculous about it, but was due to the work of the personnel.

The workers deserved to be encouraged and rewarded. This was done via the creation of distinctions that varied depending on the service branch and which were proudly displayed by companies on their adverts.

Many adverts bore a small red and blue shield with "Army " written on the red part and "Navy " on the blue with, in the centre, on a white background, a yellow letter "E " with laurels on each side. The "E " for EXCELLENT crowned the essential work and efforts of the employees, highlighting the rate of output and, in particular, the quality of the items made by the company to which it had been awarded. The award of this distinction was often a grand affair that took place in the presence of the entire workforce. A decorated stage would be made for the event where seats were set out for the factory management, representatives of the general staff, military personnel, war heroes and workers and technicians who had given their utmost in the accomplishment of their jobs. Then it was time for the speeches that paid tribute to willpower, the hard work put in by the entire workforce and the courage and exploits of the military personnel during missions that were often successful due to the quality of the equipment. The deserving workers and technicians were awarded with an "E" for Excellent badge that they quite rightly wore with pride. The nation, respectful of their work, paid homage to their sense of duty and their good work. They became an example to follow for the entire nation. They all answered the call and pulled together under the benign gaze and protection of Uncle Sam.

The badge worn by employees of factories that had been singled out for their productivity and two window Flags for Mom.

Companies that worked more for the Navy were awarded a blue banner that differed from the previous one with the addition of an anchor, but still bearing the famous letter "E". Factories that received this award soon took to flying the banner beneath the Stars and Stripes. Once the ceremonies were over, the workers returned to their posts, rolled up their sleeves and got back on with their jobs, more than ever conscious of the value of their work helping all those who were fighting overseas for their country.

Admittedly, good workers, technicians and engineers at times received their country's recognition for work they accomplished, but the nation did not forget its sons who were fighting for freedom and often cut off from their families. Here too, signs and logos started to be used by Americans to show that a son, a father or a brother were involved, in one way or another, in the war. Artists soon gave an intimate and solemn touch to this initiative. In fact, each reader at the time felt, when looking at the illustration, that he was being talked to directly, that it concerned him or her in particular. This was of course the hoped for effect. Throughout all these adverts, we can almost see the stern stare of Uncle Sam looking straight at you, a finger pointing to your chest, exhorting you to give, again and again, for your country.

Flag for Mom Window

Many adverts bore a small inserted drawing of red banner with a white rectangle with one or several blue stars in its centre, symbolising a father, son or several members of the family in uniform. This was the Blue Star Mothers flag and it was hung in the windows of houses in towns and villages across the United States. It was also often found in apartments, on a living room wall, hanging above the fireplace, or placed on a cupboard surrounded by family photos and keepsakes.

Placed in a General Electric advert published in Collier's on 11 September 1943 and Life on 27 September, this document is a perfect example of this symbol linked to aviation. I takes us into the living room of an average American family typical of the time, living in a comfortable house. The illustration fixes for eternity a moment of relaxation in this troubled time. Hung up on the wall, the flag is a reminder of the son who is serving as a pilot. Beneath it is a close up of his framed photo where he wears his flying suit. The father, sat near the dining table, has a copy of the famous National Geographic and is looking at a map, trying to find where is son is stationed. He points to the place on the map and tells his wife, who uses the opportunity to ask him what record he would like to listen to on the new high-tech pick-up radio. Throughout the wartime years, the top of the hit parade was occupied by artists such as Glenn Miller, Benny Goodman and Abbott & Costello singing with the Andrews Sisters, who gave people hope via a new sound that even the Germans liked.

Sitting on the staircase, the sister is playing with a cat. In another part of the room, the

HOME OF THE BRAVE

A woman waters her window plants. In the quiet living room, the Belmont Radio - phonograph takes pride of place. Well displayed in a window is a Flag for Mom with two stars, showing that two sons are away fighting on some distant front. The mother works for the Red Cross. This is a family where very member is at war !

This composition was made by *Tom Hall*, an illustrator whose name appears often on adverts published in magazines.

Life, 10 July 1944.

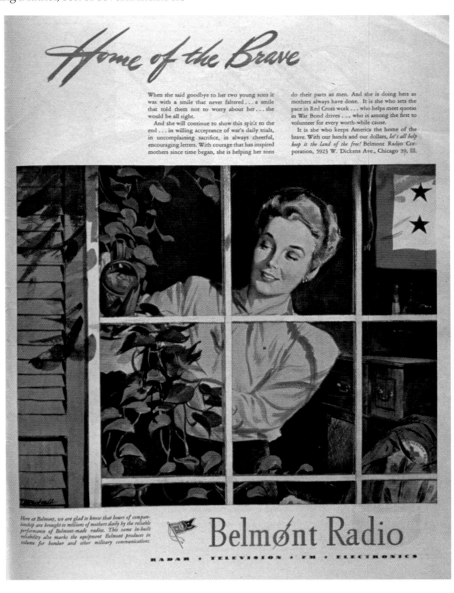

younger brother shows his little sister the Dauntless kit that he has just made, explaining part of a dogfight. On the wall is an aircraft recognition leaflet and instructions for making a kit, in other words, a dream house for the kid that I was at the time.

This type of atmosphere was typical of many families whose loved ones were away fighting on various fronts, families that the flag brought together, sometimes forming friendships where they could swap news about husbands, children and what they wrote in their letters home. They could talk about the latest news, both good and bad, and the end of the war.

When bad news reached a family concerning a loved one killed or posted as missing, neighbours would come round to show their solidarity and bring some comfort and understanding. On the opposite side, good news would often be a good excuse to throw a party where people could release their strain and fears.

The Comet company was a large manufacturer of scale flying planes and model kits. In 1942, they sold ID model kits to the civilian market. This photo shows the advert and the Comet team creating the models for the navy and civilians, the P39 kit and its box.
Airtrails, June 1942.

"We never knew till now how much enjoyment an FM radio-phonograph could give us!"

The car's in the garage. Shoe leather is scarcer. Everybody's staying home more now—and it's turning out to be fun!

And you are doubly fortunate if you own a General Electric FM radio-phonograph.

This electronic instrument is two instruments in one. You flick a button, and in comes the news of the world, a play, a comedy, a symphony orchestra, a dance band.

Your mood changes. You want another kind of relaxation. So you flick another button, put on the records, settle back, and the *permanent* treasures of the world's music are at your command.

What endless hours of delight await you then! The great symphonies of Beethoven, Brahms, Schumann. Glimpses into fairyland on children's records — the story of Red Riding Hood, and Babar, and Sleeping Beauty. Gems of jazz, and historic moments such as Congress' Declaration of War.

All the inspiration, the entertainment of recorded music, plus the eventful happenings of our day — in one glorious instrument!

General Electric is building radio for military purposes alone now. But after Victory, the General Electric radio-phonograph with FM (Frequency Modulation) will be available to every one, at a modest and reasonable price. It will be a finer instrument than ever before, because of wartime developments in the science of electronics.

FREE: Send for the fascinating 32-page book in full color: "Electronics—a New Science for a New World." Tells the story of FM radio. Hundreds of thousands of copies have been printed. Write for a copy to *Electronics Department, General Electric, Schenectady, New York.*

Tune in "The World Today" and hear the news direct from the men who see it happen, every evening except Sunday at 6:45 E. W. T. over CBS. On Sunday listen to "The Hour of Charm" at 10 P. M. E. W. T. over NBC. Buy War Bonds today for the better things of tomorrow—including a G-E FM radio.

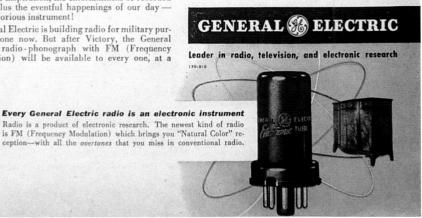

GENERAL ⊕ ELECTRIC

Leader in radio, television, and electronic research
170-810

Every General Electric radio is an electronic instrument

Radio is a product of electronic research. The newest kind of radio is FM (Frequency Modulation) which brings you "Natural Color" reception—with all the *overtones* that you miss in conventional radio.

WE NEVER KNEW TILL NOW...

I believe that this advert is by *Leslie Shalburg* (1897-1974), one of **Esquire**'s most verbose artists. **Life**, 27 September 1943.

5¢ SUNDAY NEWS 5¢
NEW YORK'S PICTURE NEWSPAPER

Comic Section NEW YORK, SUNDAY, OCTOBER 17, 1943 Published Each Sunday.

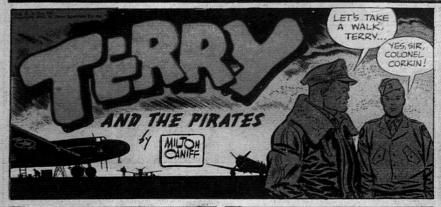

✪ CHAPTER 6

Comics on the war path

Aviation themed comic strips were, without doubt, one of the essential conveyors of propaganda. Their goal was to motivate and enthuse the young and recruit aeronautical personnel, but also to amuse and strengthen the minds of the fighting men via army newspapers such as Stars and Stripes and GI Comics.

The comic strips were imaginary places where heroes had the most extraordinary adventures and where, at the end of each colour episode, published in the Sunday supplement of newspapers such as the New York based Sunday News, the storyline ended in cliffhanging suspense. Readers would then wait impatiently to find out what happened next where the main character found himself in some perilous, often implausible situation. Using his skill and courage, he would, of course, in the space of a few pictures, manage to extract himself from the sticky situation, only to fall into another, even more perilous than the previous one. The suspense was never-ending.

These adventures were not always purely fictional as some characters were inspired by real men and the stories were based on real events as told by the press. There was, therefore, some truth to them. In post war France, Jean-Michel Charlier, used this formula with success and became part of the exclusive club of great storytellers that held their audience captive.

In the Sunday News of 17 October 1943, Milton Caniff made quite a splash when he published a "Terry and the Pirates" comic strip. He had dreamed for a long time of a meeting between Terry and Colonel Cochran, alias Flip Corkin; the latter being a reminder of the sense of duty, qualities and spirit that an air force pilot required. The effect was stronger than that of a presidential speech. The following day, the Californian representative Carl Hinshaw, told Congress about Caniff's comic strip. Thousands of these comic strips were used to boost the morale of the troops. One could say that its impact was a great as those of the best US Air Force propaganda adverts. Another great Milton Caniff success with the troops was the army newspaper Male Call publication. Milton Caniff's contribution to the war effort, due to the size and quality of his output, was very important and often acclaimed.

Buck Danny was created in 1947 in the French Spirou comic book and is a perfect example of the genre and a tribute to these men. It is still read today, is very collectible and remains well known. In the United States, the most important artist and uncontested master of the wartime period, was Milton Caniff (1907-1988) for his series "Terry and the Pirates" that he continued until 1947. The storyline centred on an aviatorwho became a hero after Pearl Harbor and the series was an extraordinary piece of propaganda. During the period 1942-1944, Terry came across real people, intrepid aviators, some of whom, under fictional names, became important characters in the

Milton Caniff (1907-1988) at his home in 1982.

...

(PREVIOUS PAGE)
TERRY AND THE PIRATES
The legendary strip of **17 October 1943.**

Greetings From Burma

TERRY, STEP UP HERE AND SAY HELLO TO YOUR FRIENDS IN THE E.T.O.

G'WAN, BURMA, I KNOW WHAT THOSE JOKERS WANT TO SEE... AND IT'S NOT ANOTHER 2ND LOO-TENANT!

for STARS AND STRIPES and the GEES in the EUROPEAN THEATRE from MILTON CANIFF

N.Y. 1944

Reg. U. S. Pat. Off.:
Copyright, 1944, by News Syndicate Co. Inc.

series. The character of Flip Corkin was, in fact, inspired by that of Colonel Philip Cochran, famous for his exploits with a P-40 in North Africa and later in Burma with a P-51. The 9 August 1943 issue of Life included a large article on him with a black and white drawing portraying one of his missions and published especially for the occasion. Colonel Clinton Vincent, aged 28, was part of Colonel Claire Lee Chennault's staff, commanding the 14th Air Force in China. He fought with the 23rd Fighter Group with his P-40, Peggy II, with which he scored 6 kills. He would be the last commander of the 23rd FG and became the second youngest general in the US Air Force. He appeared in the series under the name of Vincent Casey. General Henry Harley Arnold, the commander in chief of the USAF, deemed the work of Milton Caniff as being of great importance to the Air Force. He even delegated an officer to provide him with a maximum amount of information in order to render his drawings as realistic as possible. As far as I know and despite a lot of research, Milton Caniff did not ever create any aviation adverts. However, he did illustrate a lot of military manuals and army posters, as well as adverts for "Terry and the Pirates". One such example is that published in the Monday 11 September 1944 issue of "Stars and Stripes" , Greetings from Burma for Stars and Stripes and gees in the European Theatre. His work had a great influence on the war effort. Also, he no doubt inspired many other advertisement illustrators with the style and accuracy of his drawings, and no doubt made many people want to become illustrators.

If we had to mention another great comic strip artist who became one of the best advertisement illustrators, it would have to be the talented Noel Sickles, a great friend of Milton Caniff. He remains, without a doubt, the artist whose talent and skill had the most influence on the style of the comic strip. This also applied to Milton Caniff when, as debutant artists, they both worked together. He took over the Scorchy Smith series from its creator John Terry. He radically revamped this comic strip, the drawings, characters, secondary characters of mercenaries fighting against tyrants, formidable megalomaniacs, all sorts of gangsters and bad guys. As a kid, this comic strip was one of my favourites. Scorchy Smith, that Noel Sickles drew between 1935 and 1936, was republished in French in 1980 by Futuropolis under the supervision of Etienne Robial. This quality publication and brave departure from the fashionable comic strip of the day, has allowed enthusiasts to discover one of the genre's finest pre-war series. It might be said that the exploits of Scorchy Smith that preceded the Second World War, subconsciously gave many young people a taste for flying and adventure. Later, following the attack on Pearl Harbor, they would join the ranks of the US Air Forces.

Frank Robbins took over Scorchy Smith in 1937 with his very personal style, a style of quality. He carried on drawing this series until 1944. I discovered this artist in the

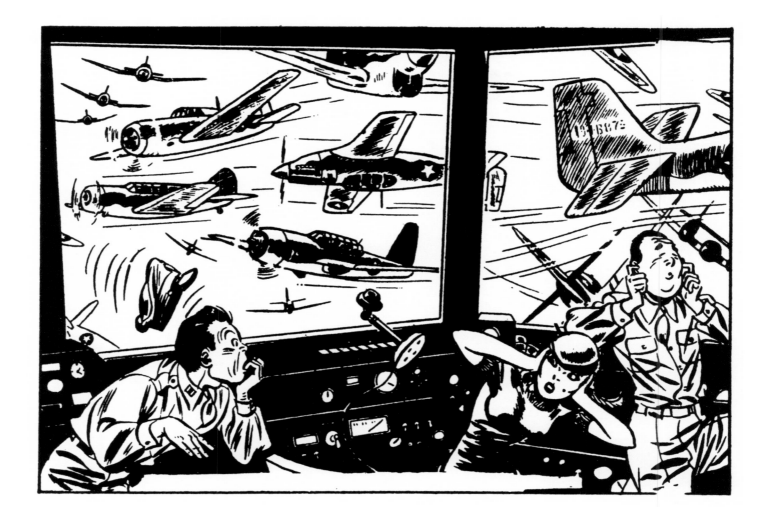

"Hurrah" comic around 1938. He undertook a few illustrations for The Saturday Evening Post. We can mention the submarine adventure comic strip, "It's a long way down" in issue number 6 of 6 May 1944.

Following his remarkable work with the Scorchy Smith series, Noel Sickles was one of the great news and advertising illustrators. He worked for magazines such as, Life, Look, The Saturday Evening Post and National Geographic. For Life, we can mention the article published in issue number 25 of 25 January 1943 and in the following issues, on the crash and rescue of Edward V. Rickenbacker during a mission in the Pacific whilst flying a first model B-17 in 1942. On the subject of the Second World War, Look published a black and white comic strip series covering the exploits accomplished on land, sea and air. These feats of arms were related over two pages in the form of adventures illustrated by artists such as Walter Richard and Albert Dorne, stories made up of approximately eight pictures depending on the subject. They were designed in a movie story board format. In the 12 January 1943 issue of Look, Noel Sickles tells us of the difficult times experienced by the crew of an 8th Air Force B-17 named "Philly" on the European front and flown by Lieutenant Charlie Paine. This Flying Fortress and its crew had been badly mauled by German fighters, but Paine managed to bring it home, just managing to land on an emergency airstrip in England.

(PREVIOUS PAGE)

Advert by *Caniff* for "Terry and the Pirates". **Stars and Stripes, 11 September 1944.**

..

The exploits of Cochran in Tunisia. **Life, 9 August 1943.**

"Male call" by *Milton Caniff*, was a huge success with the troops and reserved for army publications only. In fact, due to the scale and quality of his work, this author's contribution to the war effort was very big and often praised.

In southern Tunisia Cochran blew up German and Italian trucks hidden under haystacks. Drawings to illustrate this article were made especially for LIFE by Caniff.

CHARLIE PAINE: One Against Forty

On October 2, 1942, Lieut. Charles Paine brought a Boeing Flying Fortress through one of the great flights of the war. Last in a large formation day-raiding an air base in northern France, Paine's bomber was jumped by forty of Germany's best fighters. They knocked out two of his engines, shot away half the controls, smashed the landing gear, ripped a wing, stabilizer, and rudder, poured 200 bullets into the fuselage. Paine's crew fought on while he piloted the badly crippled bomber home.

Lieut. Charles Paine

STORY BY DON WHARTON—DRAWINGS BY NOEL SICKLES. 16th of LOOK's articles on AMERICAN HEROES

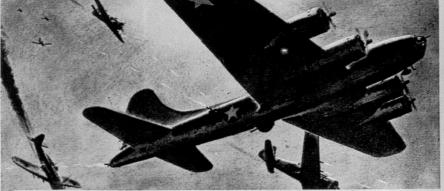

1 Across Northern France Charlie Paine pilots a Flying Fortress in the Army Air Force's 13th daylight raid on Nazi Europe. Paine is a lean, angular, 27-year-old Georgian who joined the squadron the night before. Flying for the first time with the crew of "Phyllis," he holds last place in a tail-end formation streaking 50 miles inland toward a plane factory at Meaulte—used by the Luftwaffe as a repair base. Approaching at 24,000 feet, the bombers find the camouflaged factory, line up, unload 4,000 pounds apiece. As Paine's bomber crosses the target he hears shouts over the interphone: "Here they come!" From all sides swarm forty Focke-Wulf 190's—some from Goering's renowned Yellow Nose squadron.

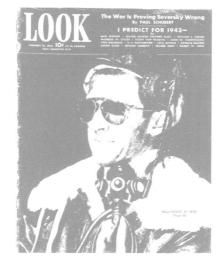

LOOK

The War Is Proving Seversky Wrong
By PAUL SCHUBERT

I PREDICT FOR 1943—

10¢

5 While machine-gun bullets tear into the fuselage, another 20-mm. shell lands directly on the upper turret. Gunner Tom Coburn is badly cut about the head, almost blinded by blood. He fires until he collapses.

6 Nearing the French coast, Pa[...] almost solid wall of German fla[...] choice, flies right into it—and [...] Channel. There the Focke-Wulf[...] him again, knocking out a se[...]

58 LOOK JANUARY 12

2 Machine-gun bullets tear into the fuselage. A 20-mm. shell hits, cuts the oxygen tube of Gunner Purcell. The explosion knocks off Sgt. Bouthillier's oxygen mask. Both fall unconscious. Two more shells knock out motor.

3 The bomber drops behind, fighters sweep closer. Paine starts a glide to save the men without oxygen. Shells rip a wing and rudder. Tail Gunner Taucher keeps firing while bullet holes open three inches above his head.

4 German 20-mm. shells burst inside the bomber, severing some controls. The plane's nose will not come down. Paine and his Texas co-pilot, Lieut. Robert Long, stand in their seats, push forward to bring the nose down.

8 Navigator Thompson plots the nearest air-field and Paine makes for it on two engines. His landing gear is smashed and he can turn only to the right—shells have torn great chunks out of a wing, stabilizer and rudder.

The field is one used by fighters—too small for a Flying Fortress. Then, bringing "Phyllis" down, Paine finds his flaps won't work and sees he is going to crash into a hangar. He tries to regain speed, knocks the bricks off the top of an airfield building and wabbles around the field for another try at a landing. Paine spots a row of trees on the edge of the field, deliberately clips the treetops in order to slow the Fortress down, finally comes in for a perfect belly-landing.

END 59

Noel Sickles

Published in Look : The adventures of Charlie Paine's B-17 that took place during a mission on 2 October 1942.

..

(NEXT PAGE)
Noel Sickles
Life, February 1943 and 31 May 1943.

THE CASE OF THE UNCOMFORTABLE PASSENGER
by Raymond Clapper

AIR TRANSPORT GETS THERE FIRST!

CROSS ROADS OF THE WORLD!

THE AIRLINES OF THE UNITED STATES

AIR TRANSPORT GETS THERE FIRST · · · PASSENGERS · · · MAIL · · · AIR EXPRESS

The illustrations are remarkable and reflect perfectly the severity of the fighting, the tension and fear of the crew. The illustrations are set out in a way that perfectly portrays the difficult and unbelievable flight back to an allied airfield in Great Britain. He portrays the skill and bravery of these aviators, some of whom were wounded, and the luck they had to get back safely. The article is called, "Charlie Paine one against forty".

He also illustrated a wonderful series of adverts for "The Air Lines of the United States" concerning transport aircraft in the service of their country, magnificently illustrated in his very personal style.

The documents show the importance of the men and the machines in this very important aviation department.

Let us look at two examples: in the 8 February 1943 edition of Life, we see the journalist, Raymond Clapper, a war correspondent at the time, writing an article in the cramped confines of a transport aircraft, full to the brim with supplies. Later, when covering the invasion of the Marshall Islands, he was killed when the plane he was flying in collided with another on 3 February 1944. There were no survivors. In the Life of 31 May 1943, an advert shows a civilian DC-3 at sunrise before taking off for a flight within the United States. The scene takes place at Miami. A military Curtiss Commando C46 is landing. A few men on leave climb on board the DC-3 " Cross Roads Of The World " . The atmosphere and composition of the illustration are portrayed with great skill and the aircraft are perfectly drawn. Noel Sickle drew a black and white series for RHEEM MFG Co, some of which have an aviation theme. He also drew the illustrations for the top secret Pentagon manuals.

Clayton Knight was one of the great aviation artists whose talent left its stamp on the history American aviation. Before the Second World War, he drew a comic strip scripted by the American Great War ace, Eddie Rickenbacker. The series was called "Ace Drummond." The main character was based on Charles Lindbergh, as was "Scorchy Smith". This great aviator was one of the men who fascinated the public at this time. This comic strip appeared in the French comic "Hurrah" with its American

Bert Christman was a comic strip story writer and illustrator before becoming a pilot. He worked with *Milton Caniff* and took over "Scorchy Smith" from *Noël Sickles* in 1936.

He joined the Navy in 1939 then enlisted in the Flying Tigers in 1941. He designed the personal insignia of his 2nd Squadron comrades, the "Panda Bears". Bert was killed in a dogfight over Burma on 23 January 1942.

NEWKIRK · 34 BRIGHT · 56 MOSS · 39

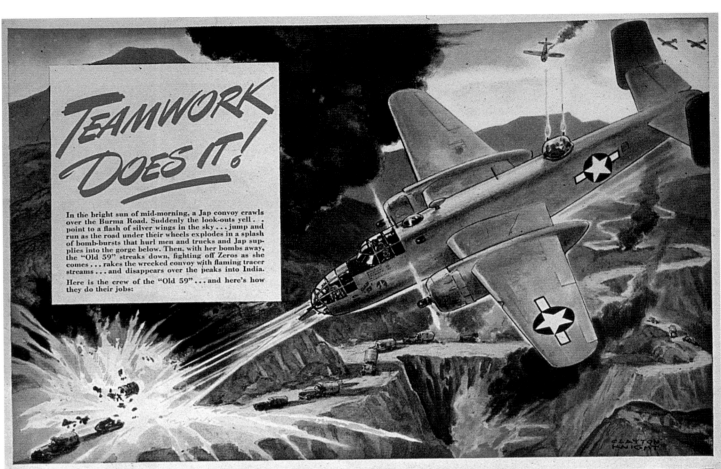

TEAMWORK DOES IT!

In the bright sun of mid-morning, a Jap convoy crawls over the Burma Road. Suddenly the look-outs yell . . point to a flash of silver wings in the sky . . . jump and run as the road under their wheels explodes in a splash of bomb-bursts that hurl men and trucks and Jap supplies into the gorge below. Then, with her bombs away, the "Old 59" streaks down, fighting off Zeros as she comes . . . rakes the wrecked convoy with flaming tracer streams . . . and disappears over the peaks into India.

Here is the crew of the "Old 59" . . . and here's how they do their jobs:

 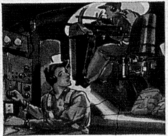

★ "Teamwork does it," says Capt. Robert Ebey, pilot, of Stillwater, Okla. "Every man on our crew is a specialist, but we don't have any 'individual stars'. In the air we fight together, as a team. And that's the way to win." Co-pilot is 1st Lt. Paul Sjoberg, of Grand Marais, Minn. "Salami", a dachshund mascot, rides behind the pilot's seat.

★ The plane, the crew, the mission's success, depend upon split-second timing, pinpoint accuracy. 1st Lt. Hilliard Peavy, navigator, of Montgomery, Ala., checks course by "shooting the sun" . . . while in the waist behind him, Sgt. Francis Donnelly, radiogunner, of Philadelphia, mans the world's most modern radio equipment.

★ Sgt. Donnelly shares his "office" with S/Sgt. Lyle Wilson, mechanic-gunner, of Conneaut Lake Park, Pa. Besides firing the top-turret guns, Sgt. Wilson is the "Old 59's" engineering specialist . . . takes care of engines, bomb-release mechanism, electric, hydraulic and oxygen systems—and in emergencies has repaired them in the air.

★ 1st Lt. George Jernigan, bombardier, of Charleston, W. Va., lets his bombs go, and then gives the gunners a hand. The "Old 59's" bombs have blown Jap shipping out of the Tongking Gulf, plastered Jap airfields from Helo to Mandalay, blasted railroad yards, bridges and ammo dumps all over the China-Burma-India theater.

★ All AAF gunners are aerial sharpshooters . . . and S/Sgt. Rudolf Madsen, of Eugene, Ore., tail-gunner, is a dead-shot with twin 50-calibers. Flying, fighting, working *together*, the air combat crew of the "Old 59" is typical of the thousands of such crews that have made the AAF the "greatest team in the world."

Clayton Knight. The Saturday Evening Post, 4 September 1944.

name, something which is relatively rare. The propaganda adverts that he designed for the US Air Force are extremely good by their choice of subjects, style of drawing and precise layout that strikes the eye and the imagination. They highlight perfectly their objective of recruiting personnel to form a united team and a powerful air force.

Let's cite as an example " Team work does't "

This advert tells us of an action that took place on the way to Burma with a B-25 Mitchell of the 14th Air Force. The plane attacks a Japanese convoy whilst at the same time fighting off a patrol of Zero fighters. In comic strip style, we see the crew at their positions in various vital parts of the plane. The role and speciality of each man is described and what we see is a close-knit crew with rock solid morale at a time of extreme tension. This advert was published in The Saturday Evening Post of 4 September 1944.

In The Saturday Evening Post of 30 September 1944, C. Knight tells us the story of the B-24 Liberator "Double Trouble". This plane was carrying out a reconnaissance flight over New-Guinea and had just destroyed a Japanese merchant ship when it was suddenly attacked by twelve Japanese Zeke Zero fighters. Furiously assailed from all sides, the aircraft suffered serious damage. Thanks to the courage, skill, training and perfect synchronisation of its crew, it succeeded in shooting down five enemy planes before regaining its base. The story is told like a combat debriefing. This action led to the pilot being awarded the DFC and Silver Star. The rest of the crew were awarded the Silver Star, which explains the title " 5 Zekes Zero DFC and Silver Star ".

The famous aircraft manufacturer, Grumman, was the creator of the carrier-borne small and solid Wildcat fighter. Designed by William T. Schwendler, it first flew in 1939. This glorious aircraft was involved in all the fighting in the Pacific during the Second World War. Flown by Navy and Marines pilots, it accomplished miracles.

Grumman adverts singing the praises of its aircraft were present in magazines throughout the war.

The Wildcat's exploits were shown in comic strip style in the special USAAF issues of Flying magazine between August and October 1943. The August 1943 issue tells of a glorious feat of arms during the attack on Wake Island. On 8 December 1941, the Japanese destroyed twelve Wildcats from the Marines VMF 211 group. In the two weeks that followed this disaster, four aircraft ensured the non-stop defence of the island and fended off the formidable Japanese attacks. The island eventually fell to the attackers, but during the fierce fighting, two Wildcats equipped with under-wing bombs destroyed an enemy cruiser. This action is told and illustrated by Samuel Josephs of the L.E. MC GIVENA-Co. Inc. agency, for Grumman. The story praises the qualities of this aircraft and an authentic heroic exploit that took place during catastrophic events for the United States.

The October 1943 issue tells us of an unbelievable story. On 7 August 1942, American amphibious forces landed at Guadalcanal. After fierce fighting, the island fell on 28 October 1942. The Grumman Wildcats were at the forefront of the US aircraft used by the Marines. On 17 August 1942, the Americans captured the Japanese held

Clayton Knight
The Saturday Evening Post,
30 September 1944.

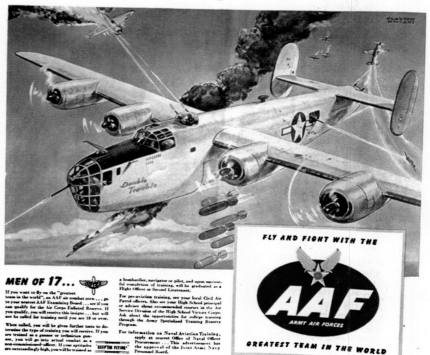

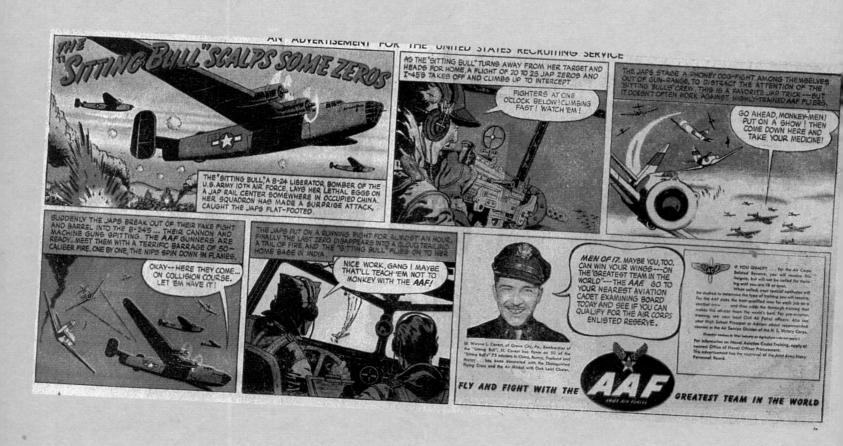

THE GOLDEN AGE OF FLYING COMIC STRIPS

Twentieth Century-Fox, Bendix and even the Army Air Forces used this art form for their newspaper adverts.

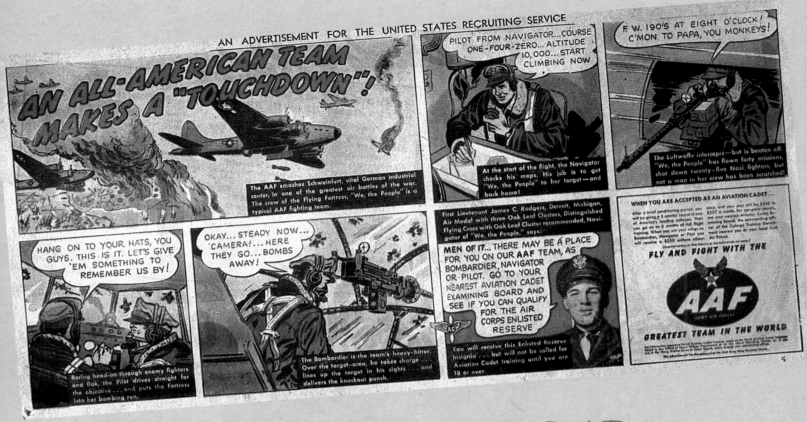

THE ARMY AIR FORCES

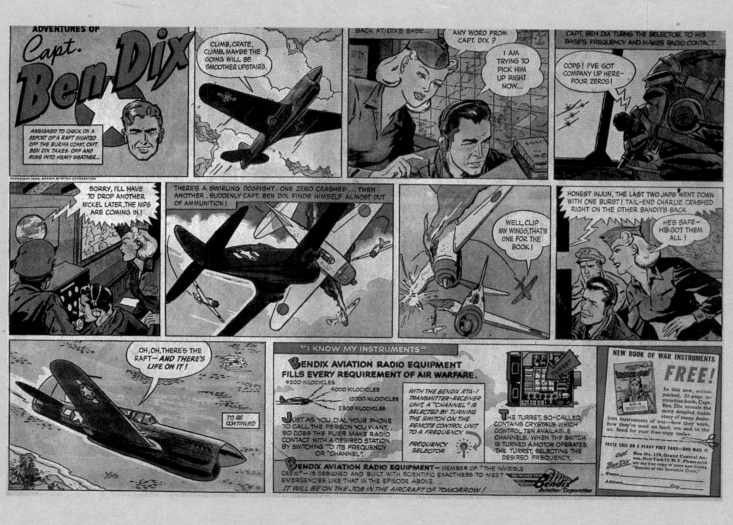

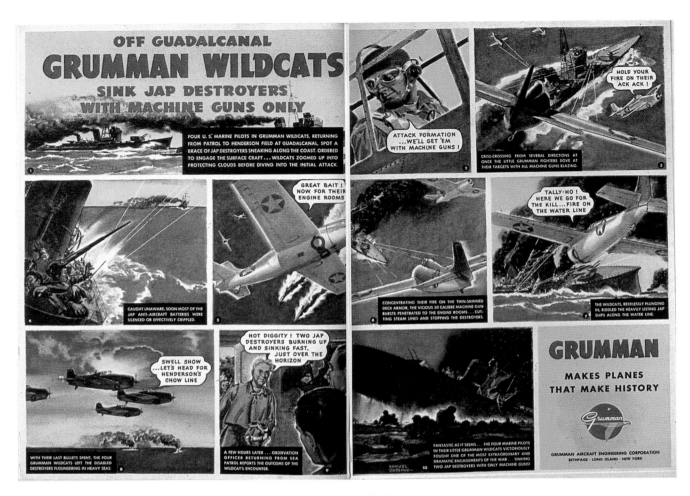

The incredible exploits of a handful of Wildcats during the first battles in the Pacific.

Artist and Art Director: *Samuel Josephs.*

Client: Grumman Aircraft Engineering Corp. Agency : L.E. McGivena Co. Inc.

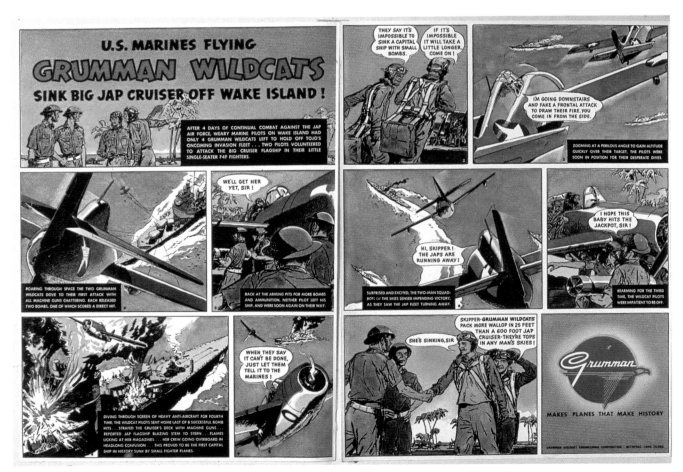

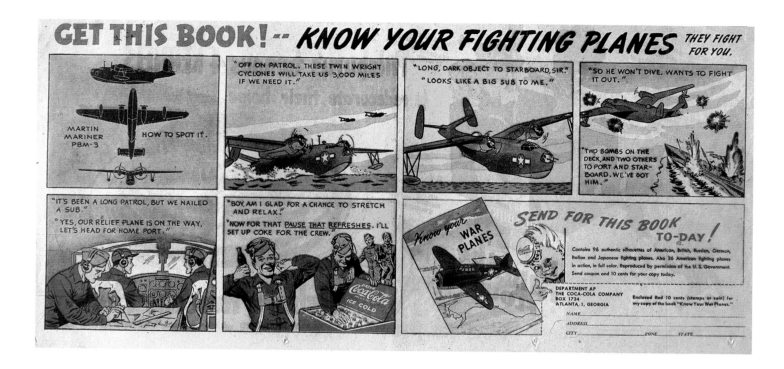

airstrip that was of great strategic importance for future operations. After bloody fighting, the situation swung in the favour of the United States and peace returned to the island definitively on 7 February 1943. The airstrip entered into history under the name of Henderson Field, in honour of Major Loftan Henderson of the US Navy, who was killed at Midway whilst commanding dive bombers.

The advert tells, in comic strip form, the incredible adventure of four Wildcats based at Guadalcanal and which sank two Japanese destroyers by using only their machine-guns. This unbelievable exploit could be straight from the first Buck Danny adventures that were published in France and created by Jean-Michel Charlier. This comic strip was also illustrated by Samuel Josephs.

The Coca-Cola company published a well designed comic strip series in Sunday supplements, called " Know your fighting planes ".

This comic strip began with three views of the portrayed aircraft. The five following boxes followed a mission by the plane, with the final box showing the pilots visibly happy whilst quenching their thirst with this famous drink.

The movie industry used comic strips to promote its products, this was the case with "Winged Victory" produced by Darryl F. Zanuck in association with the US Army Air Force and including the following actors and actresses, PVT Lon, Mc Callister, Jane Crain, SGT Edmond O'Brien, Jane Ball, Judy Holliday, CPL Lee J. Cobb...

Camel cigarettes, made by the R.J. Reynold Tobacco Co, used all the technical means of the time: photos, quality illustrations painted by great artists such as Paul Rabut, and a particularly good layout to promote the quality of its cigarettes. This brand really put forward its position in the industry, in every army corps and on every front. These adverts, that often portrayed aviation, were published in many magazines of the period and had a really successful impact on the public and the army.

The promotion of Camel products often took the form of comic strips. The adventures featured a happy end with the characters being able at last to enjoy these cigarettes. These comic strips were generally illustrated by artists such as Howard Williamson or Milburn Roser, who worked for the William Esty C. Inc. agency. They were extremely well drawn in the style of the classics of the time. One such advert that is

KNOW YOUR FIGHTING PLANES
The Coca-Cola advert and the book that people could obtain.

TARGET FOR TODAY - ANOPHELES

Sunday News. 20 May 1945.

typical of these comic strip adverts, appeared in the 28 October 1944 issue of Collier's. It tells the story of a CNAC DC-3 loaded with fuel cans. This transport airline flew the route between India and China, flying over the Himalayas, to supply the Flying Tigers. The story portrays this Dakota flying through a forest on fire in order to escape from Zero fighters. It is titled, " Danger aunt Nellie's upstairs ", this being the nick name of the Zeros flying above the DC-3. The pilot, Charles Sharkey was a real life character and his name is included in the list of veterans in the " Hump Pilots Association " book. The Sunday supplements of the great newspapers published a great quantity of adverts in this way in their comic strip booklets.

In the Sunday Times comic strip booklet dated 20 May 1945, the Camel advert humorously tells the story of a peaceful mission under the title," Target for to day : anopheles ", where we see a Havoc spraying DDT over the jungle to kill off the mosquitoes.

We can also mention the commentaries of Captain Bendix concerning the exploits of a pilot flying various planes on different fronts. This series glorified the products of the Grace company in a simple, precise, dynamic and easy to read style. The artists who created these series of comic strip adverts contributed in the amusing of service men and women at the front and at home, portraying the atmosphere of the period. They held spellbound young and old alike, civilians and servicemen and women, with events inspired by real life. Courage, friendship and heroism were very present in these series. Today these comic strips have disappeared into the mists of time and it is a shame that only a few collectors are interested in them.

DANGER… AUNT NELLIE'S UPSTAIR !

Charles Sharkey's exploit. **Collier's.** 28 October 1944.

The "Petty Girl" suit of 1940

BY JANTZEN

A great artist turns to swim suit design! With the same master strokes in simplicity of line that have made him so famous with brush and canvas. Here's George Petty's conception of the Suit of Youth, classic in design with slenderizing princess lines.

Tailored by Jantzen in a perfectly amazing new fabric, *Sea Ripple*. A swim suit that actually stretches all ways! A swim suit with real foundation garment control! It fits as you have never known a swim suit could fit. See it—feel it—try it on. Lastex* yarn has been knitted-in for perfect figure-molding. There's a new experience in beauty of line and perfection of fit awaiting you. In the new fashionable colors—$6.95 in U.S.A. For illustrated style folder, men's or women's, address Dept. 311.

A reproduction of this Petty Painting without advertising copy will be sent on receipt of 10c in stamps or coin.

JANTZEN KNITTING MILLS, PORTLAND, OREGON; VANCOUVER, CANADA

*Reg. U.S. Pat. Off.

Jantzen

SWIM SUITS AND SUN CLOTHES

- IF YOU LIKE SMOOTH CURVES YOU'LL LOVE THIS SUIT -
George Petty

© JANTZEN KNITTING MILLS, 1940

★ CHAPTER 7

Pin-ups and squadron insignias, adverts

During the Second World War, an official government service was given the task of looking at and approving the various squadron emblems for the USAF, US Navy and USMC, as well as those of other groups. Initially, these insignia were supposed to be used as nose art for aircraft.

In fact, very few aircraft bore these insignia, apart from some navy planes in the form of small decals placed in front of the cockpit. We should mention the pre-war 'Felix the Cat' that was chosen for the Buffalo aircraft on board the aircraft carrier Saratoga. The Grumman Wildcat engaged in North Africa bore the 'Red Ripper' Insignia of VF-41 under the cockpit canopy. The Hellcats of VF-1 used an insignia in the shape of a top hat placed just in front of the cockpit.

Other carrier borne aircraft stood out from the rest with various insignia. On the other hand, in the various corps of the US Air Force, they were naturally used and displayed above the entrances to bases and headquarters. These insignia are often seen and were even worn on the right side of Navy G1 jackets and the A2 and B3 jackets of US Air Forces crews.

This said, crews preferred to make their own nose art to decorate and personalise their planes, taking their inspiration from all areas. Pin ups painted by skilled artists in magazines were very popular choices.

This Varga pin up, taken from an Esquire calendar was used as nose art on a USAAF reconnaissance Mosquito as well as the B-25 Mitchell "Paper Doll" and the B-24 Liberator "Heavenly Body".

Esquire is a good example of pin up art and this explains why it is so sought after by collectors today. In 1933, George Petty, inspired by his own daughter, drew the famous "Petty Girls". He also illustrated, for the Jantzen bathing costume brand, a series of newspaper adverts portraying charming young ladies. On of his pin ups became the famous nose art of the no less famous B-17 Flying Fortress, "Memphis Belle".

In October 1940, a new pin up created in a very personal style became all the rage. These were the Varga Girls created by Alberto Varga. Other ravishing girls saw the day under the brushstroke of Gil Evgren who illustrated Coca-Cola adverts.

CHRISTMAS GREETINGS
Illustrations by *Alberto Vargas*.
Esquire 1944,
a small 8 x 12 cm advertising calendar.
...

(PREVIOUS PAGE)
THE PETTY GIRL
Pin up by *Georges Petty* advertising Jantzen swim suits.
Life, 27 May 1940.

These pin-ups adorned the noses of many aircraft. The flying girl was seen on a USAAF reconnaissance Mosquito, as well as the B-25 Mitchell "Paper Doll" and the B-24 Liberator "Heavenly Body".

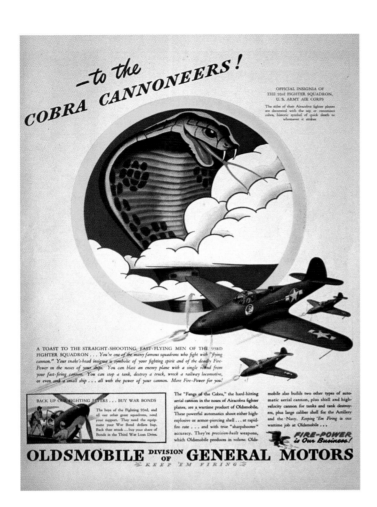

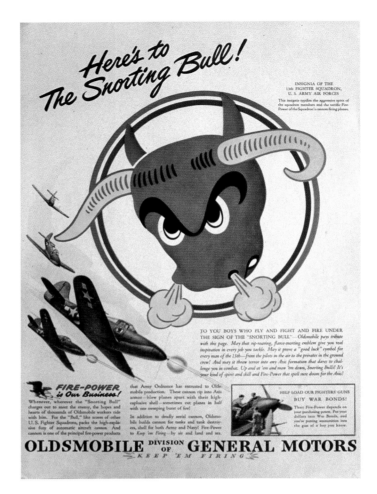

These three artists illustrated many calendars that are today highly sought after by collectors.

The GIs loved the photos of entertainers and starlets published in Yank. The cartoons and comic strips were also a great source of ideas when it came to creating nose art and insignia. However, the crews' own inspiration, sometimes fuelled by a secret fantasy, helped them in the creation of their nose art that despite being un-official, was nonetheless tolerated. Some were deemed to be too risqué and did not get past the censor and were banned from being published in aviation magazines.

In its June 1943 issue, National Geographic Magazine published a series of official insignia. In 1945, they it even created a special issue on the subject that included insignia that stood apart by its creativity and which were sometimes made for big companies

TO THE COBRA CANNONEERS!

This insignia represents a cobra rearing up and ready to strike above the clouds. This insignia was used by the 93rd Fighter Squadron (FS) of the 81st Group of 12th Air Force. This air force fought on the Mediterranean front with the P-39 Airacobra. **Life, 18 October 1943.**

..

HERE'S TO THE SNORTING BULL!

This angry bull, ready to charge, was part of the 13th Fighter Squadron of the 53rd Group of the 3rd Air Force, based in the east of the United States. **Magazine cut-out 1943.**

SKY-DIVER WITH BOMBS AND CANNON!

This humoristic picture of a diver holding a bomb, symbolises the 500th Fighter Bombers of the 85th Fighter Bomber Group of the 3rd Air Force based in the east of the United States. **Life, 4 September 1944.**

..

SLUGGING JACK RABBIT!

Jack, the aggressive boxing desert rabbit, was adopted as the insignia of the 96th Fighter Squadron of the 22nd Group of the 12th Air Force fighting on the Mediterranean front with its P-38 Lightnings. **Collier's, 2 October 1943.**

"LIGHTNING BUG" THAT CAN REALLY SLUG!

This odd flying insect, its stings ready to strike the enemy, belonged to the imagination of an artist in the 332nd FS of the 329th Group of the 4th Air Force based in western America. The drawing evokes the Lightnings which equipped this group. **Life, 27 November 1943.**

..

GREMLIN - ON A DOUBLE-EAGLE!

This gremlin, looking like a an aggressive devil riding a wild double-headed eagle, was used by the 339th FS of the 347th Group, whose planes operated in the Far-East. **Life, 15 May 1944.**

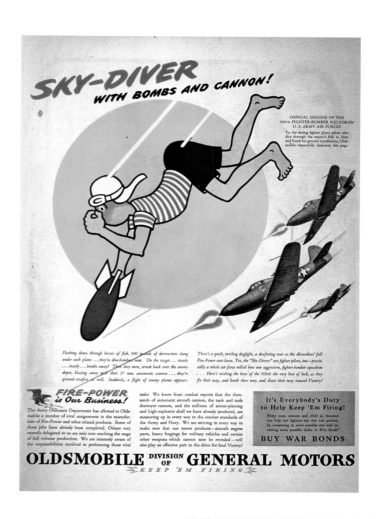

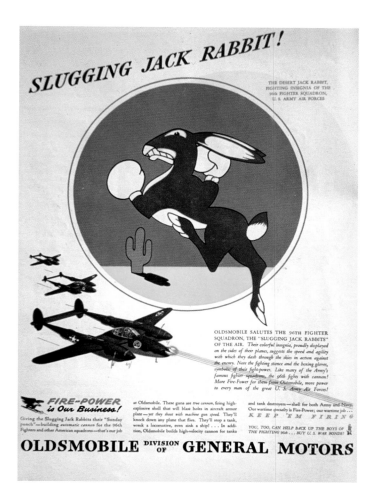

OLDSMOBILE DIVISION OF GENERAL MOTORS
KEEP 'EM FIRING

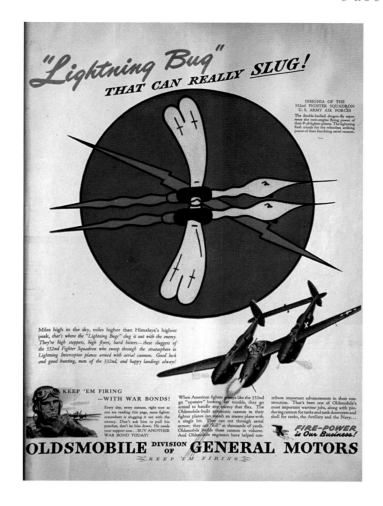

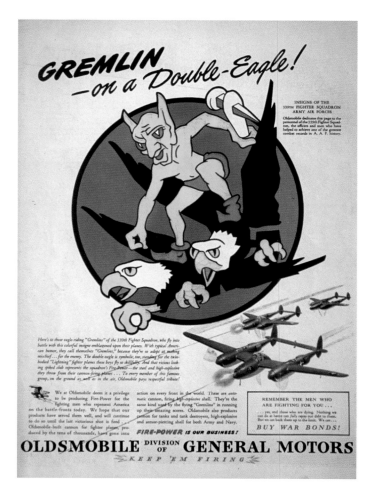

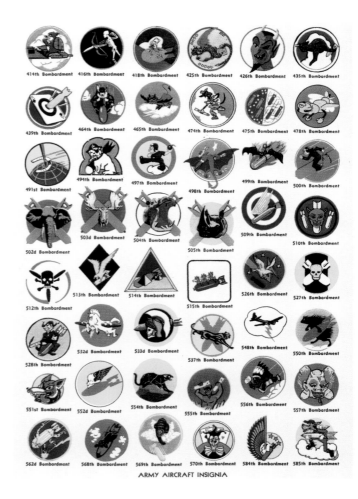

ARMY AIRCRAFT INSIGNIA

mobilised for the war effort. Thus, the Oldsmobile Division of General Motors, whose motto was "Fire power is our business", made machine-guns for planes, artillery and various other armaments. To promote its products, the company used a series of insignia surrounded by planes corresponding to the group indicated in the insignia, but not, because of censorship, showing where these squadrons were based.

The legendary special issue of **National Geographic** dated **1 December 1944**.
The documentary interest of this issue lays in the fact that it shows many insignia that were not officially recorded by the end of the war.
...
(FOLLOWING PAGE)
BLACK PANTHER WITH FISTS FULL O'FIRE!
This roaring black panther, flanked by two bolts of lightning, was used by the 84th FS of the 78th Group of the 8th Air Force based in England.
The Saturday Evening Post, 18 March 1944.

"SUPER-MOUSE" U.S.N.
This super mouse, equipped with an aerial for communication, binoculars for observation and a bomb for action, dives towards its target. It was used by the Navy's VB-14 reconnaissance and bombing group.
Life, 25 December 1944.
...
"BOMB BUSTERS"- OF THE AAF
This strange boxing animal that looks as if it is straight out of a cartoon, swings a powerful left hook to a bomb, destroying it in the process. This insignia was that of the 54th FS of the 343rd Group of the 11th Air Force based in the

Aleutians and equipped with the P-38 Lightning. In this advert they are destroying a Japanese bomber. **Life, 7 August 1944.**
...
PUGNACIOUS PUP!
This winged bulldog was adopted by the aviators of the 355th FG, a group which, after training in the United States with the P-39 Airacobra, fought on the European front with the 8th Air Force and equipped with the P-51 Mustang.
News Week, January 1944.

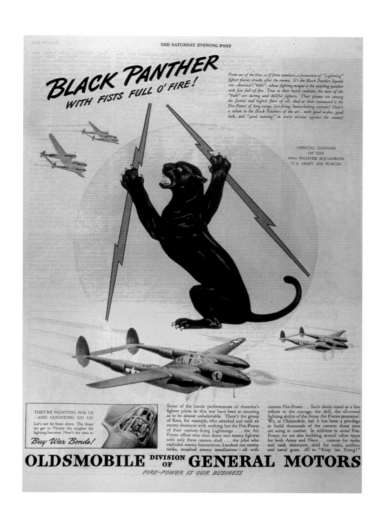

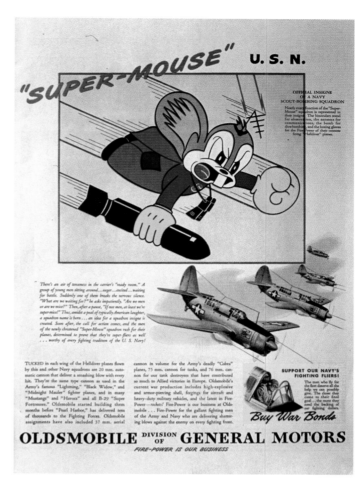

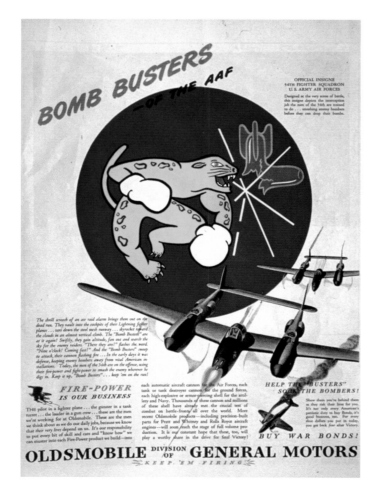

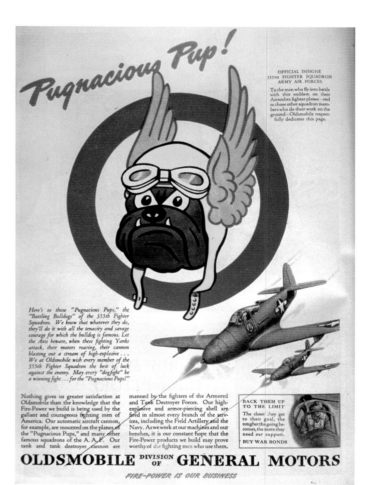

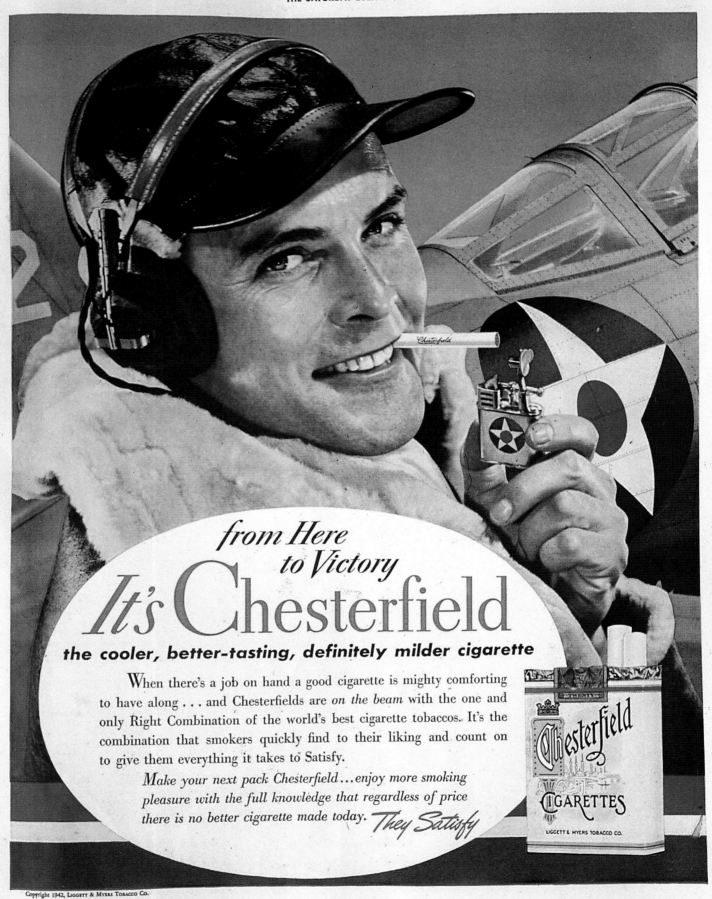

from Here to Victory

It's Chesterfield

the cooler, better-tasting, definitely milder cigarette

When there's a job on hand a good cigarette is mighty comforting to have along ... and Chesterfields are *on the beam* with the one and only Right Combination of the world's best cigarette tobaccos. It's the combination that smokers quickly find to their liking and count on to give them everything it takes to Satisfy.

Make your next pack Chesterfield ... enjoy more smoking pleasure with the full knowledge that regardless of price there is no better cigarette made today. *They Satisfy*

FROM HERE TO VICTORY IT'S CHESTERFIELD. The Saturday Evening Post, 29 August 1942.

★ CHAPTER 8

Photography in advertising

Throughout the Second World War, photos played an important role in the creation of press adverts. Advertising agencies used talented photographers for numerous campaigns promoting a whole host of products.

Many of these adverts were made in a studio or outside using a large amount of lighting. The most used camera was the Linhof 4"x 5", equipped with colour or black and white photographic plates or rolls of 6 x 9 film.

Movie stars, singers and music hall entertainers, as well as models, took part in these advertising campaigns alongside test pilots, military personnel and workers.

The popular Chesterfield cigarette brand, made by the Ligett Myers Tobacco Company, recruited the Newell Emmet Company agency to undertake its colour photograph advertising campaign, in which the photographer, Ruzzie Green took part. Male and female models, movie and show business stars all took part, not forgetting aviation that was also present.

Throughout the entire war, Camel made powerful advertising campaigns in magazines and newspapers. These cigarettes were made by RJ Reynolds Tobacco, who recruited the William Esty Co Inc. agency to take care of their advertising.

Illustrators and photographers, like Victor Keppler, played an active role in glorifying this brand via a great variety of subjects that often used aviation as a backdrop.

Amongst the many companies that used photography, we can mention Milky Way, Kodak and Goodyear.

After a training flight, a young pilot poses at the rear of a P-43 Lancer. Well equipped, wearing his sheepskin flying jacket and cap and with a smile on his lips, he gives an impression of rock solid morale. He incarnates the example for all young trainee pilots to follow in this difficult year of 1942, symbolising the fearless hero who will take part in future battles. Using his lighter, decorated with the US Army Air Forces star, he lights his well earned cigarette. The aircraft bears the American star with the red circle in its centre, emblematic of this period. After the first dogfights, the red circle would disappear in order to avoid any confusion with Japanese aircraft.

This clear and shadow-less advertising photo is typical of the day and all of the adverts created for this brand were made in the same style. The pilot's face does not yet show the tension, fatigue and the difficult fighting that will mark future missions.

These war movies in full color were made with a "home movie" CINÉ-KODAK

TOPS IN THE SKY

This advertising photograph shows a well equipped and fit pilot, smiling as he climbs into his cockpit. He is holding a Milky Way. The text of the advert describes the nice and energising qualities of this candy bar.

Collier's, 11 November 1944.

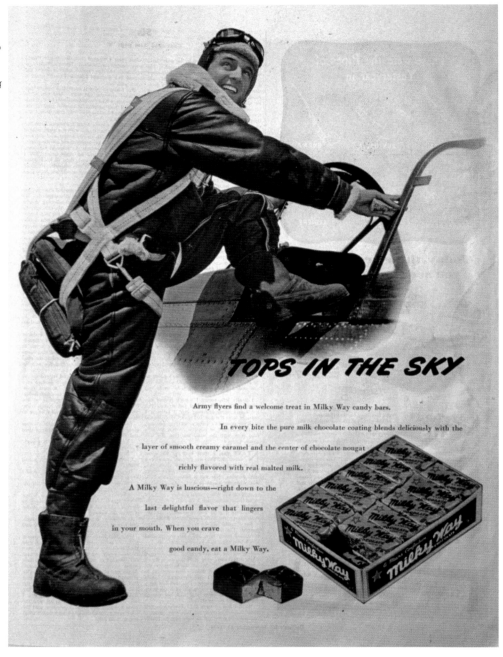

(FOLLOWING PAGE)

THEY KEEP ON SCORING FOR MILDER BETTER TASTE

A young Navy pilot, on the wing of his Wildcat, pleased with the way his mission went, offers a cigarette to a member of the ground crew who has just painted the tally markings on the fuselage. This carefully set out and well lit advertising photograph portrays a moment of relaxation after a hard fight. "They keep on scoring for a milder, better taste".

Life, 26 July 1943.

..

''RED'' HULSE

In this Camel advert, made up of various colour photos, the flyer is none other than the test pilot Barton Fred Hulse who later became chief test pilot for Curtiss. He is seen here in at an air base in front of a Helldiver and some 503C Seagulls, enjoying his Camel cigarette after a successful test flight. This advert appeared in several magazines including **The Saturday Evening Post of February 1943.**

..

TAIL-GUN TOMMY TALKING…

In the big "America at war" series ordered by Camel was this advert made up of four photos portraying a certain Tommy, a tail gunner in a B-17 Flying Fortress and, at the bottom left, a certain Elsie Clark, an employee with an armaments manufacturer. Both smoke, in their free time, the same brand of cigarettes.

Life, 27 December 1943.

FIRST IN THE SERVICE – THEY'VE GOT WHAT IT TAKES

Glider pilots are at the heart of this Camel advert. The illustration portrays a training aircraft and appears to be by *Paul Rabut*. The central photo to the right is that of a young pilot lieutenant.

At the bottom left is Charlotte Gillam, the general inspector and controller of aeronautical materiel. They both express the pleasure they feel when smoking this brand of cigarettes.

Cut out advert, **1943.**

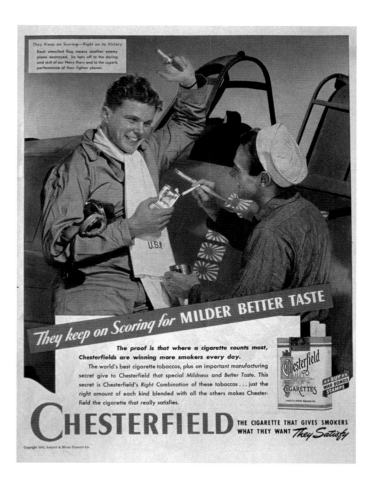

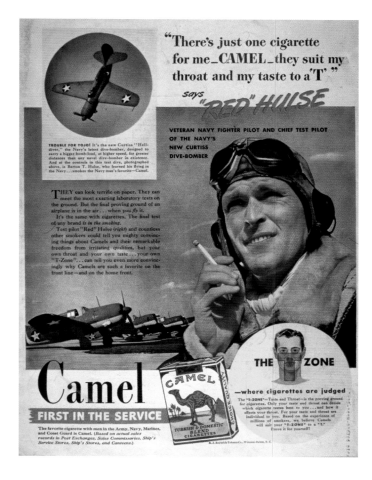

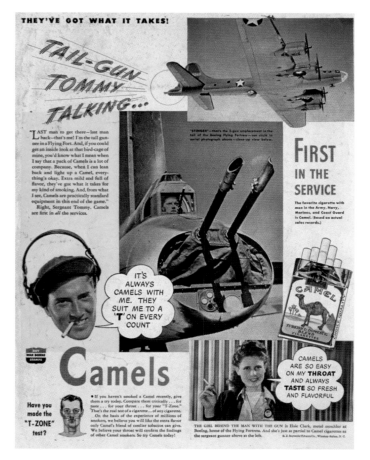

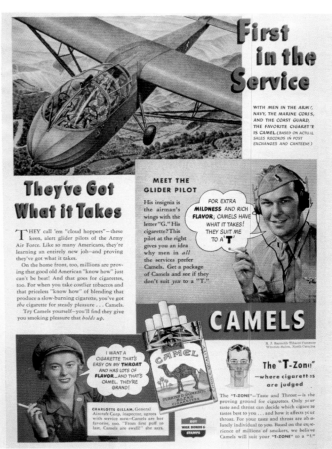

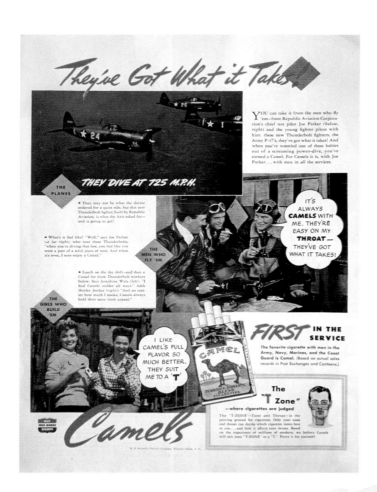

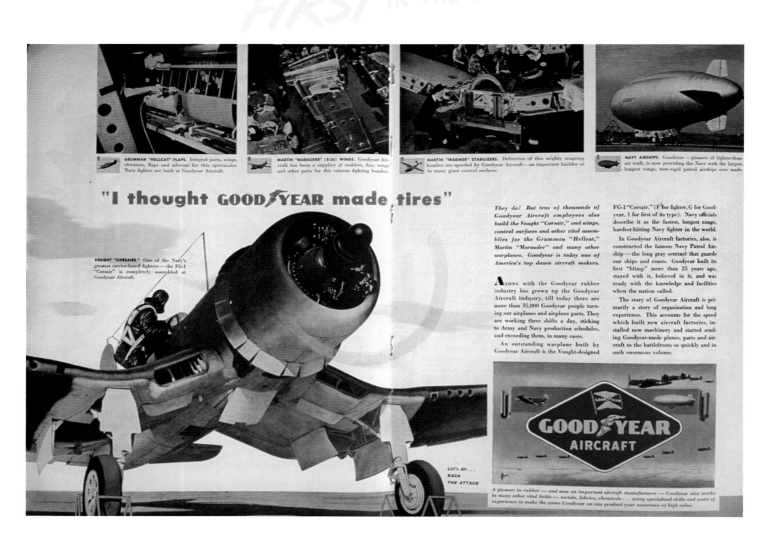

One crew of American Airlines photographed in Arctic region by Ivan Dmitri

Yesterday 6 Weeks – Today 45 Minutes!

Forty-five minutes are less than a 1,000th part of six weeks. That shows the change in today's world.

Infinitely less change in transportation developed during past *centuries* than during the last few *years*.

Our Army's Air Transport Command makes thousands and thousands of regular flights, over oceans, arctics and deserts, saving immeasurable time for war passengers and for tons of fighting freight.

The air transport achievements during this war are on such a tremendous scale and of such significance that they stagger the imagination.

They are easier to mentally digest in small doses. A report from New Guinea: a laborious six weeks' trip over mountain and jungle trails by horseback is now easily accomplished in 45 minutes by air, so whole divisions are moved that way.

From the Navy: San Francisco to Hawaii in about eleven hours, with 35 persons and 14,000 pounds of vital cargo.

Many deserve the credit—Generals, Admirals, Airlines and Aircraft manufacturers—but especially, we believe, credit is due to the air transport crews in the air and on the ground.

Many of these are domestic airline crews, whose companies are playing a major role in global wartime air transport under the direction of our Army and Navy.

They are demonstrating that time and distance have been overcome as barriers to movement in all directions.

The well-being of people always has advanced in ratio as distances lost their handicaps and communications became quicker and easier. The long search for the solution culminates in the transport plane; the airborne are the reborn!

THE NATIONAL AND INTERNATIONAL **AMERICAN AIRLINES** *Inc.* ROUTE OF THE FLAGSHIPS

YESTERDAY 6 WEEKS – TODAY 45 MINUTES!
To inform the public about the contribution of American Airlines Inc. and to illustrate this advert that showed the importance of air transport, Ivan Dmitri photographed the crew of a C-87 Liberator Express on an Alaskan airfield. The caption of this advert highlights one of this organisations qualities in that a place that took six weeks to reach before, now only takes 45 minutes.
Fortune, April 1944.

..

(PREVIOUS PAGE)
THEY'VE GOT WHAT IT TAKE!
Back to base after a tough training flight in a P-47 Thunderbolt, the pilots enjoy a moment of relaxation smoking their favourite Camel cigarettes. This is also the case with two women during their break at the factory which makes these prestigious planes. The presence of this brand is the symbol of a pleasant moment of relaxation in all places.
Collier's, 7 August 1943.

..

"SHE'S ALL YOURS WHEN YOU WIN YOUR NAVY WINGS OF GOLD"
This excellent colour US Navy propaganda photograph shows a friendly lieutenant talking to a very interested young man about the qualities of the Chance Vought Corsair and the sprit of comradeship that unites every member of the large Navy family. For this possible future recruit, "she's all yours when you win your Navy wings of gold."
The Saturday Evening Post, 19 December 1942.

..

I THOUGHT GOODYEAR MADE TIRES
For this Goodyear Aviation advert, a test pilot climbs into the cockpit of a F4U Corsair made by this company. Four other small photos show what this company produces. As for the plane, designed by I.I. Sikorsky and R.B. Beisel, it undertook its maiden test flight in 1940.
Life, 14 February 1944.

U.S. Army Air Transport Plane on African desert. Photo by Ivan Dmitri

AIR IS EVERYWHERE, IMPARTIALLY

"No problem has greater bearing upon us as individuals and as a nation than that of the postwar use of universal air."

* * *

The founders of our nation came here *to get away* from Europe.

Due largely to pre-air geography, our national history has been one with emphasis upon self-determination, self-sufficiency and isolation . . . resulting in the greatest nation on earth with the highest standard of living.

The descendants of our founders, however, invented a machine—the airplane—that makes us more accessible to, and brings us infinitely *closer* to all of the earth's inhabitants than ever before. Daily the world becomes effectively smaller.

About 88 years ago our government introduced camels into Texas, New Mexico and Arizona to carry the mail. The experiment proved unsuccessful. Camel caravans, traveling at about 2½ miles per hour, are still a common sight in many parts of the world. Contrast that speed with the 300 miles an hour of our modern transport planes!

The increasing use of the air realm for national and international vehicular traffic rapidly is changing the relationship of all nations and of all peoples. This trend will increase, not diminish, after the war. It presents national and personal problems and opportunities.

The U.S. has the world's best Airlines; therefore we believe the way to adjust to this *world* change is for us first to become an airfaring nation at *home*—domestically and hemispherically.

After the war our aviation impetus should be accelerated, not retarded.

We need surface transportation, but in addition, we must travel *above* the earth in order to have security *upon* the earth.

A. N. KEMP
President

THE NATIONAL AND INTERNATIONAL **AMERICAN AIRLINES** *Inc.* ROUTE OF THE FLAGSHIPS

AIR IS EVERYWHERE IMPARTIALLY

Around 1856, the American government introduced Camels to carry the post in New-Mexico, Texas and Arizona. This was not a good solution.

Now, in 1944, the Liberator Express transports heavy goods at the speed of 300 mph.

To advertise American Airlines Inc., Ivan Dmitri takes us to an airfield somewhere in the Libyan desert, where an American serviceman points out a C-87 to a local accompanied by his two camels.

The Saturday Evening Post, 30 September 1944.

(FOLLOWING PAGE)

During the war, Kodak made numerous adverts that kept the public informed of its constant technological advances.

..

FROM MIDWAY ON...

Colour Kodak 16 mm film was used in the filming of numerous footage during the Second World War, thanks to a process put into service by this large company. This advert recalls the names of a few famous films Midway Incident, Eagles of the Navy and Aleutian Emplacement, that were often directed by the great names of cinema such as John Ford, William Wyler, George Stevens and many others.

Life, 4 October 1943.

..

KODAK'S NEW PHOTOGRAPHIC METHOD GETS PLANES INTO PRODUCTION 60 DAYS SOONER

This Kodak advert shows us a new photographic technique of transferring plans onto metal. This process saved sixty working days in the production of aircraft. The colour photo shows a Vultee Vengeance A-31 with RAF roundels, about to take off on a bombing mission. The text explains that the bomb bay equipment was made quicker thanks to this method developed by Kodak. **Life, 12 April 1943.**

"V⋯-MAIL"⋯

KODAK CREATED, U.S. GOVERNMENT ADOPTS "V⋯-MAIL"…
In the United States, the fast transportation of mail by plane
posed a major problem in that it weighed too much. Kodak came
up with the answer by creating "V. Mail". The letter was written on
standard writing paper, then photographed on 16 mm film that
could hold 1,700 letters. When it arrived, a machine printed them
out on paper. The British, starting in April 1941, used a system
based on the same principles, known as "Air Graphi" . The
illustration shows how it works.

Life, 26 October 1942.

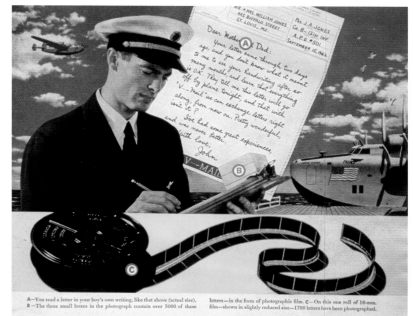

A—You read a letter in your boy's own writing, like that above (actual size). B—The three small boxes in the photograph contain over 5000 of these letters—in the form of photographic film. C—On this one roll of 16-mm. film—shown in slightly reduced size—1700 letters have been photographed.

Kodak created, U.S. Government adopts "V⋯-MAIL"…
for communication with our men on distant fronts

YOUR BOY writes you a letter on a sheet of paper—regular letter size. This is photographed on Kodak microfilm—is reduced in size to about a quarter of a square inch …Now it has only 1/100 of the weight of normal mail.

With thousands of other letters—85,000 letters weighing 2000 pounds weigh only 20 when reduced to microfilm—it is swiftly flown from his distant outpost to America.

Here, again through photography, the letter addressed to you is "blown up" to readable size—folded, sealed in an envelope, and forwarded to you. It is as clear as the original writing. It really *is* the writing of your boy because it's a photographic print.

And your letters to him, which you write on special forms, go by the same space-saving, time-saving V⋯— Mail.

Kodak developed and perfected the process…Pan American Airways and British Overseas Airways, the two great pioneers in transoceanic air transport, blazed the air trails …and the three companies, as Airgraphs, Ltd., offered the service to the American and British governments.

IN APRIL, 1941, under the trademark "Airgraph," England first employed the system to solve the problem of getting mail to and from the forces in the Near East. The Airgraph System was gradually expanded until it knits the British Empire together with about a million letters a week—personal and official.

And now the men serving overseas in the American armed forces also have the benefits of this form of speedy correspondence.

Airgraph, or V⋯— Mail as it is called here, is an adaptation of Kodak's *Recordak System* which has revolutionized the record-keeping methods of thousands of banks and business houses. Many records of the U.S. Census, Social Security, and Army Selective Service are on microfilm—error-proof, tamper-proof, lasting photographic copies of the original bulky records.—Eastman Kodak Company, Rochester, N. Y.

SERVING HUMAN PROGRESS THROUGH PHOTOGRAPHY

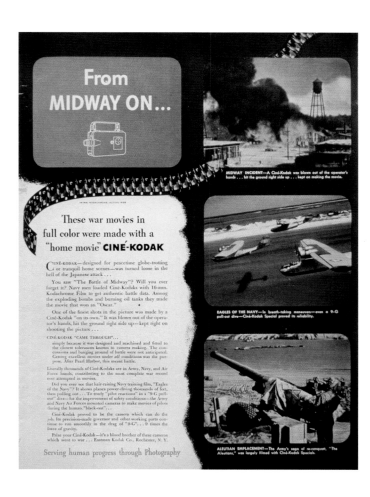

From MIDWAY ON…

MIDWAY INCIDENT—A Ciné-Kodak was blown out of the operator's hands…hit the ground right side up…kept on making the movie.

These war movies in full color were made with a "home movie" CINÉ-KODAK

CINÉ-KODAK—designed for peacetime globe-trotting …or tranquil home scenes—was turned loose in the hell of the Japanese attack…

You saw "The Battle of Midway"? Will you ever forget it? It shows planes power-diving thousands of feet, then pulling out…To study "pilot reactions" in a "9-G, pull-out" dive—for the improvement of safety conditions—the Army and Navy Air Forces mounted cameras to make movies of pilots during the human "black-out"…

Literally thousands of Ciné-Kodaks are in Army, Navy, and Air Force hands, contributing to the most complete war record ever attempted in movies.

Did you ever see that hair-raising Navy training film, "Eagles of the Navy"? It shows planes power-driving thousands of feet, then pulling out…To study "pilot reactions" in a "9-G, pull-out" dive—for the improvement of safety conditions—the Army and Navy Air Forces mounted cameras to make movies of pilots during the human "black-out"…

Ciné-Kodak proved to be the camera which can do the job. Its precision-made governor and other working parts continue to run smoothly in the drag of "9-G"…9 times the force of gravity.

Prize your Ciné-Kodak—it's a blood brother of these cameras which went to war…Eastman Kodak Co., Rochester, N. Y.

EAGLES OF THE NAVY—In breath-taking maneuvers—even a 9-G pull-out dive—Ciné-Kodak Special proved its reliability.

ALEUTIAN EMPLACEMENT—The Army's saga of re-conquest, "The Aleutians," was largely filmed with Ciné-Kodak Specials.

Serving human progress through Photography

THE BRITISH CALL THIS VULTEE DIVE BOMBER THE "VENGEANCE"…In the U. S. Army Air Force it's known as the A-31…Each ship gets its first bomb load months earlier, due to the time originally saved by Kodak's Matte Transfer method.

Kodak's new photographic method
gets planes into production 60 days sooner

THE human hand may err, or the mind may wander. But a photograph allows no mistakes. The hand, in transferring a tedious, detailed mechanical drawing, is slow—while a photograph is quickly made.

These two facts are the key to another "industrial revolution" which has come within the last year—lopping from two to four months from the time necessary to put an airplane, of a new design, into production.

Kodak perfected Matte Transfer Paper—a means of applying a photographic emulsion to other surfaces. At the aircraft factory, under "safe" red light, the transfer paper is cemented to a sheet of metal—then the paper base is stripped away, leaving the emulsion on the metal.

If desired, this metal may be a sheet of structural aluminum which is used in constructing an airplane. The metal is a "printing surface"—capable of becoming a photographic print.

In the meantime, the draughtsmen are at work on another sheet of metal, making their mechanical drawing of an airplane part. The sheet on which they work has a coating of Kodak's fluorescent lacquer. This glows, with a blue light, in the presence of X-rays—except where the pencil lines black it out.

The finished drawing sheet is exposed to X-rays, and placed in contact with the sensitized aluminum. The result is a lifesize photograph of the drawing on the metal…Another method widely employed is conventional photographic copying and enlarging—using Matte Transfer Paper to produce a printing surface on metal.

With either method, Matte Transfer Paper brings the speed of photography—and no

IN SCORES OF OUR AIRCRAFT FACTORIES the designers make their original drawings on metal coated with Kodak's fluorescent lacquer. These are then transferred, photographically, to structural metal "sensitized" by the Matte Transfer process—metal which may be used to build a full-scale test model plane.

mistakes in transfer. Multiply the saving by the number of parts in an airplane and you have the total saving, in time and money.

For test flight, experimental models have been made from the first photographic copy and flown with fragments of the mechanical drawings showing on the airplane parts. Normally, pattern plates—templates—are made from the photographic pattern; from then on parts are duplicated mechanically.

But in any case, from two to four precious months are saved—and the planes so vital to our victory roll that much more quickly off the production line…Eastman Kodak Company, Rochester, N. Y.

Serving human progress through Photography

Training and Teamwork Brought us Back

BACK IN THE U. S. A. *Left to right:* Major Crosson, Captain Grant, Sgt. McCaskey, Sgt. Johnson. When this picture was made, Sgt. Steslow was an Aviation Cadet, in pilot training.

by Capt. Charles S. Grant

As Navigator of the B-26 bomber, *So Sorry*, Capt. Grant flew 37 combat-missions in the Southwest Pacific theater. Here is the Captain's story of his most unforgettable flight.

THE *So Sorry* was dishing it out that morning over the New Guinea coast. Six or eight Zeros had jumped the formation, and our gunners—Sgts. Lawrence Steslow, Melvin McCaskey and Andrew Johnson—were strictly "on the ball."

Johnson in the top-turret, Steslow firing from the tail, and McCaskey manning both guns in the waist had cleared the air of enemy fighters as our pilot, Maj. Gerald Crosson (then a Capt.) swung in over our objective at 8,000 for a long, steady bombing run. A few flak bursts blossomed around us—but we ignored them. We wanted to be sure that we drew a good bead on our target.

The bombardier's eye was glued to his sight. He had the Nip air-strip caught square in the crosshairs, and was all set to lay his eggs in there . . .

And then the whole sky caved in on us! A terrific shock hit the plane—as a 75 mm. ack-ack shell tore through the bomb-bay doors, three feet from my head, and burst backward.

I had a sensation of overpowering heat . . . and the entire compartment around me was one great swirling ball of angry red and yellow flame.

The blast picked the *So Sorry* up and stood her on one wing. Her bomb-bays became a shower bath of oil

and hydraulic fluid. The bombs jammed in their racks. The elevator controls were severed and the rudder and ailerons partially fouled.

It looked like we'd spin right into that ack-ack battery. But with the stick limp and useless in his hands, Major Crosson managed to pull us out with the trimtabs! It was the finest piece of flying I have ever seen.

The nearest spot for a landing was back of the Allied lines, 200 miles south. But before we had gone a third of the way, we ran into typical New Guinea weather. Every landmark suddenly "socked in." We limped along on dead reckoning.

Now a navigator has to say to himself: "You're right!" —and believe it. And when you're as scared as I was that day, you sweat out even the simplest calculations. I didn't take any part of the ride "with my feet on the desk."

When my charts said we should be over our base, we ducked cautiously down through the fog and driving rain. Sure enough, there was a landing strip . . . and bouncing along beside it, an American Jeep. We knew we were home.

Major Crosson cut the engines, feathered his props and brought us in with our wheels up, our flaps down, our bomb-bay doors wide open and our bombs still hanging crazily in their racks. We hit hard—slid 400 yards —and buried me under an avalanche of dirt scooped up through the open doors.

I dug myself out and looked around—at the men whose courage and skill and training had brought this airplane back when it should have been at the bottom of the Pacific Ocean.

And, looking at them, I knew why *nothing* will ever stop the AAF. I knew what the General meant when he called it "the greatest team in the world."

U. S. ARMY RECRUITING SERVICE

TRAINING AND TEAMWORK BROUGHT US BACK.

Life, 23 October 1944, a story perfectly illustrated by *Cecil Calvert Beall*.

⊛ CHAPTER 9

A time of heroes

A mobilised America needed pilots and mechanics and knew that it could call upon its young and their enthusiasm for aviation, something that had been fuelled by the exploits of Lindbergh naturally, but of course also by Wiley Post and Howard Hughes. The magazines of the day, using artists such as Clayton Knight, Heaslip, Prins, C.C. Beall, and Clymer, published numerous USAAF, US Navy and Marines recruitment posters. The latter portrayed the great deeds of a patriotic, valiant and audacious youth, followed with great interest by the kids of the time.

In order to make this recruitment campaign a success, straightforward examples were needed, well illustrated and capable of catching the eye as much as the imagination; it had to trigger a desire in the sub-conscious in order to make people pull together in the great war effort.

Subjects were studied and chosen very carefully in order to create this trigger, the desire and the sense of duty needed to join the great saga of the American combat aviators. The titles and slogans were straightforward, but hard-hitting. This was well-made propaganda that fitted perfectly the atmosphere of the period.

Amongst the great number of propaganda documents published by magazines inciting people to join the air forces, we can look more closely at two examples.

In the 23 October 1944 issue of Life, a story well illustrated by Cecil Calvert Beall, tells of the difficult mission of a 5th Air Force B-26 Marauder in the Pacific. The reader is inside the aircraft when Japanese flak explodes near the fuselage, setting off a fire that is quickly extinguished thanks to the skill of the crew. The badly damaged Marauder "So sorry" eventually gets back to base. The text is in the style of a detailed newspaper article. It shows how difficult these missions are, the crews' fears that are quickly conquered thanks to their rock solid morale. These raids were no fun and the text tells how a crew worked under duress. The title is, "Training and teamwork bought us back ".

In the 15 May 1944 issue of Life, 22 year old Major Carl W. Payne from Columbus, Ohio is the subject of a propaganda page illustrated by artist Glen Mitchell. It shows P-38 Lightnings attacking a formation of German planes, titled "Let's Go !" and is a perfect example of movement and colour.

This story is interesting as Carl W. Payne really existed. He did not fly a P-38 as shown in the story (due to censorship, such things had to be kept from the enemy in wartime), but a P-51 Mustang in the 12th Air Force, 31st Fight Group, 309th Squadron.

He scored seven kills and finished the war as a lieutenant-colonel. The text tells of one his trips back home to the United States and when he explained to young aviators the role they were to play in the great air force family.

These propaganda adverts portray in a very simple way, missions in the various theatres of operations in Europe, Africa and the Pacific. They are short and to the point, but do not omit highlighting the most intense moments. Well made, they often portray the riskiest moment of a mission, told in a direct style to the reader by those that flew on this type of operation. They underline the quality of the aircraft and also that of the crews' training, highlighting the team spirit and the skill of the fighter pilot. The impact

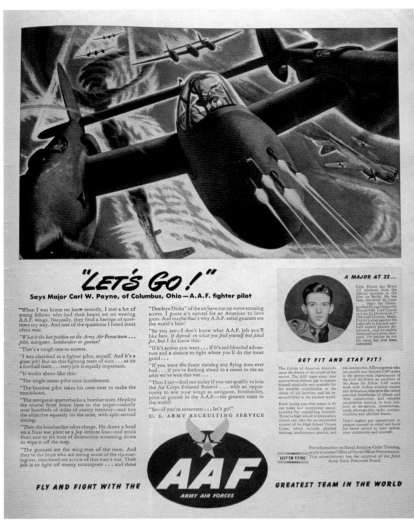

"LET'S GO!"

Life, 15 May 1944.

Illustration by *Glen Mitchell*.

of these adverts was a sure bet. The impressive number of men who enlisted and fought in the air forces is proof of that.

Today, when we look at these pictures (without losing sight of their real objective), we have to place ourselves in the turbulent context of a difficult time where courage and team spirit drove the men and women who made this such an epic period.

The entire nation was behind them in their struggle, exulting in the tales of their exploits and sharing their fears, tragedies and joys.

A very beautiful film portrays with emotion the return to civilian life experienced by these men effected by their war service. The story is based on real life events and poignantly reveals war in all its horror. It is not a heroic panorama, but more a human story to dwell upon. This was William Wyler's great Oscar winning historic film, "The best years of our lives" (1946). Courage is needed to fight, but also to face peace. How many demobilised men, sometimes physically and mentally affected, were as distressed as those portrayed in the film when returning to civilian life ? How many came back from hell forever broken and disillusioned ? The worst was yet to come, however: the lack of understanding of those who had remained at home. In the best of cases, it would take time, love and patience to fill the gap and help them find their place in a normal existence.

Not all were heroes, but all did their duty, as shown by their medals that were awarded because they had been earned and not out of kindness, medals they could be proud of. They had earned the respect of the entire nation, old and young alike.

Many of them, more or less happy survivors, did not like to talk about these dark times. One such example is the actor James Stewart who flew a B-24 Liberator on many missions on the European Front. He can be seen in his flying suit on the colour front page of the 12 January 1943 issue of Life.

Two adverts portray perfectly the fierce nature of the fighting. The artist, Rico Tomaso for Nash, in the 20 November 1945 issue of Look, shows a young pilot lieutenant climbing down from a DC-4 as he returns home. His face expresses all the feeling of a man who has experienced fierce combat, the loss of friends and the fear of difficult missions. His jacket is adorned with the prestigious medals that bear witness to his bravery and his luck in having survived the most perilous situations. The illustration is extremely well drawn and the young officer's face expresses the need to start again and build a world of peace. The way he feels is perfectly summed up in the title : "Now I know".

Made for Wieth, a pharmaceutical company (plasma, penicillin etc.), this advert, illustrated by the talented Stahl, was published in the 20 August 1945 issue of Life, at the end of the war, therefore. The scene takes place on the deck of an aircraft-carrier during a kamikaze attack. The back drop shows a sky filled with bursting flak and a burning enemy aircraft plunging into the sea. At the same time, a Hellcat has just landed, flown by an ace credited with eight kills, whilst a doctor is treating another pilot laid out on a stretcher. The text says, "Don't try to tell this doctor the job's nearly done".

LOOK

JANUARY 12, 1943 **10¢** 12¢ IN CANADA
YEARLY SUBSCRIPTION $2.50

The War Is Proving Seversky Wrong
By PAUL SCHUBERT

I PREDICT FOR 1943—
By
MAX WERNER • MAJOR GEORGE FIELDING ELIOT • WILLIAM L. SHIRER
MARQUIS W. CHILDS • PIERRE VAN PAASSEN • JOHN W. VANDERCOOK
FRED OECHSNER • H. V. KALTENBORN • CECIL BROWN • DONALD NELSON
UPTON CLOSE • EDWARD MURROW • FRAZIER HUNT • ROBERT ST. JOHN

HOLLYWOOD AT WAR
(Page 30)

HOLLYWOOD AT WAR. Look, 12 January 1943.

"NOW I KNOW..."

Back here . . .
Back home . . .

With our missions done and the roar of guns and the bombs fading and faint in our ears . . .

Back here, I remember how, out there, we went in, wave after wave, ducked through the flak and made our runs and the bomb-bursts splashed on the factories below and the flames shot up and the smoke came down and hung like a shroud over the rubble that had been a town, and then was dead.

Back here, I remember, now, the power of America at war!

I don't want to kill . . .
I don't want to destroy . . .
I want to work and build and make things live and grow.

Now I know we've got the power and the might to smash factories and cities and countries into dust . . . I know that here at home we've got the power and the will to build new towns and cities . . . to build an even finer, an even greater country of our own . . .

Now I know Americans can think and plan and work together to build the greatest war machine the world has ever seen . . . I know there's no limit to what we can do when this war's won and we've come home for peace.

Now I know this war will not be fought in vain . . . this Victory can be made real for all of us . . . if we can keep on working together not to destroy but to create.

Now I know that if we turn all the power we have gained in war, to peace . . . there can *always* be for me and every man a boundless opportunity to dream, to work, to grow . . . to build *our* America the way we want it to be . . .

That's what War . . .
That's what Victory . . .

That's what Peace means to me.

. . .

When Victory comes, Nash will go on . . . from the building of instruments of war to the making of two great new cars designed to be the finest, biggest, most comfortable, most economical, most advanced automobiles ever produced for the medium and low-price fields . . . the new Nash Ambassador Six and the new Nash "600."

And we will build these cars in numbers three times greater than we ever have before!

In this way, Nash will help contribute the jobs, the opportunities, the futures which will insure the strong, vital and growing America all of us owe to those who have fought to preserve it.

NASH
of NASH-KELVINATOR CORPORATION

"NOW I KNOW..."

Illustration by *Rico Tomaso*. Life, 15 May 1944.

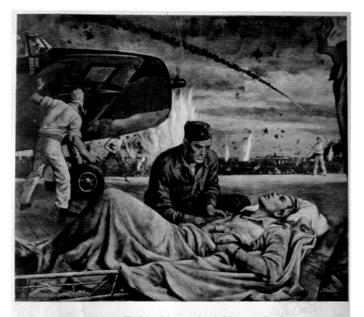

Don't try to tell _this_ doctor the job's nearly done...

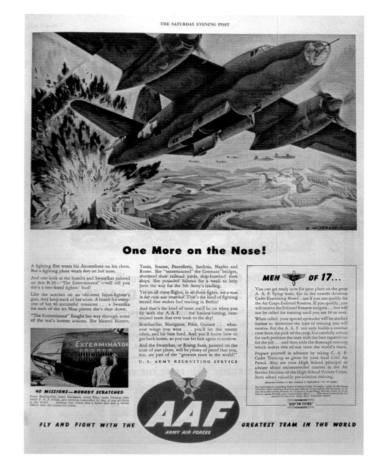

One More on the Nose!

DON'T TRY TO TELL THIS DOCTOR THE JOB'S NEARLY DONE...
Stahl.

Life, 20 August 1945.

..

ONE MORE ON THE NOSE!

On the Italian front, a B-26 Marauder drops its bombs on a strategically important train station. The mission is accomplished. The pilot proudly wears his medals on his chest. As for the plane, its missions are marked on its nose. The longer the list, the greater the glory.

This Marauder "The Exterminator", undertook forty missions without incident and had scored a tally of six enemy fighters shot down. This AAF advert was painted by _Glenn Mitchell._

The Saturday Evening Post, 18 March 1944.

..

GUARDIAN'S ANGELS

This Army Air Force recruitment advert tells of the adventures of a 12th Air Force B-17 in Italy, a Flying Fortress named "Sad Sack" after a famous comic strip character. This series portrayed the adventures of an ordinary GI and his terrible mishaps. It was illustrated by Sgt George Baker and published in Yank magazine for the Army.

A B-17, badly damaged during a mission, was saved by the escorting P-38 Lightnings and managed to get back to its base. This illustration is by the great aviation artist _Glen Mitchell._

Life, 3 March 1944.

Guardian'Angels

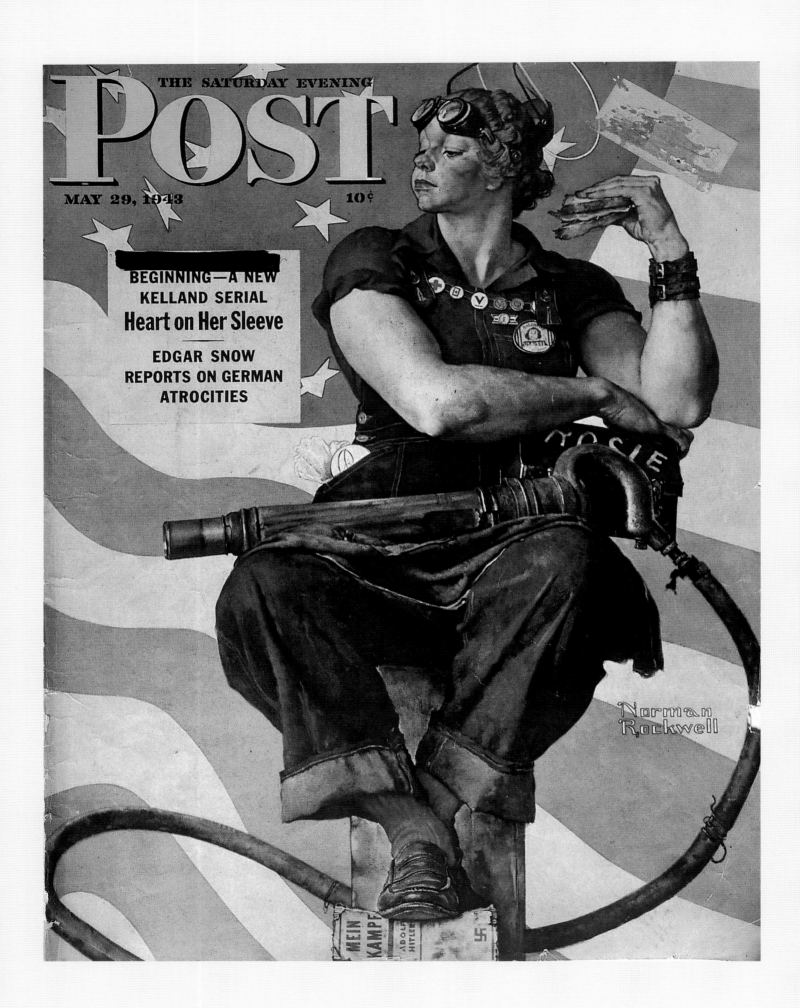

Norman Rockwell. Rosy the Riveter.

The Saturday Evening Post, 29 May 1943.

✪ CHAPTER 10

Women and aviation

Women factory workers
Rosie the riveter, a symbol

During the Second World War, women played an active role in industry in general and in particular that of aviation. Many adverts of the time pay tribute to their endurance and ardour that they showed in their work.

In November 1940, it was almost unheard of to employ women workers in American aeronautical factories and it was a situation surprisingly similar to that in France at the beginning of the Great War.

At the time of Pearl Harbor in December 1941, women made up only 1% of the workforce in this sector of industry. Two years later, in December 1943, approximately 475,000 women were already employed in the manufacturing of transport and combat aircraft. Like the men, they welded, forged and riveted. Rosie the Riveter became their symbol; the perfect woman working in the factories and workshops of the great aeronautical companies.

A famous poster shows her dressed in blue overalls and with her hair tied back under a red and white polka dot headscarf. Pulling up her sleeve, she shows her muscled arm, thus revealing her physical strength and also the proof of her courage and energy that her work demands. Her arm could also symbolise an insulting gesture towards the enemy, as if she were saying, "Our fighting men on all fronts want planes? They'll get them !. The poster's slogan is a very straightforward, "We can do it"; and indeed they did !

It fell to the great Norman Rockwell to pay tribute to all these women via a magnificent front cover illustrated for The Saturday Evening Post of 29 May 1943. It shows a powerfully built woman dressed in her work overalls, sat on a tin can eating her sandwich during her break with the American flag for a backdrop. She proudly wears, pinned to her overalls, all the badges of the various war effort associations and services, as well as the pass for the company she works for. Placed on her lap is a bag bearing the name Rosie, in which she keeps her lunch and a few personal items. Also on her lap is a riveter, a tool that looks like a weapon, which in this case it is, a weapon of productivity.

J. Howard Miller (1918 – 2004)
WE CAN DO IT!
Poster made for the Westinghouse factories.
The artist took inspiration from a United Press International photo showing the factory worker Geraldine Doyle.
When the poster was published, the name "Rosie the Riveter" was not yet used to describe women working for the war effort.

This remarkably well portrayed character would make an excellent sculpture to be placed at the entrance of an aviation museum. It is even a veritable model of perfection of which the low angle view chosen by the artist accentuates the strength. As with all Norman Rockwell illustrations, her face, with its clearly feminine characteristics, despite her impressive muscles, expresses in this moment of relaxation, a whole range of sentiments: an iron willpower, a sense of responsibility and pride in work well done. She is a cog in the huge machine. She thinks of the new planes that will go to war, perhaps flown or maintained by friends or members of her own family. During this period, all hearts were filled with patriotism and maintained a necessary ardour as nobody doubted that the road to victory would be a long one. With a certain, obvious fact ; the victory would be an Allied one. The faces illustrated by Norman Rockwell reflect a soul and a different personality according to the subject, which was his strength, as well as his great artistic skills. Rosie often had the place of honour in best selling magazines. Her character was inspired by an incredible, hard-working, tough woman called Rosine Bonavita who worked in the Grumman factory at Long Island. She had to be seen punching in the 3,345 rivets of an Avenger in one shift to the envious amazement of her male colleagues.

In fact, it was not necessary to invent a heroine as there were plenty of real ones, something which made Harold O. Williamson of the Palm Springs WWII Air Museum de Palm Springs remark, that the war had got far more women out of their kitchen than their famous "Women's lib movement" .

The Saturday Evening Post of 1 January 1944 promotes in its own way the qualities of Maxwell filter coffee. After hours of hard work on a production line, a woman worker feels dead beat. Quick, a cup of nice, hot coffee carried in its thermos flask ! Her smile and energy quickly return. In another Maxwell advert, a pilot back from a difficult mission and still marked by long moments of fear and nervous tension, enjoys a cup of coffee and makes the most of a well-earned moment of relaxation.

For the Texaco company, we find our behind the scenes heroine building an airframe with the caption, "From Alice...to Eddie...to Adolf ! , in an advert that is particularly representative of the American nation's frame of mind throughout the war. The country is producing as many planes as possible necessary to ensure victory. In this year of 1943, there was no time to lose : the fighting men need planes ? They'll get them ! This advert speaks to all the Rosies by using a real name and glorifying the individual and collective effort.

On 18 March 1944, The Saturday Evening Post published a Northrop Aviation, advert with the hard hitting title, "To the Ladies, God Bless Them". The advert portrays two women working on the tail-plane of a P-61 Black-Widow (an aircraft that, for a long time, puzzled and terrorized German soldiers). A message is written on the first base coat of zinc-chromate that will be covered by the final coat of paint, "Buy war bonds with all your might. Back up the men who fly and fight". It is a very beautiful advert that sums up the preoccupations and thoughts of the time.

A Martin Aircraft advert chants "Reinforcements". It is women who are given these delicate tasks. The text along with an illustration of a woman skilfully using a drill is unambiguous and pays tribute to women: "Feminine touch is sure, skilful in precision aircraft work. Women learn fast, work hard."

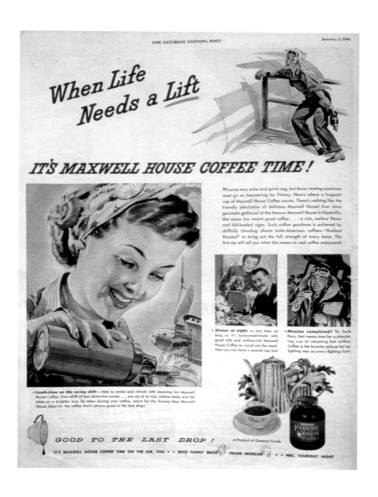

WHEN LIFE NEEDS A LIFT **The Saturday Evening Post**, 1 January 1944. FROM ALICE… TO EDDIE… TO ADOLF! **Life** , 15 March 1943.
TO THE LADIES, GOD BLESS THEM! **The Saturday Evening Post**, 18 March 1944. REINFORCEMENTS! **Life**, 21 December 1942.

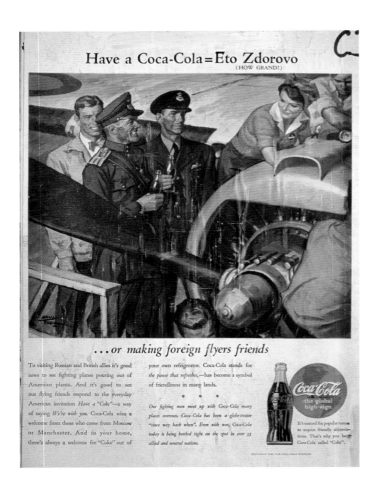

During the Second World War, many large convoys of ships crossed the North Atlantic with supplies for the European front. Officers and ratings on the bridge of a US Navy escort vessel show their joy at the sight of two Mariners flying low over the ships; protection and reinforcement come from the sky and German U-Boats had better watch out.

In this Martin Aircraft advert, Warren Baumgartner uses all of his skills as a water-colour artist. His spontaneity, precision and use of colour give depth and outline. The Martin Mariner 162 A, designed by Glenn Martin and William K. Ebel, first flew in 1937.

Saul Tepper, in a series of adverts for Coca-Cola and based on the inter-allied friendship between aviators, shows Rosie working on a Martin-Baltimore in Royal Air Force livery, smiling at a British officer and a Russian accompanied by a factory press service interpreter.

Not forgetting to show their products in use in industry as well as in the home, Johnson's Wax takes us, in 1945, to a flying-boat production line. Victory is on the horizon. However, the joy of a hard earned peace may not last long and the sky is filling up too quickly with dark clouds. The euphoria of victory is in danger of melting away and the friends of yesterday may become the enemies of tomorrow. Other conflicts are breaking out all over the world and are confining the days of heroes, solidarity and friendship to the history books. These political changes did not reduce the important role played by women during the Second World War that has been played down since, far from it in fact, they appear like heroines every bit as good as the men that they replaced by necessity and who they supported via their work. However, a new world, a new vision and new way of thinking were to emerge.

Rapidly, the film industry glorified all of the Rosies involved in the war effort. On 17 August 1942, Life published an advert for a propaganda film, the illustration of which appears to have all the hallmarks of the talented Ren Wicks. As for the film, "Wings for the Eagle", it pays tribute to the men and women working in the aeronautical industry. The text contains the slogan "Dedicated to the workers who are now making wings for the Eagle "(We can, We must, We will). This feature length film with Ann Sheridan and Dennis Morgan, directed by Lloyd Bacon and produced by Warner Bros, was filmed in black and white on the Lockheed P-38 and Hudson assembly lines. The story takes place at a time when the United-States badly needed planes and, therefore, workers. Amongst the women who answered the urgent call, one would become famous, Norma Jean Baker, the future star Marilyn Monroe. Later on, in 1980, Connie Field made a 65 minute documentary on Rosie the Riveter, portraying the lives of women during the Second World War via old photos, interviews and period film.

Inspired by these ardent, hard-working women, Red Evans and John Jacob Loed wrote a song, the musical background of which used the rhythm of the riveting machines in action, bringing back to life the atmosphere of the time; a period of ideals, courage and pride in one's work, solidarity between men and women of all backgrounds all working towards one goal: victory ! This was something that did not go un-noticed by the press at the time who filled their pages with photos, illustrations and articles about Rosie in action.

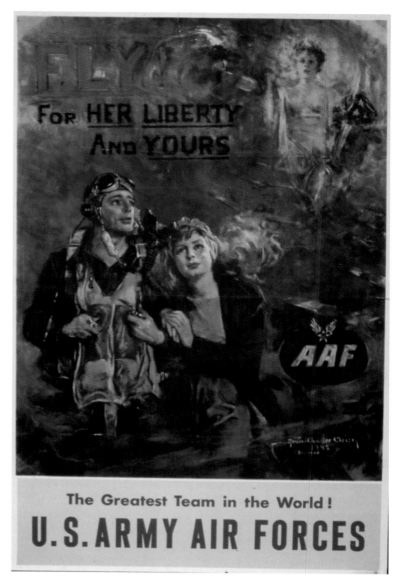

The aviator and the worker, the best team in the world !

Women pilots

Women aviators wore a funny little insignia on their A2 flying jackets, representing a winged-woman designed by the grand master of animation, Walt Disney. The WASP, Woman Air Service Pilots, delivered all types of aircraft, fighter or bombers, from the factories to the bases in the United States, from where they were dispatched to the various theatres of operations. The creation of this service owed a lot to the insistence of Jacqueline Cochran towards the military authorities. She was a brave, determined, independent, full of fight and ambitious female pilot who also, as it happens, took command of this women's service that was appreciated by all. He determination comes across in sentence that features in her book , "The Stars at Noon": "I may have been born in a slum, but one day I decided to fly in the sky up to the stars".

In other words, tenacity pays off, something that she had already brilliantly proved previously when, after several record attempts and as many failures, she managed, in 1938, to win the Bendix Trophy whilst flying a Seversky.

In the light of their amazing performances, the number and diversity of the planes that were ferried, these women are part of an intense period of history that owes at least part of its panache to them. Moreover, magazines, including the best sellers, often paid long tribute to these women aviators. Take, for example, the 19 July 1943 issue of Life, with its front cover showing the 22 year old Shirley Slade sitting on the tail plane of a T6, whilst the article is in the form of a nine page photographic report. Flying magazine also dedicated several issues to them: "The Fifinellas", by Barbara Selby, July 1943 ; "The WASP", by John Stuart, January 1944 ; and "Requiem for the WASP", by Barbara E. Poole, December 1944.

What we should retain today are the smiles of these pretty young women, brave, enthusiastic and proud in the contribution they made to the great war machine that sometimes crushed their youth and their lives.

On the other hand, amongst the few Grumman female test pilots flying the F6 Hellcat as soon as they left the production lines, we mention the name of Teddy Kenyon. She appeared in several magazines in a comic strip style advert for Camel cigarettes. We first see her in The Saturday Evening Post of 10 June 1944. Barbara Jane, painted by Coby Whitmore, an artist who found his inspiration in the eternal woman, promotes the Du Barry beauty products. Here she is on the wing of a Hellcat, dictating to a technician, who notes everything down, the results of a test flight that she has just carried out.

We should not forget the role of the women pilots of the "Civil Air Patrol" . We come across them in several adverts: for Camel in the 4 March 1942 issue of Life, where a series of photos explains their role, in the style of many adverts made by this company. The main colour photograph allows us to see a women aviator in a rare moment of relaxation, happily smoking the cigarette that she is promoting without having to worry about any form of censorship. We also see the action woman in a Norge advert (Life, 25 October 1943), the refrigerator and household appliance specialist. In this gouache, the female aviator, on a night-time mission, is flying over a lighthouse on the coast.

The nurses

The incarnation of comfort, even in the midst of hell, strict at times, but with kindness in their eyes, nurses cared for service personnel wherever they were needed, be it on land, at sea or in the air, working in the base hospitals as well as exposed to the dangers of the front line.

Their sense of duty and courage honours them as they always gave their best at a time when it was needed. They had to be strong, brave and competent when it came to smiling at and comforting men at death's door or terribly wounded. They found the right words to bring comfort to despairing souls. Naturally, illustrators did not have to

Life, 19 July 1943.

This issue had an article on the training of female pilots.

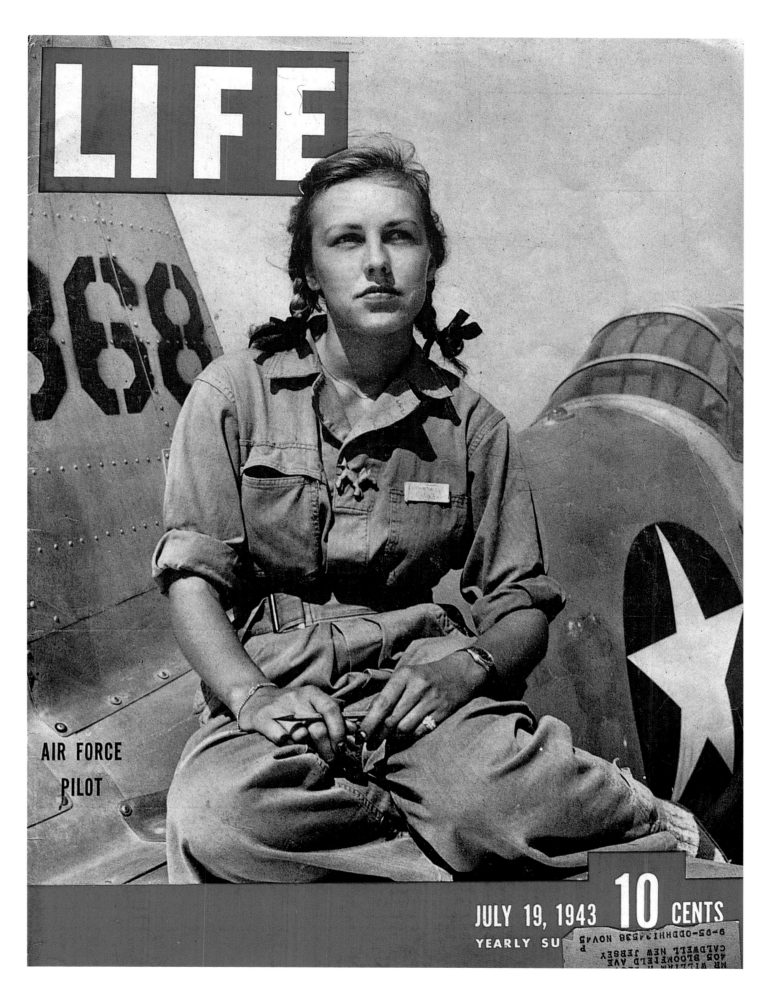

LIFE

AIR FORCE
PILOT

JULY 19, 1943 **10** CENTS
YEARLY SU

Shirley Slade seated on the tail-plane of a training aircraft at Avanger Field, Sweetwater, Texas. In September, Slade obtained her wings as a member of the "Women Airforce Service Pilots", Class 43-5. Photo: *Peter Stackpole*. Life, 19 July 1943.

"I TAME HELLCATS!"

The Saturday Evening Post,
10 June 1944.

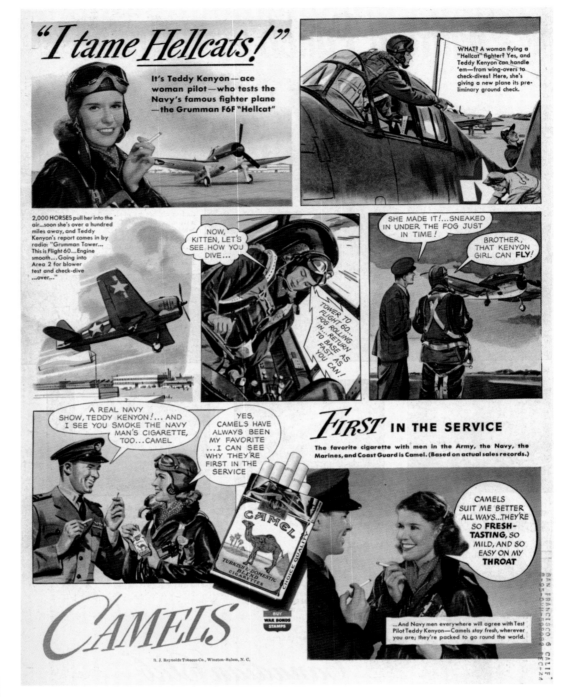

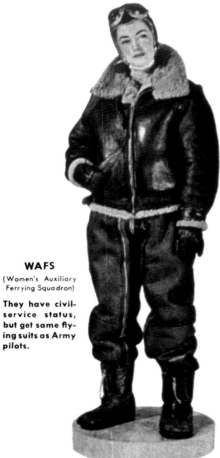

WAFS
(Women's Auxiliary
Ferrying Squadron)

They have civil-
service status,
but get same fly-
ing suits as Army
pilots.

(FOLLOWING PAGE)

TEST PILOT – SIZE 10

Barbara Jayne, a test pilot with Grumman, promotes Du
Barry beauty products.

..

THEY'VE GOT WHAT IT TAKES!

The period slogan, this time with a female pilot of the
Civil Air Patrol. **Life, 4 March 1942.**

..

WITH US IT'S CHESTERFIELD

A rare WAFS, Women Auxiliary Ferrying Squadron
advert. It was made by Chesterfield and published in
Newsweek, 18 October 1943.

NIGHT PATROL

The refrigerator and electrical goods for the Army
maker Norge, pays tribute to the women of the Civil Air
Patrol that watched over the land and coastlines of the
United States. Their role ranged from looking out for
forest fires, undertaking rescues of all sorts and
spotting enemy submarines lurking off the coast.
American Home Journal, November 1943.

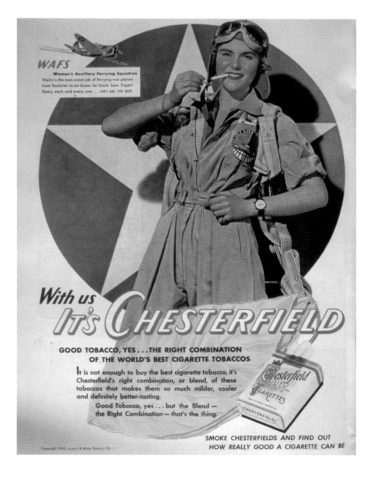
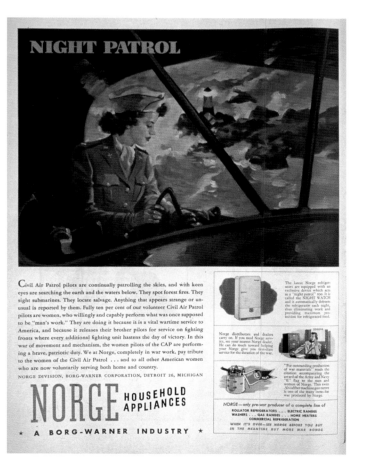

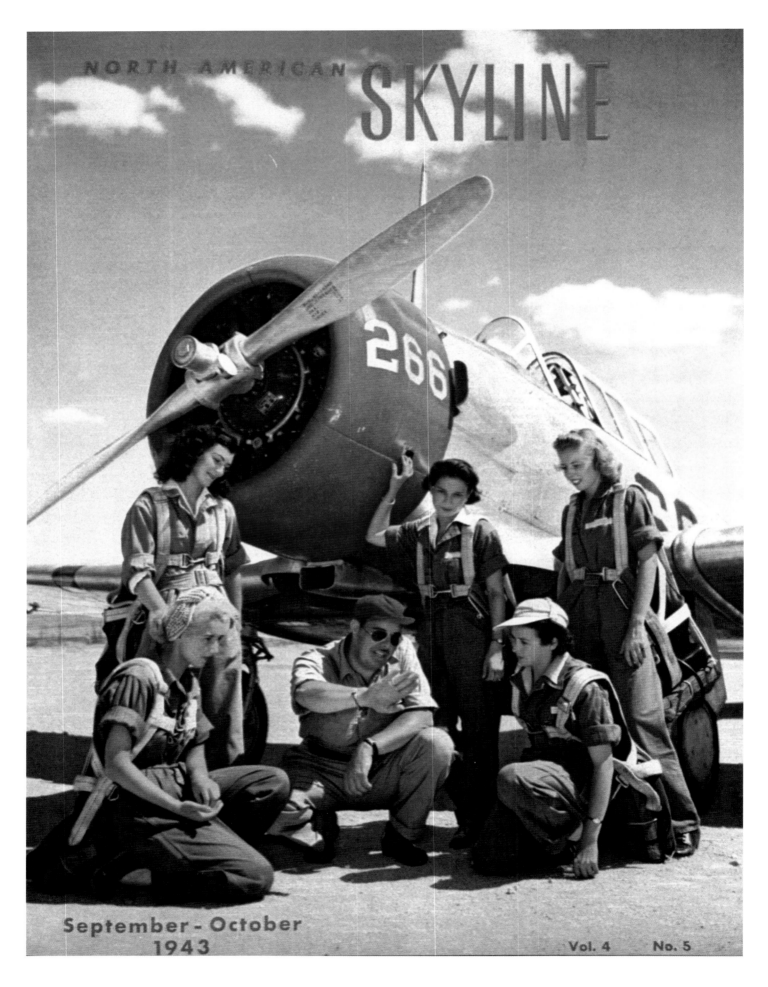

NORTH AMERICAN SKYLINE

September - October
1943

Vol. 4 No. 5

The North American magazine carried a front page photo showing women listening to a instructor explaining a flight phase in front of a T-6.

Skyline, September - October 1943.

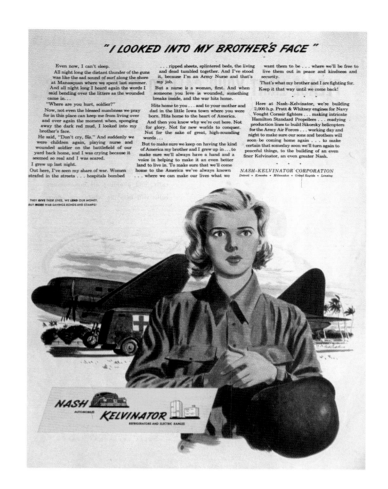

"I LOOKED INTO MY BROTHER'S FACE"

Even now, I can't sleep.

All night long the distant thunder of the guns was like the sad sound of surf along the shore at Manasquan where we spent last summer. And all night long I heard again the words I said bending over the litters as the wounded came in...

"Where are you hurt, soldier?"

Now, not even the blessed numbness we pray for in this place can keep me from living over and over again the moment when, sponging away the dark red mud, I looked into my brother's face.

He said, "Don't cry, Sis." And suddenly we were children again, playing nurse and wounded soldier on the battlefield of our yard back home, and I was crying because it seemed so real and I was scared.

I grew up last night.

Out here, I've seen my share of war. Women strafed in the streets . . . hospitals bombed . . . ripped sheets, splintered beds, the living and dead tumbled together. And I've stood it, because I'm an Army Nurse and that's my job.

But a nurse is a woman, first. And when someone you love is wounded, something breaks inside, and the war hits home.

Hits home to you . . . and to your mother and dad in the little Iowa town where you were born. Hits home to the heart of America.

And then you know why we're out here. Not for glory. Not for new worlds to conquer. Not for the sake of great, high-sounding words . . .

But to make sure we keep on having the kind of America my brother and I grew up in . . . to make sure we'll always have a hand and a voice in helping to make it an even better land to live in. To make sure that we'll come home to the America we've always known . . . where we can make our lives what we want them to be . . . where we'll be free to live them out in peace and kindness and security.

That's what my brother and I are fighting for. Keep it that way until we come back!

Here at Nash-Kelvinator, we're building 2,000 h.p. Pratt & Whitney engines for Navy Vought Corsair fighters . . . making intricate Hamilton Standard Propellers . . . readying production lines to build Sikorsky helicopters for the Army Air Forces . . . working day and night to make sure our sons and brothers will soon be coming home again . . . to make certain that someday soon we'll turn again to peaceful things, to the building of an even finer Kelvinator, an even greater Nash.

NASH-KELVINATOR CORPORATION

Detroit • Kenosha • Milwaukee • Grand Rapids • Lansing

THEY GIVE THEIR LIVES. WE LEND OUR MONEY.
BUY MORE WAR SAVINGS BONDS AND STAMPS!

NASH KELVINATOR AUTOMOBILES
REFRIGERATORS AND ELECTRIC RANGES

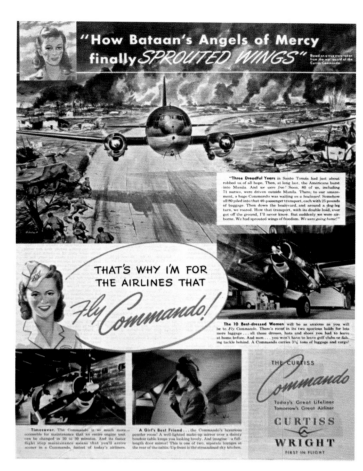

"How Bataan's Angels of Mercy finally SPROUTED WINGS"

THAT'S WHY I'M FOR THE AIRLINES THAT *Fly Commando!*

THE CURTISS *Commando*
Today's Great Lifeliner
Tomorrow's Great Airliner
CURTISS WRIGHT FIRST IN FLIGHT

tax their imaginations in the portrayal of the role played by nurses that were consequently used in many adverts. In the 13 November 1943 issue of Collier's, Nash Kelvinator paid tribute to the nurses that accompanied wounded men as they were flown back home. The spirit of these women is perfectly portrayed by Fred Ludekens. In this painting, a nurse is seen walking away from a Dakota, accompanied by the words "I looked in my brother's face ". The face reflects a range of contradictory feelings and is still marked by the horrors of war.

On 5 February 1945 at Manila, 66 nurses captured at Bataan and Corregidor by the Japanese and held prisoner for nearly three years, were liberated after much suffering. On 12 February, the authorities, fearing a Japanese counter-attack, flew them to safety on board a Curtiss Commando C-46. No less than 80 people were on board the plane that was designed to carry 40, and it still managed to off from a road despite being so overloaded. This story of this exploit, which helped establish the reputation of the Curtiss C-46, is told in the March-April 1945 issue of Curtiss Fly Leaf.

"I LOOKED INTO MY BROTHER'S FACE"
Collier's, 13 November 1943.

...

"HOW BATAAN'S ANGEL OF MERCY FINALLY SPROUTED WINGS"
This advert was made for Curtiss Wright and illustrated with talent by *John F. Gould.*
It recalls a historic event that was also mentioned in the press.
Collier's, 28 July 1945.

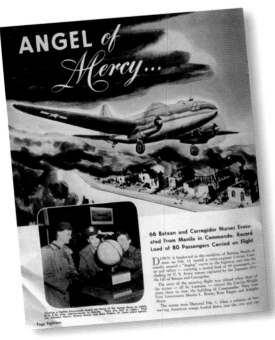

ANGEL of *Mercy...*

66 Bataan and Corregidor Nurses Evacuated From Manila in Commando; Record Load of 80 Passengers Carried on Flight

KEEP 'EM FLYING—

PART TWO

The battalion of artists

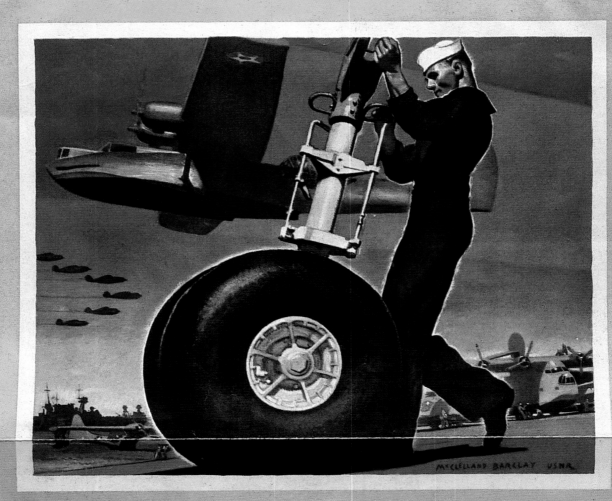

Naval Aviation
has a place for You...
★ Pilots ★ Machinist's Mates
★ Radiomen ★ Metalsmiths
★ Ordnancemen
Learn the right-way ~ the Navy-way

Apply today

⭐ CHAPTER 11

Illustrators on all fronts

Many artists, thanks to the diversity and quality of their work, contributed to maintaining the energy of a people at war via the adverts published in the press between 1941 and 1945. Because of their vision, we can glimpse the atmosphere of this period and its glorification of the fighting personnel, the equipment and products of the day. They made the young dream, gave them courage, enthusiasm, a sense of duty and on occasions, comfort.

Who were these artists, hard working and filled with enthusiasm by the job at hand ? They were one of the important links in the well-made propaganda chain, popular with readers of the period and today with the collectors of magazines published during this time.

With their talent, they created an impressive historic panorama. Sadly, I have not been able to identify all of them, only the best known. Advertisement illustrations were not always signed by the artist and mistakes may have been made with some. For other lesser known, often very talented artists, I found no information throughout my long research. When travelling in the United States, one may come across their work in numerous museums.

Hats Off to Naval Aircrewmen!

(PREVIOUS PAGE)
Mac Lelland Barclay
This excellently painted poster was first published in advert form following the disaster that befell Pearl Harbor on 7 December 1941. It highlights perfectly the need for men and materiel and the stages and difficult events that the country will have to face before returning to peace.
It was also published in **Flying in January 1942.**

Barclay Mac Lelland, 1891-1943

Born in Saint Louis, Missouri, he studied under the guidance of great artists such as Thomas Fogarty who also had as pupils, Norman Rockwell and Walter Biggs. Before the war, he showed a preference for painting portraits of pretty women.

He illustrated remarkable adverts for the press campaigns of Camel, Fischer Body, Whitman's Chocolate, Timken Roller Bearing... During the Second World War, he was made a lieutenant in the US Navy, for whom he made many posters and portraits of officers.

This talented artist disappeared in 1943 in the South Pacific, when the ship he was sailing on was sunk by a torpedo.

He was a member of associations such as The Artists Guild, The Art Students League of New York and Society of Illustrators. In 1946, three years after his death, a foundation was created in his name to help young artists.

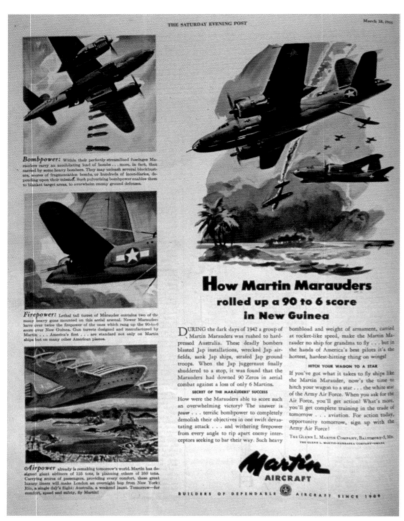

Bombpower: Within their perfectly streamlined fuselage Marauders carry an annihilating load of bombs . . . more, in fact, than carried by some heavy bombers. They may unleash several blockbusters, scores of fragmentation bombs, or hundreds of incendiaries, depending upon their mission. Such pulverizing bombpower enables them to blanket target areas, to overwhelm enemy ground defenses.

Firepower: Lethal tail turret of Marauder contains two of the many heavy guns mounted on this aerial arsenal. Newer Marauders have over twice the firepower of the ones which rang up the 90-to-6 score over New Guinea. Gun turrets designed and manufactured by Martin . . . America's first . . . are standard not only on Martin ships but on many other American planes.

Airpower already is remaking tomorrow's world. Martin has designed giant airliners of 125 tons, is planning others of 160 tons. Carrying scores of passengers, providing every comfort, these great luxury liners will make London an overnight hop from New York; Rio, a single day's flight; Australia, a weekend jaunt. Tomorrow—for comfort, speed and safety, fly Martin!

How Martin Marauders rolled up a 90 to 6 score in New Guinea

DURING the dark days of 1942 a group of Martin Marauders was rushed to hard-pressed Australia. These deadly bombers blasted Jap installations, wrecked Jap airfields, sank Jap ships, strafed Jap ground troops. When the Jap juggernaut finally shuddered to a stop, it was found that the Marauders had downed 90 Zeros in aerial combat against a loss of only 6 Martins.

SECRET OF THE MARAUDERS' SUCCESS

How were the Marauders able to score such an overwhelming victory? The answer is *power* . . . terrific bombpower to completely demolish their objectives in one swift devastating attack . . . and withering firepower from every angle to rip apart enemy interceptors seeking to bar their way. Such heavy bombload and weight of armament, carried at rocket-like speed, make the Martin Marauder no ship for grandma to fly . . . but in the hands of America's best pilots it's the hottest, hardest-hitting thing on wings!

HITCH YOUR WAGON TO A STAR

If you've got what it takes to fly ships like the Martin Marauder, now's the time to hitch your wagon to a star . . . the white star of the Army Air Force. When you ask for the Air Force, you'll get action! What's more, you'll get complete training in the trade of tomorrow . . . aviation. For action today, opportunity tomorrow, sign up with the Army Air Force!

THE GLENN L. MARTIN COMPANY, BALTIMORE-3, MD.
THE GLENN L. MARTIN-NEBRASKA COMPANY-OMAHA

Martin
AIRCRAFT

BUILDERS OF DEPENDABLE AIRCRAFT SINCE 1909

Warren Baumgartner

HOW MARTIN MARAUDER…

With a few well-executed watercolours, Warren Baumgartner pays tribute to the qualities of the B-26 and he concludes with a futuristic illustration of a huge seaplane, the symbol of progress achieved for post war projects.

The main illustration is inspired by true events that took part in the skies over New Guinea and New England. The B-26 Marauders shot down ninety Japanese fighters, losing only six of their own aircraft.

The Saturday Evening Post, 18 mars 1944.

Baumgartner Warren, 1894-1963

Born in Oakville, Missouri, he was a great nature lover, especially when it came to fishing in the rivers surrounded by the forests of his childhood. He studied at the Chicago Art Institute. When we look at a water colour by this great artist, we are struck by the quality of the composition with the chosen subject, the realism and perfect balance of colour, the touches of water colour, the flat tints, shade, luminosity and transparency that is all rendered with great accuracy. He was particularly skilled at bringing out the contours of machines and people, even the faces whose expressions, however varied, were captured in a few quick, neat strokes of a brush. He captured the slightest shade of lighting and the depth of field.

This great illustrator could undertake a great variety of illustrations with perfect realism. He worked for various magazines, including the excellent Collier's for which he illustrated many news articles. One piece of work that stands out is a very beautiful water colour of the Normandie passenger ship entering into the port of New-York, published in issue number 25 of Collier's and illustrating the article "Midnight Sailing". He also undertook advertisement work for Western Electric, Remington, General Motors-Spar Plug, Division General Motors Corporation, RCA Radio Corporation of America. Above all, it was for Martin Aircraft that he made a magnificent series on the various aircraft made by this company. We owe him very beautiful illustrations of Martin Mariner flying boats, the B-26 Marauder and the Baltimore, planes that are very well drawn and perfectly captured at a precise moment of action. He was without doubt a very good aviation artist whose work was particularly well spirited. He was also commissioned by the Blaine Thompson Co. agency to make the poster for the Warner Bros film, Air Force.

His various works won him many awards. As a member of Society of Illustrators, the Water Colour Association, the National Academy of Design and the New-York Salmagundi Club, he was one of the best illustrators of this period.

(FOLLOWING PAGE)

THEY'RE WRITING HEADLINES WITH…

As well as a description of the aircraft's capabilities, this advert creates a link between the crew and the reader. Who are these men ? Do you know them ?

They are part of your circle and are fighting on the frontline. They are defending our common ideals ! This famous bomber undertook its maiden flight in November 1940. It went into production immediately without the prototype undergoing a prolonged period of testing. It was designed by Glenn L. Martin and William K. Ebel.

W. Baumgartner undertook these illustrations with great skill. The portraits of the aviators are especially well rendered by the accuracy of the stroke and use of watercolours.

Collier's, 21 August 1943.

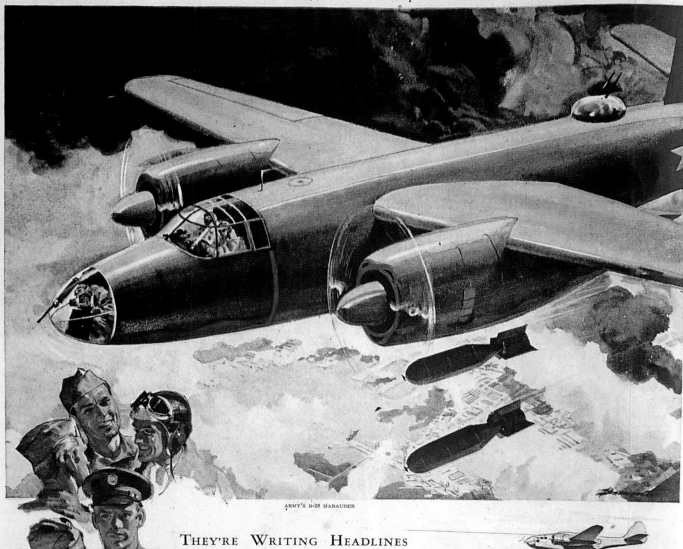

ARMY'S B-26 MARAUDER

THEY'RE WRITING HEADLINES
WITH A
MARTIN MARAUDER

BRITAIN'S BALTIMORE

Alex . . . Joe . . . Steve . . . Ed . . . and Bill. You know them. Alex, who used to bring your groceries . . . Joe . . . Steve . . . Ed and Bill, who used to go with little Sally Miller. Likeable, quick-to-laugh young Americans. Give them the best aerial schooling in the world, put them in a rocket-fast, Martin B-26 Marauder, and they're a flyin', fightin' team that wins!

There's a reason for this, of course. Aircraft are highly complicated mechanical devices . . . and these boys were fitting together mechanical gad-gets, tinkering with tools, racing old jalopies, when their adversaries were learning to "heil" and "banzai." They've got the feel of speed, the mechanical know-how that makes natural born pilots, gunners and bombardiers.

This same instinctive technical skill gives America fighting planes like the Martin B-26 Marauder . . . Sleek, graceful, packed with speed, power and punch, it's the kind of plane that makes young America's eyes light up . . . makes him say, "Put me down for the Air Force!"

What's more, American technical skill is going to play a major role in fashioning the future. Already Martin has completed plans for giant air-liners of 125 or more tons . . . mighty ships that will bring distant nations to within hours of your doorstep. At the same time, our Army and Navy airmen, imbued with the thrill of flight, the love of speed, are resolving never to be shackled to earth again. They're in the air . . . to stay!

Alex . . . Joe . . . Steve . . . Ed . . . and Bill. They're doing more than win a war. They're building a world that will take your breath away.

The Glenn L. Martin Company, Baltimore
The Glenn L. Martin-Nebraska Company—Omaha

NAVY'S MARTIN TRANSPORT

NAVY'S MARINER PATROL BOMBER

Martin
AIRCRAFT
Builders of Dependable ⊛ *Aircraft Since 1909*

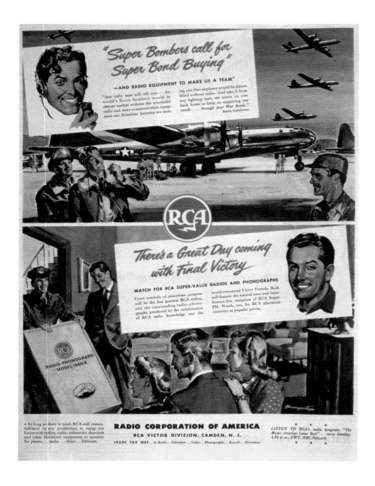

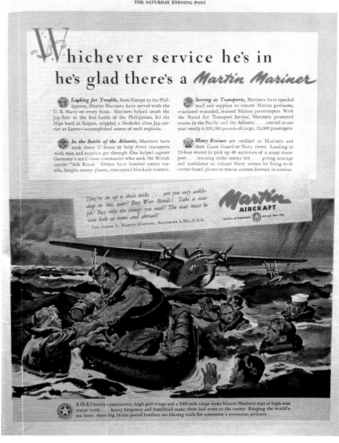

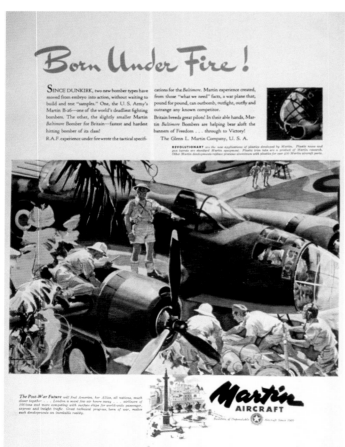

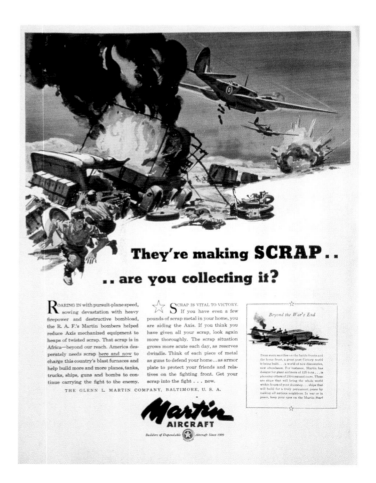

Warren Baumgartner

"SUPER BOMBER CALL FOR SUPER BOMB BUYING"

The technological prowess and professionalism of RCA and the call to buy war bonds for the final victory are the themes of this advert. On a B-29 Superfortress base somewhere in the Pacific, a crew shows the importance of radio and internal communications when on missions. Peace is fast approaching and the aviators are thinking of their return home and the purchase of a new radio-phonograph made by this company.

Collier's, 18 November 1944.

WHICHEVER SERVICE HE'S IN…

The survivors of a torpedoed American merchant ship in the North Atlantic are saved by a powerful Martin Mariner seaplane in rough seas. The aircraft has successfully undertaken its mission as a Saint Bernard of the seas. This powerful illustration, along with its caption, portrays the Mariner's capabilities in its numerous missions.

The Saturday Evening Post, 21 April 1945.

BORN UNDER FIRE!

This Martin Aircraft advert portrays a Martin Baltimore, an aircraft that saw much service with the RAF in Libya and Tunisia, and which was, moreover, designed for the British by Glenn Martin and William Kebel from the Maryland. Its maiden flight was on 14 June 1941. In this watercolour, the artist shows the aircraft along with its crew as they prepare for a mission somewhere on the Mediterranean front.

Life, 25 May 1942.

THEY'RE MAKING SCRAP…

In this Martin Aircraft advert, the illustrator looks through the eyes of the war correspondent. He captures the instant in which the RAF Martin Baltimores drop their bombs and destroy an Afrika Korps convoy somewhere in the Libyan desert.

Life, 4 May 1943.

COMMUNIQUE… FROM THE PRODUCTION FRONT

The scene is supposed to portray an advanced Army Air Force base in the Pacific at the beginning of the war. In this excellent illustration, the aviators are reading a memo. They show an iron morale. The colour photos underline the efforts of Martin Aircraft's male and female workforce in the manufacturing of the maximum possible number of aircraft.

Collier's, 14 November 1942.

VICTORY'S WRITTEN ALL OVER THESE…

This Martin Aircraft advert shows us the victory tallies on a few bombers made by this company. A small watercolour shows one of the ground crew painting a tally mark; a ship sunk by a B-26. Amongst these planes we can make out the B-26 named "Hellcat" that is seen in other adverts. This plane flew on the Mediterranean front.

Life, 10 July 1944.

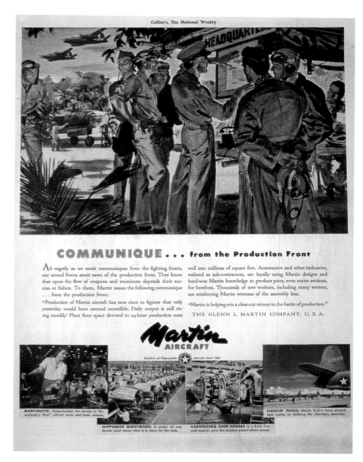

Beall Cecil Calvert, 1892-1967

Born in Saratoga, Wyoming, he studied art at the New-York Art Students League and at the Pratt Institute. His first works were water colours. He had a vigorous style and knew how to play perfectly with shade and colour, a technique that was especially liked by many Collier's illustrators.

In 1936, C.C. Beall painted a portrait of President Franklin D. Roosevelt for the cover of a Collier's issue. The President was very happy with this portrait and took on the artist as artistic director of the National Democratic Committee. During the Second World War, he illustrated numerous covers for Collier's magazine, portraying American service personnel from various army corps who had been decorated for acts of bravery. Still with this magazine, he illustrated many news articles. He worked on advertising campaigns for Alcoa Aluminum as well as the recruitment of aviators for the Army Air Force. Along with Clayton Knight, he was one of the artists honoured by being invited to see the signing of the Japanese surrender on board the Missouri battleship.

C.C. Beall

BROTHER, WE'VE PROMISED OURSELVES TO BRING YOU HOME SOON
For its advertising, Alcoa, Aluminium Company of America, chose this watercolour portraying the fierce fighting in the Guadalcanal jungle. A Marine defends a hard won position , surrounded by lush vegetation and in a suffocating atmosphere. He knows that the Japanese are laying in wait and preparing to attack. However, through a clearing in the trees, Wildcats arrive, providing air cover. The text says:"aircraft factories need more and more aluminium to provide the weapons and power needed by our fighting men and, above all, so that our soldiers can return home as soon as possible".
Life, 14 September 1942.
..

This front cover of Collier's tells of a true-life event that took place over the Pacific on 22 April 1942. A 5th Air Force B-17 Flying Fortress was flying at high altitude over Rabaul, a Japanese base at that time. One of the machine-gunners, Corporal Edward B. Malinay, turned around and saw his friend, Corporal Donald Kearn slumped unconscious over his machine-gun, with the tube of his oxygen mask cut. At such a height, no human being could survive more than a few minutes without oxygen. Using the intercom, he asked the pilot, Captain John E. Dougherty, if he could leave his post. Holding his breath, he carried his friend into the radio compartment where there was another oxygen mask, before returning to his post. For this act, Malinay was promoted to sergeant and decorated with the Purple Heart.
The illustrator has captured these events with talent and accuracy. He made several covers for Collier's, portraying the heroic feats of American service personnel.
Collier's, 2 October 1943.

President Harry S. Truman liked the illustration made by Beall on board the Missouri and made it an official document. C. C. Beall was a member of the Illustrators Society and received their award in 1961. He was also a member of the American Watercolor Society and other associations. His work is displayed in many collections, notably those of the Air Force Academy Museum at Colorado Springs and the Marines museum at Quantico (Virginia).

Beaumont Arthur, 1890-1978

The work of Arthur Beaumont, a talented watercolour artist, reflects a marvellous spontaneity and a great precision in his touches of colour and in the detail. Amongst his Second World War work, we can mention a sixteen watercolour report that was published in the November 1942 issue of National Geographic Magazine and that interested the various American forces army corps. He also undertook illustrations for the advertisements of Thomson Products Inc.

Bingham James R., 1917-1971

Born in Pittsburgh, he studied at the Carnegie Institute of Technology where he acquired a very personal precision and style. He showed an extreme skill in painting either a portrait or any kind of machinery or other item. His realistic paintings are very pleasant to look at.

His aviation or rail illustrations are absolute perfection and the colours match perfectly those of the plane or train and also that of the environment. He was one of the period's talented illustrators.

During the war, he worked on films for the US Army Air Forces. Attached to the Office of Research and Interventions, he was paid as a naval officer in a role that suited him perfectly. In his work as an illustrator, we can mention two aviation adventure articles that were published in The Saturday Evening Post, "The Immortal Harpy", in the July 1944 issue, with the adventures of a B-24 Liberator, and "The Lady and the Flat Top" ", published on 17 March 1945, the story of a medical evacuation on board a Douglas C-47, better known as the Dakota.

After the war, he illustrated a long series of police stories by Earle Stanley Garner, the famous "Perry Mason", as well as the series "Tug Boat Annie", still for The Saturday Evening Post. During the war, as well as his work as an illustrator, he worked on numerous advertising campaigns for prestigious companies: Air Transport Association, Airlines of the United States, United States Steel, Continental Can Company, Pennsylvania Rail Road, Gulf Oil Corporation, Philadelphia Whiskey, Cadillac, The Caterpillar Tractor Company, Ford-Hamilton...

He also won many awards : The Art Director Club Medal in New York, and others in Philadelphia, Chicago and Miami, crowning a career that has seen the great talent of James R. Bingham leaving his mark on a page of history. He made my generation dream and helped us to discover a new world. Today, I still look at his illustrations with an intense emotion. His work was impressive for a fairly short life.

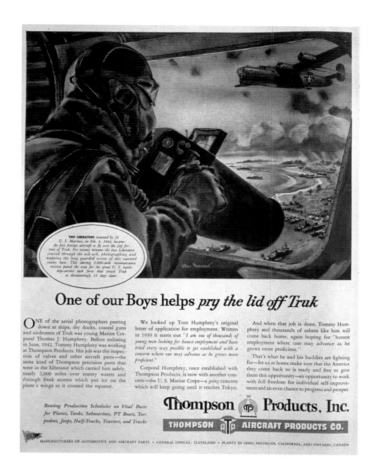

One of our Boys helps *pry the lid off Truk*

Arthur Beaumont

ONE OF OUR BOYS HELPS PRY THE LID OFF TRUK

For Thomson Products Inc., a manufacturer of spare parts for planes, tanks and various vehicles, the artist has portrayed a mission carried out by a flyer who was a former employee of this company before the war. Thomas J. Humfrey, a corporal with the Marines, was part of the first photographic reconnaissance mission undertaken by two Liberators over the large Japanese base of Truk, on 4 February 1944.

When the war was over, he returned to his job within this company.

Life, 26 June 1944.

The Saturday Evening Post, 24 June 1944.

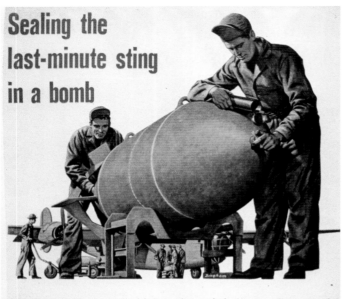

Sealing the last-minute sting in a bomb

A "block buster" bomb is harmless . . . until someone opens a "tin can."

This can contains the bomb's sting —a fuse. Without it no bomb can explode. At the last minute before a raid, the fuse is taken from the can and shoved into the nose of the bomb.

This fuse has to be *right* when it goes into the bomb. That's why it's packed in a can.

A damp fuse could turn a costly bomb into a worthless dud. But the

"bomb fuse" can, moisture-proof and air-tight, keeps each fuse safe and dry until it's needed.

Vital materials like this are riding off to war by the millions in America's favorite container. They — and the can—are working for American boys, helping them do a job and come out on top. The essential things you get in cans—food, fuel, medicine—are also going to the fighting fronts in cans.

Cans are tough. They don't break,

chip or tear. They protect against water, dirt, light, insects. Things get there—*safe*—in cans.

The can that goes to war today will be back again . . . guarding the things *you* depend on. It'll be better than ever, thanks to the experience we're gaining as packaging headquarters for the boys in uniform.

NOTE TO WAR MANUFACTURERS

Metal containers are delivering the goods safely—foods, supplies, and bullets arrive ready for action. Continental is making millions of these cans along with other war needs, including plane parts.

Yet, rushed as we are, we can still take on more! Right now, a part of our vast metal-working facilities for forming, stamping, machining and assembly is still available. Write or phone our War Products Council, 100 East 42nd Street, New York.

CONTINENTAL CAN COMPANY

It gets there—safe-in cans

HELP CAN THE AXIS—BUY WAR BONDS

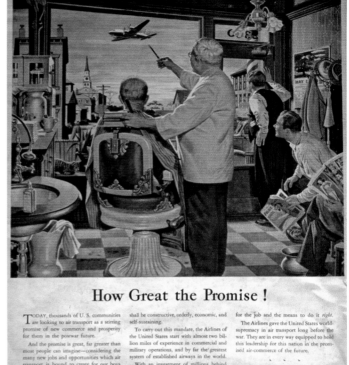

How Great the Promise !

TODAY, thousands of U. S. communities are looking to air transport as a stirring promise of new commerce and prosperity for them in the postwar future.

And the promise is great, far greater than most people can imagine—considering the many new jobs and opportunities which air transport is bound to create for our boys when they come back and for our country.

But implicit in the nation's faith in universal air transportation is the mandate that national and global expansion of services

shall be constructive, orderly, economic, and self-sustaining.

To carry out this mandate, the Airlines of the United States start with almost two billion miles of experience in commercial and military operations, and by far the greatest system of established airways in the world.

With an investment of millions behind them, they are prepared to invest many millions more in new facilities and giant fleets of faster planes.

Thus, they have the "know how" needed

for the job and the means to do it *right*.

The Airlines gave the United States worldsupremacy in air transport long before the war. They are in every way equipped to hold this leadership for this nation in the promised air-commerce of the future.

When you travel by Air make *reservations early please cancel early if plans change*. When you use Air Express *good delivery by dispatching shipments as soon as they're ready*. Air Transport Association, 1515 Massachusetts Ave., N.W., Washington 3, D. C.

THE AIRLINES OF THE UNITED STATES
LEADING THE WORLD IN AIR TRANSPORT

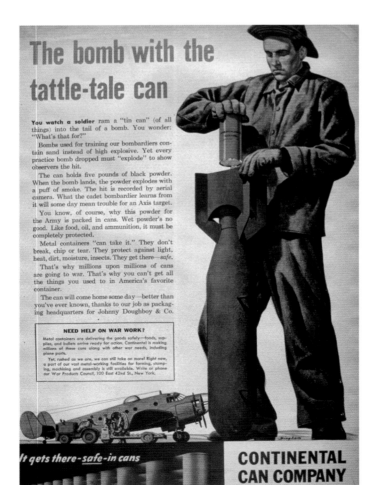

The bomb with the tattle-tale can

You watch a soldier ram a "tin can" (of all things) into the tail of a bomb. You wonder: "What's that for?"

Bombs used for training our bombardiers contain sand instead of high explosive. Yet every practice bomb dropped must "explode" to show observers the hit.

The can holds five pounds of black powder. When the bomb lands, the powder explodes with a puff of smoke. The hit is recorded by aerial camera. What the cadet bombardier learns from it will some day mean trouble for an Axis target.

You know, of course, why this powder for the Army is packed in cans. Wet powder's no good. Like food, oil, and ammunition, it must be completely protected.

Metal containers "can take it." They don't break, chip or tear. They protect against light, heat, dirt, moisture, insects. They get there—*safe*.

That's why millions upon millions of cans are going to war. That's why you can't get all the things you used to in America's favorite container.

The can will come home some day—better than you've ever known, thanks to our job as packaging headquarters for Johnny Doughboy & Co.

NEED HELP ON WAR WORK?

Metal containers are delivering the goods safely—foods, supplies, and bullets arrive ready for action. Continental is making millions of these cans along with other war needs, including plane parts.

Yet, rushed as we are, we can still take on more! Right now, a part of our vast metal-working facilities for forming, stamping, machining and assembly is still available. Write or phone our War Products Council, 100 East 42nd St., New York.

It gets there-safe-in cans

CONTINENTAL CAN COMPANY

James R. Bingham

SEALING THE LAST MINUTE STING IN A BOMB

The Continental Can Company made tins for numerous products, notably for a detonator that the armourers can be seen loading. In the background is a B-24 Liberator. This well framed and perfectly drawn illustration bears the signature of Bingham.

Newsweek (cut out), first quarter of 1943.

...

HOW GREAT THE PROMISE!

This Airlines of the United States advert takes us into a....hair dresser's in a small American town. The owner and his customers look up at the sky where a Boeing Stratoliner is flying. This composition is remarkably well illustrated and the artist received the Award for Distinctive Merit during the 1944 exhibition at the New York Art Director Club (23rd Annual of Advertising Art).

Newsweek, 24 January 1944, Cosmopolitan, April 1944.

...

THE BOMB WITH TATTLE-TALE CAN

An armourer at a United States training base, loads a black powder practice bomb. On impact, it emitted black smoke, allowing to see where it hit with accuracy. A Beechcraft Kansan AT 11 can be seen.

A Continental Can Company advert.

Newsweek (cut out), first quarter of 1943.

Brindle Melbourne, 1906-1995

Born in Australia, as his name suggests, he did not follow the usual path of the art student, but progressed by doing a variety of jobs until the day he was taken on by a San Francisco advertising agency. After his first black and white works, he began undertaking very in-depth drawings, exact to the smallest detail and very well drawn. He drew many preparatory sketches and was also a photographer, something that allowed him to build up a good foundation of documents. Later, he moved to New York where his friend, the well known artists' agent, James Monroe Perkins advised him to create colour illustrations, something that he then did with much talent.

He won an award at the annual New York exhibition at the Art Director Club in 1935 and 1938.

In 1940, he worked for Woman Home Companion magazine. At this time, other best selling magazines were trying to get him to work for them. He was also one of the illustrators for the famous Saturday Evening Post, for which we can mention the well illustrated "Eguitime Point" story published on 22 July 1944, based on aviation. During the Second World War he undertook an impressive amount of illustrations for adverts with an aviation theme, amongst his clients were, Martin Aircraft American Airlines Inc., The Airlines of United States, TWA, Grapefruit Juice, Borg Warner, Gruen Watch Company, Quaker State Motor Oil,

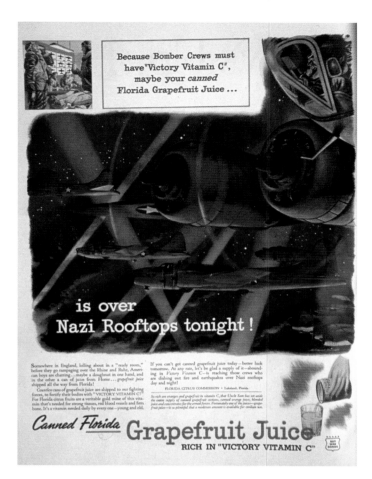

Melbourne Brindle

IS OVER NAZI ROOFTOPS TONIGHT !

B-17 Flying Fortresses arrive over their objective in Germany. The aviators look full of health, vitality and mental strength thanks to Grapefruit Juice and its victory vitamins.

Life, 10 May 1943.

James R. Bingham

READY... WILLING AND ABLE.

For The Airlines of United States, a quality illustration using the Douglas DC-3. This advert pays tribute to the civilian transport planes which, shortly after the attack on Pearl Harbor, were used by the military forces of the United States. "Ready...Willing and able."

Collier's, 23 October 1943.

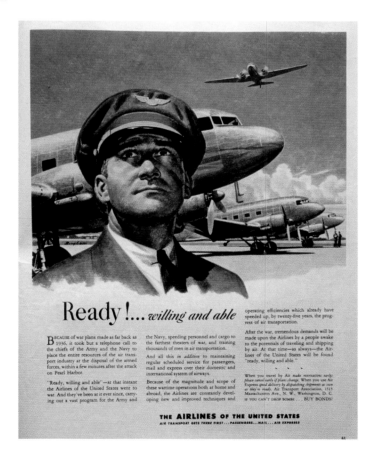

Lace for a Lady

Those ammunition links represent plenty of American ingenuity and production skill...

In the jungle heat, your armorer loaded the deadly "lace" aboard your P-38. Now you're helping to mother a flight of bombers.

Then—out of nowhere—Zeros!

You pick yours. As you press the firing button, the yellow ribbon of linked cartridges feeds into your nose guns. A jam here, and you'd be washed up. But there's never a hitch as you pour it on at the rate of 900 shells a minute.

Then your whole squadron starts scoring. The Japs—what's left of them—hightail it.

Yes, from cartridge links to planes, our fighters are getting the finest!

If a fighter's guns jam, he's really in trouble. To minimize this possibility engineers of the Spring Division of Borg-Warner have been at work on machine gun and cannon link problems since Pearl Harbor.

In cooperation with Army engineers, they have developed four new links. They have also had a part in the Army's program in producing a .50 calibre link of vastly improved performance.

To the making of these precision links, we apply the basic Borg-Warner idea: "design it better—make it better." Much of our peacetime growth is due to this

principle in our production of essential equipment for the farm and home and for the aviation and automotive industries.

So large and varied has been this production that there is reason to doubt that any American can go through a single day without benefiting from one or more Borg-Warner products.

Today Borg-Worner applies the principle of "design it better—make it better" to the production of more than 100 items for war.

ENGINEERING B-W PRODUCTION

BORG-WARNER

Peacetime makers of essential operating parts for the automotive, aviation, marine and farm implement industries, and of Norge home appliances . . . these units which form the Borg-Warner Corporation are today devoted exclusively to the needs of war: BORG & BECK · BORG-WARNER INTERNATIONAL · BORG-WARNER SERVICE PARTS · CALUMET STEEL · DETROIT GEAR AIRCRAFT PARTS · INGERSOLL STEEL & DISC · LONG · MARBON · MARVEL-SCHEBLER CARBURETER · McCULLOCH ENGINEERING · MECHANICS UNIVERSAL JOINT · MORSE CHAIN · NORGE · NORGE MACHINE PRODUCTS · PESCO · ROCKFORD CLUTCH · SPRING DIVISION · WARNER AUTOMOTIVE PARTS · WARNER GEAR · DETROIT VAPOR STOVE DIVISION

The Curtis Publishing Company, Alfred D. Mc Kelvy Company, Alcoa Aluminum, Chrysler, American Railroads, Old Grand-Dad...

He worked for large agencies such as Young Rubicam Inc. and Mac Cann Erickson Inc.

He was also a great car enthusiast and spent his rare free time restoring old automobiles. In 1971, he illustrated a remarkable book on the history of Rolls Royce that was published by Mc Graw-Hill.

His illustrations of wartime planes are in general successful in the field of realistic compositions.

Brown Reynold, 1917-1991

It was between 1940 and 1950 that the great many readers of magazines such as Life, Cosmopolitan and Argosy, discovered this great, talented artist. His aeronautical work subconsciously marked my youth and triggered an all consuming passion for American aviation of the Second World War.

In the 1930s, he worked on a comic strip as an assistant to Hal Forest. In fact, he did drawings that related the adventures of a young pilot, Tailspin

Melbourne Brindle

LACE FOR A LADY

For Borg Warner, a manufacturer of spare parts for weaponry, the artist of this advert has accurately portrayed the rearming of P-38 Lightnings based on an airfield somewhere in the Pacific. He has captured perfectly the task of the armourers busily working on their aircraft.

Fortune, May 1944.

..

This magnificent advert portrays a great moment in the history of commercial flight.

In 1935, Pan American Airways inaugurated the Transpacific- Almeda - Manila line. A magnificent four-engine Martin Clipper 130 flying boat, designed by Lester Milburn and DC Boulton, flew this route.

Three Martin Clippers were built : the China Clipper, the Hawaiian Clipper and the Philippine Clipper. Pan Am sponsored the manufacturer. The flight lasted five to six days, including the stopovers, and the twelve passengers flew in great comfort.

Fortune, July 1945.

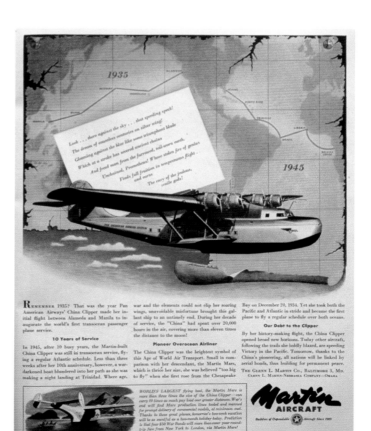

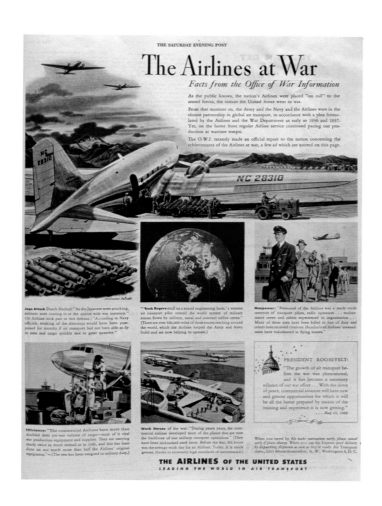

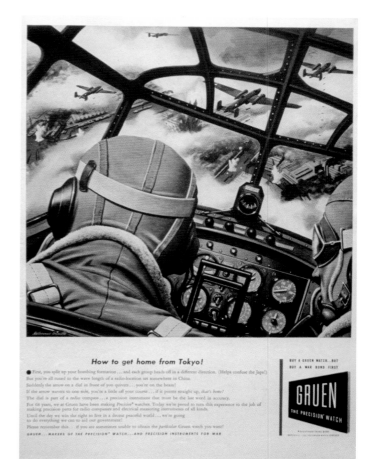

Melbourne Brindle

THE AIRLINES AT WAR

Melbourne Brindle portrays with talent real life events that took place during the Japanese attack on Dutch Harbor in the Aleutian Islands. Ten civilian DC-3 aircraft brought supplies for the American troops.

The Saturday Evening Post, 20 May 1944.

...

HOW TO GET HOME FROM TOKYO!

For Gruen, a precision watch maker, Melbourne Brindle illustrated the cockpit of a B-25 during the famous mission of 18 April 1942 which inspired the film "30 seconds over Tokyo", directed by Mervin Le Roy for MGM in 1944.

This composition, despite the quality of the drawing, is not very realistic: the flying suits, control panel, the overall shape of the Mitchells in flight. This shows that Brindle worked on this picture without having much documentation at hand.

Life, 21 September 1942.

Art Director: Daniel W. Keefe / Client: The Gruen Watch Company
Agency: Mc Cann-Erickson Inc.

...

THE LADY THAT NEVER GROWS OLD

The caption was not wrong ! The Douglas DC-3 made its maiden flight in 1935 and is still flying today with small airlines and is a favourite with aircraft collectors. This plane is far from having disappeared and has been flying for more than sixty years. This TWA advert portrays the seriousness and skill of the ground crews that work for this airline.

Collier's, 11 October 1944.

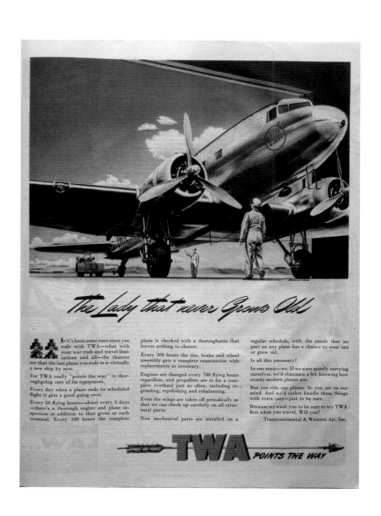

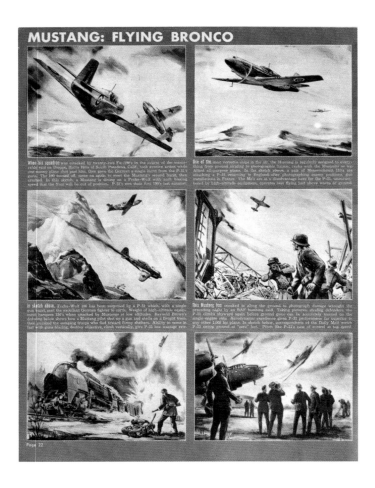

MUSTANG: FLYING BRONCO

Page 22

Reynold Brown

Above, the illustrator holds one of his printed pictures, "MUSTANG: FLYING BRONCO", in the **April 1943 issue of Air News.**

..

YANK PILOTS NICKNAMED IT "INVADER"

With this advert, North American Aviation wanted to highlight the capabilities of its A-36, designed by Edear Schmued, and which undertook its maiden flight in 1940. On 10 May 1942, the Mustang, flown by British pilots, was the first American made fighter to be based in Great Britain, from where it attacked German positions in occupied France. Flown by American pilots of the 12th Air Force, the A-36 flew their first combat sorties over Pandellaria, Italy on 6 June 1943. This was used by Reynold Brown to portray the A-36 in action. This plane was nicknamed, for a short time, the Invader by its pilots.

Collier's, 13 November 1943.

Tommy, continuing it for several years between 1937 to 1941 upon the completion of his high school studies. In France, in 1936, Tailspin Tommy appeared under the name of Jean Bolide in issues one to ninety-eight of the famous Robinson comic. He appeared in Bilboquet (1938) under the title of "Jean Reid l'audacieux". He was seen in the "L'Audacieux, in Aventures (L'Ile céleste, Le Rayon invisible) then, in 1937 and 1938, in Jumbo and L'Aventureux in 1940. He then worked with the great Norman Rockwell for whom he undertook lettering work. Working with an artist like Rockwell could only be positive for his own future work and gave Reynold Brown the skill of precision in movement that we see in his work. On Rockwell's advice, he gave up comic strips and became an illustrator.

For the aviation industry during the war, he was one of the talented illustrators lured by North American and for whom he illustrated many adverts and aircraft cut-aways such as the P-51 Mustang that were published in several magazines of the period and even to this day. He worked for North American's Skyline Magazine, creating very beautiful illustrations of the P-51 and B-25 that promoted the qualities of these historic aircraft.

It was in Flying magazine in 1945, that I discovered and admired his work for many hours at an end, something I still do. In this magazine he drew the P-38 and P-47 as well as other aircraft that were perfect illustrations. He also made a very beautiful series of illustrations on the Battle of Britain. An artist of varied talents, he was skilled in many domains. In the 1950s he became one of Hollywood's great poster artists, creating more than two hundred, amongst which were "The four horsemen of

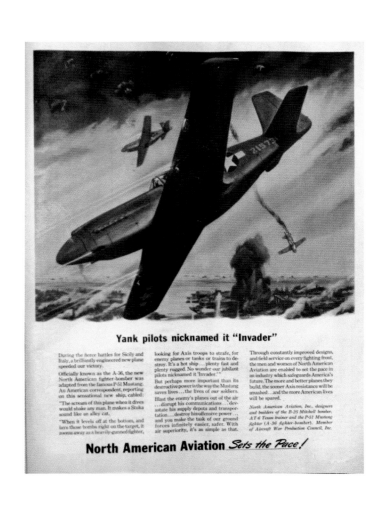

Yank pilots nicknamed it "Invader"

North American Aviation *Sets the Pace!*

the apocalypse" and " Doctor Zhivago". Later, as a teacher at the Art Center College of Design at Los Angeles, he taught Dru Strusan, the creator of the "Star Wars" and "Indiana Jones" posters. Throughout his life he undertook an impressive amount of work before finishing his days surrounded by his family at Whitney, Nebraska.

Clymer John, 1907-1989

Born in Ellensburg, in Washington State, he studied art at the Vancouver School of Fine Art in Canada, then at the Grand Central School of Art in New York. He first began illustrating for Canadian publications before working next for several magazines in the United States. Amongst his work are front covers for the Saturday Evening Post.

He also contributed to advertising campaigns, notably for Caterpillar and RCA. He also took part in the recruitment campaign for the air forces and painted a series of illustrations for the Marine Corps.

His excellent photography skills allowed him to accumulate a large amount of documentation related to the subjects he drew and painted. He was also one of the great artists that portrayed the American west. He would undertake preparatory sketches before beginning the piece of work to be published. His worked featured in many exhibitions in Canada and the United States and he won numerous awards throughout his extraordinary career.

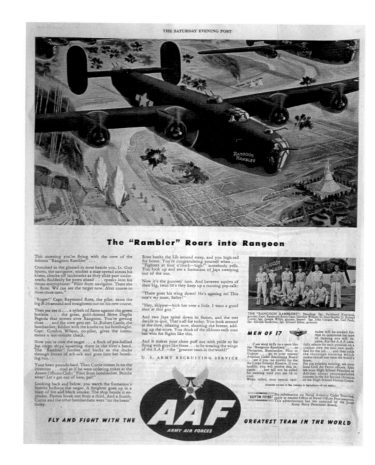

John Clymer

THE "RAMBLER" ROARS INTO RANGOON

This AAF - Army Air Forces - advert shows us the 10th Air Force B-24 "Rangoon Rambler", whose mission it was to destroy Japanese supply barges in Burma. The text introduces the crew and tells the story of the mission and is written in the style of a newspaper article with numerous details . A photo of the plane's nose and the crew authenticates this historic event. The illustration, which is unsigned, appears to be by Clymer.

The Saturday Evening Post, 15 May 1944.

. .

YOU'LL GO PLACES ON THIS TEAM!

The crew of a 8th Air Force B-17 Flying Fortress prepares for a mission in front of their aircraft, named "Winsome Winn", based in Great Britain. Their objective is to destroy a German factory making the formidable FW 190 fighters that are giving the allied bomber squadrons a hard time. This AAF propaganda advert gives the names of the men that took part in this raid, describes the action and pays tribute to them. They are just some of the unknown men fighting for victory.

The Saturday Evening Post, 29 July 1944.

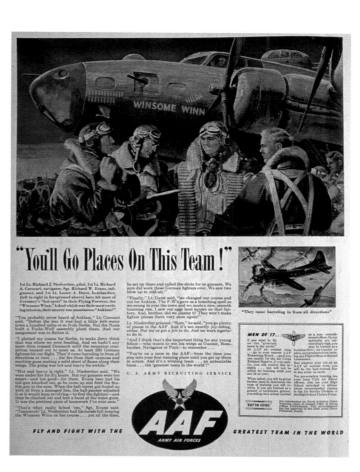

Coggins Jack, 1911-2006

During the war, he was part of the Yank team, the American Army magazine. This painter-illustrator stands out due to his spirited and highly realistic drawings and paintings.

Cornwell Dean, 1892-1960

When one entered Dean Cornwell's studio in New-York, the eye was caught by a large sheet of white paper placed on a drawing board surrounded by ten or twelve charcoal sketches, these being the preparatory drawings of the subject he was going to work on.

The flying fish with a steel lung

FIRST it flies. Then it swims. And anything it hits goes boom!

It's Uncle Sam's aerial torpedo. The kind our torpedo bombers are using these days to deal out grief to Axis ships.

Inside this "flying fish" is a steel lung, full of compressed air. When the torpedo is released, the compressed air drives it viciously toward its target.

A special kind of steel is needed to make the steel lung. It has to be thin and light to help reduce to a minimum the load the torpedo plane must carry. And it has to be very strong—to withstand air pressure of many hundreds of pounds per square inch.

The special steel for the lungs of aerial torpedoes is just one of the many developments that have emerged from United States Steel laboratories to help win the war.

You've read about some of the others: special steel springs for torpedoes and bombs; portable steel landing mats for bombers; new steels for aviation; tin plate, made with only a fraction of the precious tin once needed.

Will they benefit you after the war?

You can be sure they will. For then the new steels inspired by war will be ready to serve you in a thousand peacetime products . . . from lawn mowers to skyscrapers. You'll find that the U·S·S Label means more than ever on the goods you buy. And that no other material rivals steel in usefulness and long-range economy.

NEW STEELS FOR AMERICA

BUY WAR BONDS EVERY PAYDAY
The money you loan builds America's war strength. Yours again to spend in years to come . . . for new comforts, products of steel, things for better living.

AMERICAN BRIDGE COMPANY · AMERICAN STEEL & WIRE COMPANY · BOYLE MANUFACTURING COMPANY · CARNEGIE-ILLINOIS STEEL CORPORATION · COLUMBIA STEEL COMPANY · CYCLONE FENCE DIVISION · FEDERAL SHIPBUILDING & DRY DOCK COMPANY · NATIONAL TUBE COMPANY · OIL WELL SUPPLY COMPANY · TENNESSEE COAL, IRON & RAILROAD COMPANY · TUBULAR ALLOY STEEL CORPORATION · UNITED STATES STEEL EXPORT COMPANY · UNITED STATES STEEL SUPPLY COMPANY · UNIVERSAL ATLAS CEMENT COMPANY · VIRGINIA BRIDGE COMPANY

UNITED STATES STEEL

Jack Coggins

THE FLYING FISH WITH A STEEL LUNG

This advertising illustration for United States Steel shows a US Navy Avenger attacking a Japanese aircraft carrier with torpedoes.

Jack Coggins has drawn this action from an unusual angle with a well rendered movement and vigorous touches of colour.

Collier's, 26 August 1943.

This great artist was born in Kentucky and studied art in New York and at the Leonia school in in New Jersey where his work was much liked. Later, he passed on his experience to talented students such as Saul Tepper, Mead Shaeffer and Dan Content, future members of the family of great illustrators.

In 1916, at the age of 24, he made his first illustrations for The Saturday Evening Post and continued working for this magazine until 1919. At the age of 26, he was offered a large contract by Cosmopolitan. He also studied painting in fresco, a technique that matched his temperament perfectly and he left for England to work under the direction of the great master of the fresco, Frank Brangwyn.

Upon returning to the United States, he undertook some grandiose works, some of which were for the The Public Library of Los Angeles and in New York, for the Eastern Airlines Office at the Rockefeller Center. In the 1930s he was an illustrator for the following magazines: Red Book, Harper's Bazaar, The American, Cosmopolitan, illustrating the texts of prestigious authors such as Pearl Buck, Somerset Maugham and Ernest Hemingway. His technique comprised of several stages: he began by drawing numerous sketches in pencil or charcoal, followed by several watercolour studies. Next, friends, often illustrators themselves, posed for him as he photographed them in various postures. Some photos were projected onto the canvas and he then drew the general outlines. Finally, it only remained to paint the picture in oils. During the course of his extensive travels he bought many objects that he used as models in order to recreate the precise detail of an object in a painting.

When we admire a Dean Cornwell painting, we notice the precise brushstrokes and the excellent choice of lighting that softens or dramatizes a subject. The harmonious colours are carefully chosen according to the theme of the picture. His works give off an impression of power. Today, however, some illustrations can appear a little rococo, but we should remember those that marked their time and that have crossed the years. His

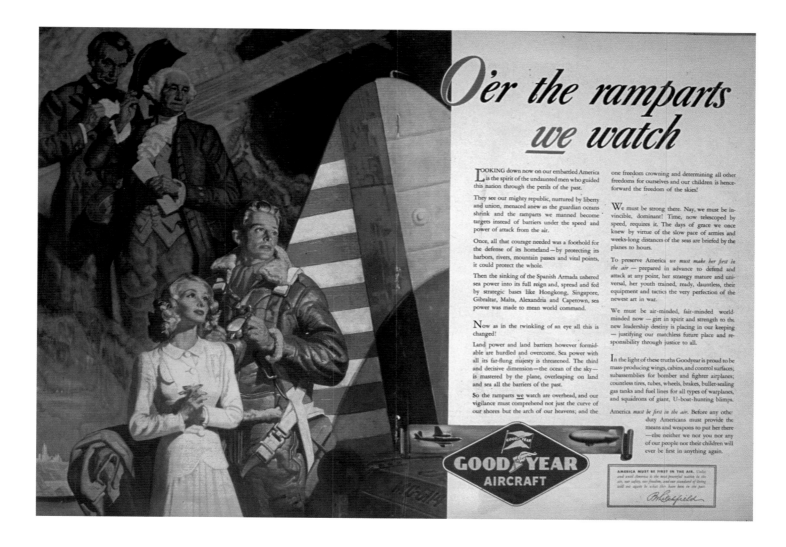

Dean Cornwell

O'ER THE RAMPARTS WE WATCH

This Good-Year Aircraft advert was published in **Life** on **16 November 1942,** and the artist, Dean Cornwell, gave full rein to his great talent. It is a powerful, moving painting, made in the pure tradition of a great heroic fresco. It conveys strength and an anguish that must be tamed.

The style and quality of the painting is reminiscent of the great Norman Rockwell. For the Americans at this time, they were at the start of the war with great victories a long way off and they needed motivating. The huge war machine was starting to move and a whole nation was working together with its allies with one aim, to defend freedom !

...

HANDS ACROSS THE SKY

This Fisher advert, where the artist once more expresses the precision and strength that characterises his work, portrays research and technology, or in other words, progress.

A researcher huddled over his microscope symbolises this impetus, whilst a pilot dressed in his flying suit looks up at a formation of B-25 Mitchells. All of these skills are focused on one goal: victory !

Life, 24 January 1944.

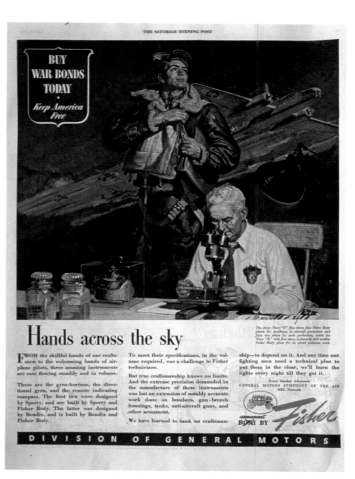

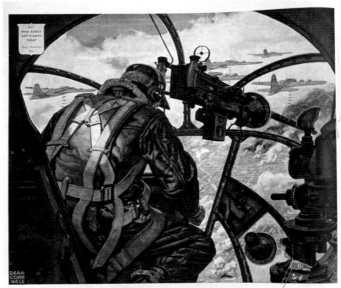

Dean Cornwell

STRAIGHT STEER

After long hours of flying over dangerous enemy territory, the Flying
Fortresses arrive over their target. The bomb aimer, positioned in the
Perspex nose of the aircraft is huddled over his Norden bombsight. The
countdown has begun. In a few seconds he will empty the B-17's bomb
bay. In this painting, the artist has recreated this tense moment. The
quality and talent of the artist is characterised by the light, the
highlighting of the reflections on the aviators leather jacket and the
accuracy in the details. This advert promoted the quality of the Fisher
made products, the one here being the bombsights.

Life, 16 September 1943.

...

STRICTLY SUPER

The end of the war is not far off. Somewhere in China, a group of B-29
Superfortresses takes off and heads towards its target, under the
enthusiastic and smiling gaze of an air force pilot, accompanied by a
young Chinese boy making the famous V-for Victory sign.

This advert was not only for the promotion of Fisher products as it also
bears a text asking people to speed up the end of the war by buying war
bonds.

Life, 2 April 1945.

...

(FOLLOWING PAGE)

ON EVERY FIGHTING FRONT

For Fisher, Dean Cornwell painted a powerful composition that
characterises the first hours of a landing. The slightest details are
accurately rendered. The amount of materiel is impressive and the
movement of the action treated with vigour. The hell's breath is present in
this fierce battle. The sky is filled with black smoke, fires are burning and
the ground churned up by the explosions. This painting could be from a
heroic panorama. In this painting, the artist has certainly done the job that
Fisher asked him to do.

Life, 24 January 1944.

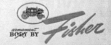

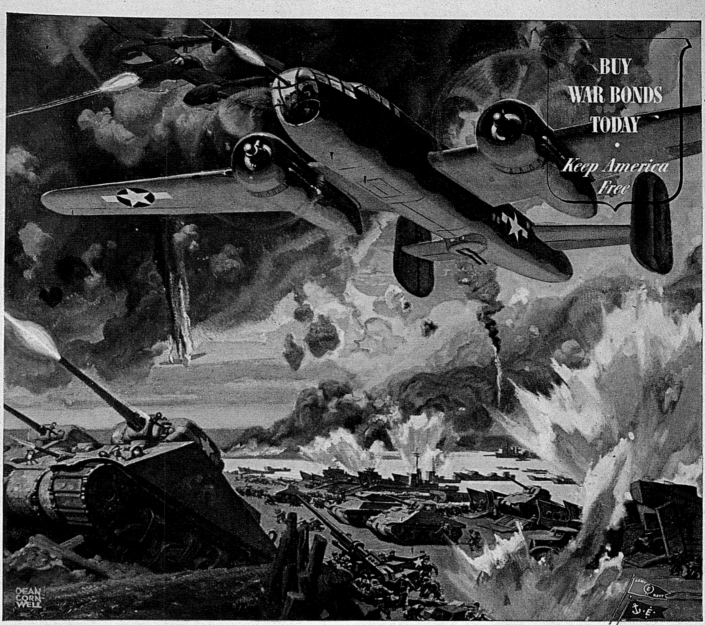

The Army-Navy "E" flies above four Fisher plants for excellence in aircraft production and from two others for tank production, while the Navy "E," with four stars, is flown by still another Fisher plant for its naval ordnance work.

On every fighting front *Fisher*

THE men who do the fighting, whether on land, sea or in the air, know how important it is to have the best equipment.

They realize that the work we do in our factories can, if done well enough, give them a combat advantage.

We realize that, too. That's why we are devoting all the skills we have developed, all the crafts we have mastered, to give our armed forces the all-important edge.

Whether it's a plane, an anti-aircraft gun, a tank, or a highly sensitive flying instrument, each gets every technical plus we can give it — and that's several.

Craftsmanship is a Fisher tradition. And today we believe craftsmanship carries a particular punch of its own to give a fighting man a break when a break is more than welcome.

Every Sunday Afternoon
GENERAL MOTORS SYMPHONY OF THE AIR
NBC Network

armament
BODY BY *Fisher*

DIVISION OF GENERAL MOTORS

117

Douglas Crockwell

HAVE A COCA-COLA = HOWDY, NEIGHBOR

Here we are in a small American town drugstore with the Coca-Cola
dispenser clearly shown. A young boy and his family listen with great
interest to a fighter pilot captain as he explains a dogfight he was
involved in. The teenage employee follows the conversation, fascinated
by his elder's exploits. This advert is admirably composed.

Life, 5 June 1944.

work remains much liked by art lovers in the United States and
it is true to say that the slightest sketch is a work of art. He
illustrated many adverts published in magazines such as Life,
The Saturday Evening Post, Collier's… and worked for
Coca-Cola, Seagram, Good Year, Pennsylvania Railroad, Wieth
Co and many other companies. When the United States declared
war, he put his hand to posters, especially with a successful series
for Fisher (a subsidiary of General Motors). Several illustrations
are based on aviation. According to what he was asked for, he
made sketches that he showed to the army before beginning the
definitive work. For reasons of national security, not everything
could be shown as censorship was very active. The various
military services for whom he worked, would give him photos
or show him films. Armed with this information and respectful of
reality, he would then express his own vision.

His work was rewarded with numerous awards. He was
president of the Society of Illustrators between 1922 and 1926 and
taught illustration techniques at the Art Students League of
New-York. Dean Cornwell was a hard working artist who
produced a vast amount of work, both in quality and quantity.

Crockwell Douglas, 1904-1968

His illustrations were signed Douglas or just with a D in order
to avoid confusion with the master of American illustrators,
Norman Rockwell. The decision to do this was taken when, in
1933, he began illustrating the front covers for The Saturday
Evening Post. He would make many others during the course of
his career.

Born in Columbus, Ohio, he studied at the Academy of Fine
Art in Chicago and in Saint Louis. A painter-illustrator, he took
part in numerous advertising campaigns for De Soto, Coca-Cola,
Grace Line, Republic Steel Corporation, General Electric, Hearst
Enterprises, Good Year…

He also worked a lot for Walter Thomson Co, as well as doing
murals, but also experimental animation films that can be found
in the Department of film and video of the Museum of Modern
Art. His style, that made him one of the great American painter-
illustrators, was rewarded with the medal of the Art Directors
Club in 1943, 1945 and 1946.

Davis Wayne Lambert, 1906-1988

This watercolour artist made an large series based on the
Hellcat in action for the Grumman company.

Dorne Albert, 1906-1965

This New Yorker was born into a very poor family not far
from Brooklyn Bridge. His childhood was beset with heart
problems and he also had to be treated in a sanatorium for
tuberculosis. The success of this much talented artist is the result
of both exemplary courage and willpower. At the age of 17, he
wanted to study art under the guidance of Saul Tepper who,
sadly at this time, could not afford the services of an assistant.

Albert Dorne then offered him a place as an errand boy in
exchange for drawing lessons. In order to make ends meet, he
had a variety of jobs before becoming an advertisement

illustrator. This hard working artist, with a gift for keen observation, would eventually reach the top rung of his profession.

His style is very easily recognisable as it often close to caricature whilst retaining a great realism in the details of objects and machines. He used all of the techniques available to an artist and had a preference for colour inks. Amongst the large agencies for whom he worked, we can mention Geyer Corwell, Newell Inc., Mac Cann Ericson Inc., and the Irwin Wasey Co, Agency.

He also illustrated advertisements for many companies such as, The Axton Fisher, Tobacco Co, Conoco (Continental Oil Cy), Reverse Copper and Brass Inc., Hiram Walker Inc., Coca-Cola, Socony Vacuum, Chrysler, Sanka Coffee, Anheur, Bush, Frigidaire Division of General Motors, BF Goodrich and American Airlines Inc.

As an illustrator, he worked for the inescapable Saturday Evening Post and Look. He also took part in a series that portrayed feats of arms by American heroes of the Second World War.

In 1948, this great cigar lover founded the famous Westport school of art in Connecticut.

U. S. Navy's Grumman Night Fighters Hit Tokyo
F6F-5N Grumman Hellcats

Wayne Lambert Davis

US NAVY'S GRUMMAN NIGHT FIGHTERS HIT TOKYO

For Grumman, the manufacturer of the Hellcat, the artist takes us into a lightning attack by Hellcat F6F 5N night fighters as they destroy a formation of Japanese aircraft. Designed by W.T. Schwendler, the Hellcat first flew in 1942.

Flying, July 1945.

..

Albert Dorne

"YOU OUGHT TO SEE THE *OTHER* GUY!"

This happy bomb aimer, back from a successful training flight, climbs down from a Beechcraft Kansan AT11 (recognisable by the shape of the door). He has a magnificent black eye, in fact a mark caused by the protective product made by Socony Vacuum and which covered the bombsights eyepiece.

Fortune, May 1943, Flying, July 1945.

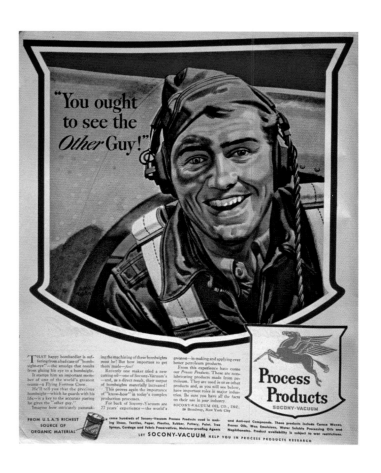

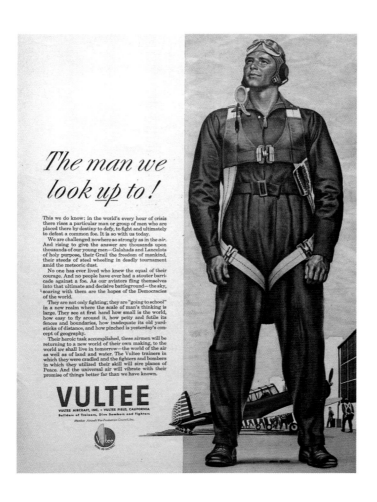

Falter John Philip, 1910-1982

John Falter was born in Plattsmouth, Nebraska. His father, H. Falter, a businessman in Atchinson, Kansas, saw that his son had a talent for art, but said that he would not be an artist until he had made the front cover for The Saturday Evening Post.

A few years later, this was achieved and John even surpassed his father's expectations as, during the course of his career, he went on to publish no less than two hundred front covers portraying his favourite theme of intimate snapshots of life in the countryside, villages and towns. At the age of 20, he sold his first illustration to the Liberty newspaper. However, in his youth, John Falter had a clear preference for mural paintings. His idol was the boxer Jack Dempsey and he made a fresco on one of his fights on the only available place, a garage wall. He even painted Dempsey's victory over Tunney before it happened, something that made him well known locally.

He then began serious art studies at the Kansas City Art Institute and in New York, at the Grand Central School of Art. During the war he served in the Navy as a boatswain. Later, after being promoted to lieutenant, he was tasked with many artistic jobs. Some of his wartime work was for adverts for Pall Mall (1940), Vultee Aircraft, Canned Florida Grapefruit Juice, Gulf Pride Oil, Four Roses Frankfor Distilleries, Magazine Publishers of America, Esquire... One that stands out is a portrait of Clark Gable in his flying suit that made the front cover of Look on 29 March 1943 (see page 15), or the poster portraying a sailor designed for the Security of War Information Committee. This talented artist showed great skill in illustrating a variety of subjects, with a precision in the machines, people, various accessories that made up well balanced compositions. After the war, he illustrated more than forty books for Reader's Digest. We owe to him the portraits of Admiral Halsey, Louis Armstrong,

John Philip Falter

THE MAN WE LOOK UP TO!

This excellent Vultee Aircraft advert shows us a training base for military pilots. The proud instructor looks up at the sky where his trainee pilots are flying. Behind him, a formation of Vultee Valiant BT 13 aircraft are ready for take off. This plane, whose maiden flight took place in 1939, was used to train many pilots.

Life, 28 September 1942.

Art Director: Franklin D. Baxer / Client: Vultee Aircraft Inc.

Agency: Ruthrauff-Ryan Inc.

..

A QUESTION FOR A MAN ARRIVING ON THE CLIPPER

This scene takes place shortly after America's entry into the war. Arriving in England after a comfortable trans-Atlantic flight on board a Boeing 314 Clipper, a journalist signs the praises of "Four Roses" bourbon. This aircraft made its maiden flight on 31 May 1938. It was delivered to Pan Am in 1939. Twelve of these aircraft were made.

The American, February 1942.

Art Director: Herbert Bishop / Client: Frankfort Distilleries Inc.

Agency: Young-Rubicam Inc.

Olivia de Havilland and James Cagney. John Falter was a member of the Society of Illustrators, but did not often exhibit his work. The amount of work he produced was, nevertheless, large, as can be seen by the paintings displayed in several museums or in private collections.

Freeman Fred L., 1906-1988

During the Second World War, this artist, a reserve officer with the US Navy, commanded three ships and took part in the operations at Guadalcanal, the Aleutians, Saipan and Guam.

An excellent illustrator, he worked with big magazines such as The Saturday Evening Post and Collier's.

Gannam John, 1907-1965

Growing up in Chicago, he had to leave school at the age of 14 following the death of his father, carrying out a variety of small jobs before becoming an errand boy for an engraving workshop. He was endowed with a sharp sense of observation and studied art by himself. Exceptionally talented, he became a great watercolour artist.

When one looks at his preparatory studies, painted in watercolours, one is struck by the spontaneity and precision of the brush strokes. The characters are perfectly rendered, as are the objects, machines and decor. His work reflects a strong personality. In New York, upon the request of Henry Quinam of Woman's Home Companion of the Crowell Collier Publishing Company, he undertook his first compositions, then soon began working for other magazines such as The American and Cosmopolitan. He also took part in numerous advertising campaigns for the Air Transport Association, RCA, The Air Lines

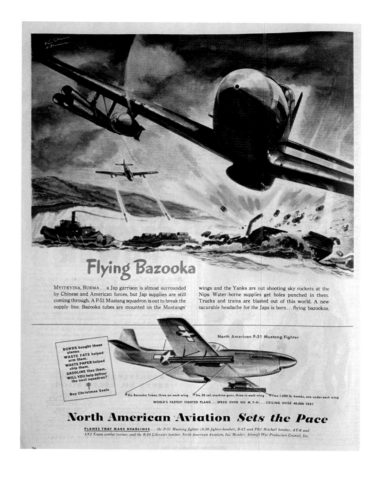

Fred L. Freeman

FLYING BAZOOKA

This North American Aviation advert was inspired by real events that took place in Myitkyina, Burma. A Japanese garrison, almost overcome by Sino-American forces, continued to receive supplies via the river, but these were destroyed by rocket equipped P-51 "Flying Bazooka" Mustangs.

This illustration shows the P-51 in a flare manoeuvre that highlights the power and elegance of this aircraft.

Collier's, 30 December 1944.

. .

John Gannam

YOUR WAR BONDS WILL BUY…

This RCA advert bears the signature of a famous watercolour artist. The action filled illustration shows A20 Havocs attacking a surfacing Japanese submarine at low altitude in the Pacific. This Douglas made aircraft was designed by E.H. Heinemann and undertook its maiden flight in 1938. From the outset of the fighting, it was active on all fronts and achieved great success.

As a contrast to the previous illustration, the peacetime image shows a family listening to its radio-gramophone and relaxing in a comfortable living room. **Life, 14 February 1944.**

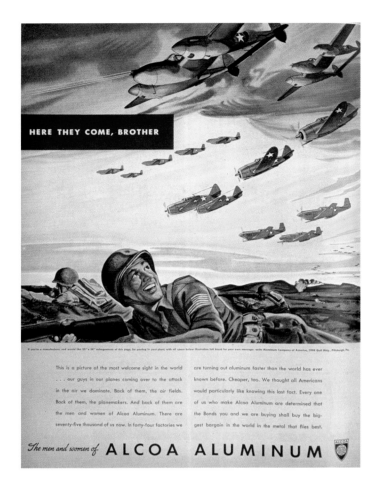

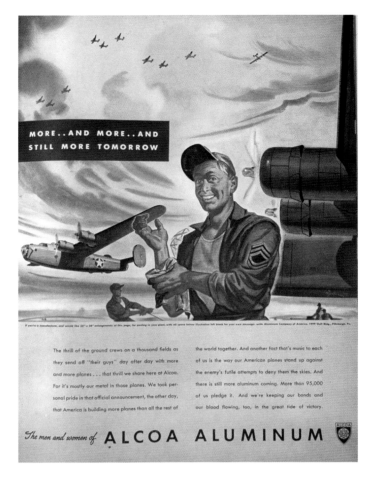

of United States, Stromberg Carlson, Gruen Watch Company and Pacific Mills.

His watercolours were well received in several exhibitions and he was a member of several societies.

Gicha

During the war, his signature appeared on advertisements placed in numerous magazines for Alcoa Alumine, with aviation being the recurring theme. He also worked for the H. H. Robertson Company and Westinghouse.

His advert illustrations were undertaken in watercolours and were very spirited in style.

Godwin Frank, 1889-1959

Born in Washington State, Frank Godwin had the great advantage of having a father who was the editor of the Washington Star. As a young man, he served his apprenticeship with this newspaper, before studying at the Art Student League. After a first paid illustration in New York, his illustrations appeared in Liberty, Cosmopolitan, Collier's and other magazines. He also made advertisement illustrations for Texaco, Prince Albert, Coca-Cola et Armstrong Cork Company of which Newsweek published a large series.

He was a great comic strip artist too, thanks mostly to two series : Connie and Rusty and Riley. In France, Connie was published before the war, in 1938, under the name of Cora or Diane in Mickey. She was a great pilot always caught up in

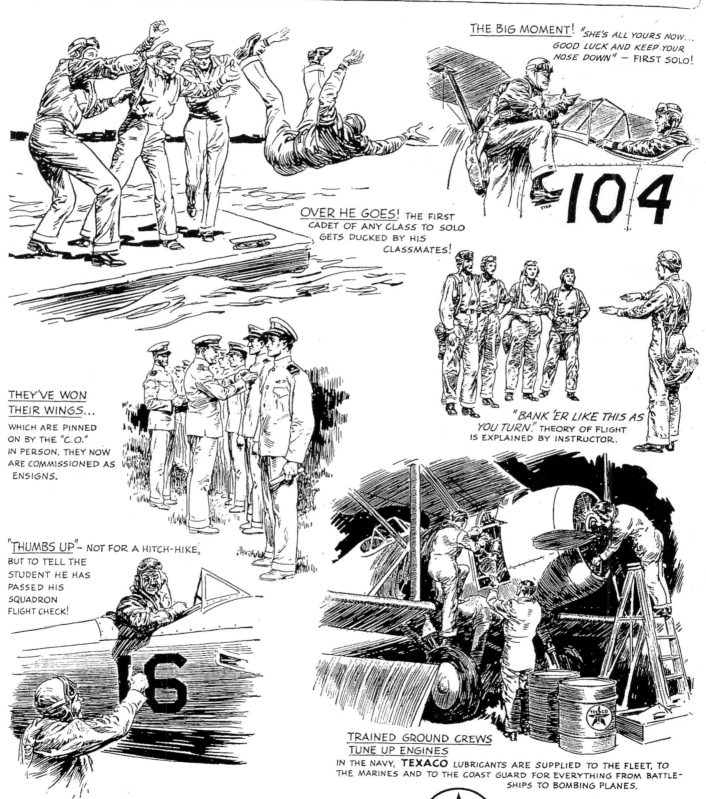

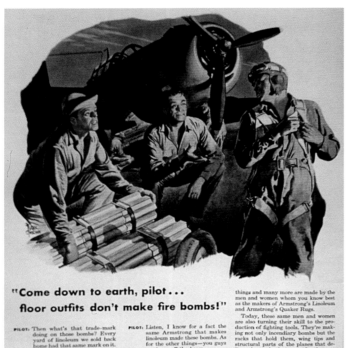

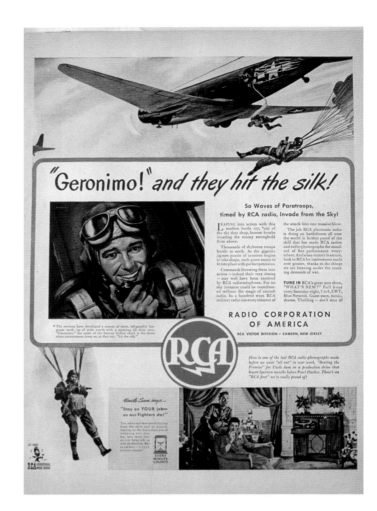

Frank Godwin

"COME DOWN TO EARTH, PILOT...

This Armstrong Cork Company advert uses an aviation theme. A crew prepares for a mission in front of a Vultee Vengeance A31. The scene is accurately portrayed. The illustration was inspired by a colour photograph which was used for two adverts, one for Vultee Aircraft published in the Newsweek of 13 October 1941, the other for Kodak published in the 12 April 1943 issue of Life.

Newsweek, 2 August 1943.

..

John F. Gould

"GERONIMO!" AND THEY HIT THE SILK!

This RCA advert, a maker of radios and record players, alternates several images of war and peace. Using the theme of paratroopers, the illustrator, in an excellent layout, shows, at the top, men jumping out of the famous transport plane, known in the United States as the USA C-47 Skytrain, and as the DC-3 Dakota in Great Britain. Close up in the centre, a pilot gives the green light to jump. At the bottom right hand side, a moment of well earned relaxation during a period of leave, with a paratrooper and his wife in their nice living room, listening to their favourite records on a well-made RCA pick-up.

Life, 27 December 1943.

mysterious adventures. Rusty Riley appeared in Donald, in the 1950s, under the name of Bob Riley.

Gould John F., 1906-1996

Born in Worcester, Massachusetts, he studied art at the Tiffany Foundation, whereupon he qualified at the Pratt Institute where he taught for twenty-two years, as well as in other establishments such as the Newark School of Fine Art and Industrial Art.

He illustrated numerous detective novels, before working for the famous Saturday Evening Post.

Amongst the many illustrations he made for this magazine, we can mention four aviation themed stories, On the nose (4 September 1943), Letter from Mary (5 January 1943), Where the buffalo roam (13 March 1943), 18 Men and a boat (19 December 1942).

His work appeared in Collier's and Red Book and he also worked a lot in advertising. Some of his clients included, Radio Corporation of America (RCA), Consolidated Vultee Aircraft, Curtiss Wright and Fiberglas. The work of this talented watercolour artist is in many collections.

Grohe Glen, 1912-1956

Grohe was born in Chicago where he studied at the Art Institute and the American Academy of Art. In 1937, he obtained his first job at the Swann Studio. Next, he left for New York where he joined a team of advertising illustrators. A little later, we find him at the Charles E. Cooper studio.

(PREVIOUS PAGE)

John F. Gould

''CHALK UP ANOTHER DEAD DUCK, JIM!''

In this illustration, a US Navy pilot announces over the radio the destruction of a Japanese aircraft carrier by torpedo planes. In the second picture, a couple in their living room listen to the latest news. This RCA advert highlights the importance of radio communications in combat zones and within American families.

The Saturday Evening Post, 23 October 1943.

...

Glen Grohe

THAT'S US YOU'RE GIVING THE FLAG, MISTER

Facing the wind, a carrier-borne squadron of Grumman Wildcats prepares for take off. Glen Grohe has captured the exact moment when the deck officer lowers the flag to signal take off.

This small carrier-borne fighter was in the fight from the outset, gaining its reputation at the hands of Navy and Marines pilots. It fought with distinction during the battles of Midway, Coral Sea, Gilbert Islands and at Guadalcanal in the South Pacific. Designed by William T. Schwendler, it made its maiden flight in 1931. This advert could be acquired in poster format by manufacturers if they so wished.

The Saturday Evening Post, 4 October 1942.

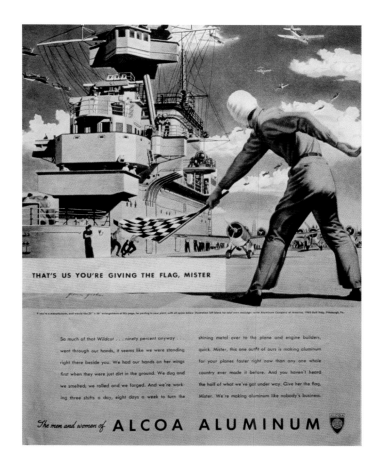

Glen Grohe

BELLY GUNNER'S PRAYER AT 50 BELLOW

Seen here is the belly turret of a B-17 illustrated for United Steel. It could be thought that this was the most dangerous place to be during aerial combat, but it was not. The gunner was protected by armoured plating and he could communicate with the crew via an intercom. In the event of a serious problem, the turret pivoted to allow him to regain the inside of the aircraft. The most dangerous positions were those of the waist gunners. **The Saturday Evening Post, 13 March 1943.**

...

(FOLLOWING PAGE)

William Heaslip

Two adverts painted for "Coca-Cola". They show the P-40 E and the Martin Marauder.

He came to the attention of artistic directors of magazines due to the originality and creative strength of his advertisements. He thus worked, as an illustrator, with the big magazines such as The Saturday Evening Post, This Week, Cosmopolitan and Good Housekeeping.

He designed averts for the Don Chemical Company, Conoco, Travellers Insurance, Sylvania Electric Product Inc., John B. Stetson, Good Year, Stewart Warner USS Steel, Alcoa Aluminum, Martin Aircraft, Pullman, Kuppers, Borg Warner and Ethyl Corporation. In fact, Glenn Grohe dealt with a whole range of subjects and excelled in different styles; often depending on the subject. He drew a lot of preliminary sketches that became more and more evolved before starting the final piece of work. He mostly worked in tempera, but with certain subjects preferred using oil paints. His agent was James Monroe Perkins who had other prestigious artists on his books such as, Melbourne Brindle, Atherton, Robert Riggs and John Wickery.

Glen Grohe had a passion for photography and cinema. He made a documentary on paintings and drawings made by the mentally ill in a hospital shortly before his death.

Heaslip William, 1898-1970

Born in Toronto, Canada, as a young boy he had already decided that he wanted to be an artist. He served a five-year apprenticeship as a lithographer. During the First World War he enlisted in the Royal Flying Corps, showing an interest in flying and aeronautical subjects. After the war, he went to live in New York and studied at the Art Student League and the National Academy of Design. In 1920, he received his first award for a pencil drawing.

Cy Caldell, an aviation writer, paid tribute to two American aviation artists: William Heaslip and Clayton Knight, whom he considered as being the greatest of their generation due to their talent, the quality and movement of their compositions and the realism of the aircraft.

In 1928, the Berry Loid company ordered a series of fourteen colour illustrations that were published as posters in the best known aviation magazines. The planes were camouflaged in the colours of birds' feathers. Heaslip worked for the Shell Oil Company, the adverts of which appeared in several magazines. During the Second World War, he illustrated propaganda adverts for the US Air Force and the Bellanga and Aerols companies. Upon the request of Coca-Cola, he illustrated five advertising campaigns portraying American aircraft either flying alone or in combat. These sequels were made up of 38 x 33 cm boards supposed to be hung up in drugstore windows.

The first series was published in 1941 before Pearl Harbor, the second in 1943, comprising of two sequels, the fourth in 1944 and the fifth in 1945. Heaslip worked with aviation magazines and magazines such as The Saturday Evening Post, Collier's, Boy's, Life, Liberty, The New York Times and Skyways.

In the 1940s, when one entered his studio situated in 54th Street, New York, one would see a huge, well-lit room with a large ceiling window. His workplace was furnished with a few chairs and a divan, easels and drawing-boards.

Curtiss "Warhawk" P-40 Pursuit • U. S. Army Air Force
Attacking Zeros in Pacific Theatre

Martin "Marauder" B-26 Medium Bomber • U. S. Army Air Force
Skip bombing enemy objectives

William Heaslip in his studio.

(FOLLOWING PAGE)

Lloyd Howe

CURTISS-WRIGHT SALUTES THE FLYING TIGERS

Like birds of prey, the P-40B Tomahawks dive down onto the Japanese bombers. The manufacturer of this aircraft, Curtiss Wright, played a vibrant tribute to the Flying Tigers. This advert was painted in watercolours by this company's P-40 illustrator. A telegram sent by General Chennault thanked the manufacturer for this aircraft's performances. The P-40 Tomahawk flew for the first time in 1939. It was designed by Don R. Berlin.

Flying, October 1942.

...

WARHAWKS FOR VICTORY

The history of the Curtiss P-40 E, a plane that was in the fighting from the outset, is filled with all sorts of adventures and exploits. It was immortalised in comic strips, newspapers and movies. For Curtiss Wright, L. Howe has portrayed a victorious dogfight against Japanese aircraft shortly after America's entry into the war.

Flying, August 1942.

...

TRIUMPH IN TUNISIA

In Tunisia, on 18 April 1943, Curtiss P-40 F aircraft of the 57th FG, accompanied by Spitfires, attacked a large formation of German transport and fighter planes, shooting down many of them during the course of the fierce dogfight. This day became known as the "Palm Sunday massacre". As for the Allies, they lost six P-40 and one Spitfire. The story of this great victory was told in newspapers and inspired a Curtiss Wright advert, painted in watercolours with strength and precision.

Flying, August 1943.

...

CURTISS WARHAWKS STRIKE WITH GUN AND BOMB

For Curtiss Wright, the artist portrays a bombing run by US Army Air Forces P-40 Warhawks against a column of enemy tanks in the Libyan desert.

Published in November 1942, this illustration realistically captured the future fighting that took place on the Mediterranean front in 1943.

Flying, November 1942.

A lot of objects created an atmosphere, with two plane propellers hung on a wall, flying suits, flying goggles, aircraft models, piles of magazines, books, photos, sketches and drawings all over the place. It was a paradise for today's collector. This description of his studio was written by E. Jay Doherty in the January 1943 issue of Flying.

Howe Lloyd

Howe was an illustrator for Curtiss between 1942 and 1942 with the promotional campaign of the legendary P-40 that achieved the first victories. He was a precise artist, whether painting in watercolours or gouache, and the action was well portrayed with perfectly drawn planes. Some adverts were absolute perfection, with the colours of the planes and the decor giving the compositions an air of reality. His rapid style was that of a war correspondent capturing an amazing picture.

He worked for the company magazine Curtiss Fly Leaf, illustrating articles and the rear cover page. It would appear that he only worked for this company.

Knight Clayton, 1891-1969

A resident of Rochester, New York, he studied at the Art Institute of Chicago and married Katherine Sturges, a well known advertising artist who worked with her husband in the illustration of aviation books.

During the First World War he joined the Royal Flying Corps in France and, as a pilot, was shot down by the Germans and taken prisoner, spending long months in hospital recovering from his wounds. After the war he resumed his career, illustrating books and magazine articles with an aviation theme. Following closely the technological advances of planes and flying techniques, he was a guest of the American air forces. He was the illustrator of the Ace Drummond, with the Great War ace Eddie Rickenbacker.

On the eve of America's entry into the war, Clayton Knight was in charge of an association helping American aviators that had joined the Canadians and British of the Royal Air Force during the difficult days of the Battle of Britain.

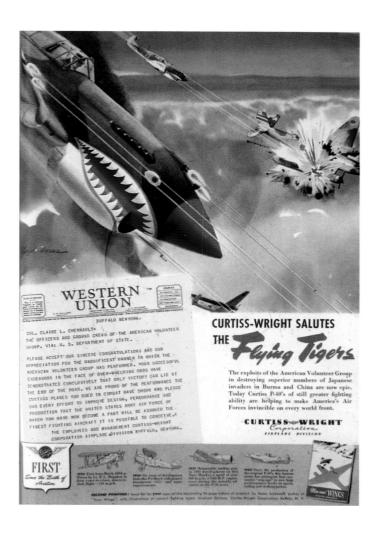

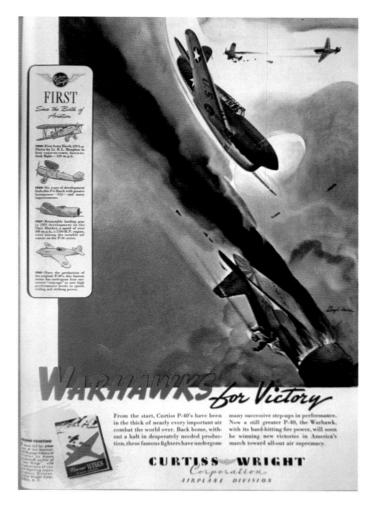

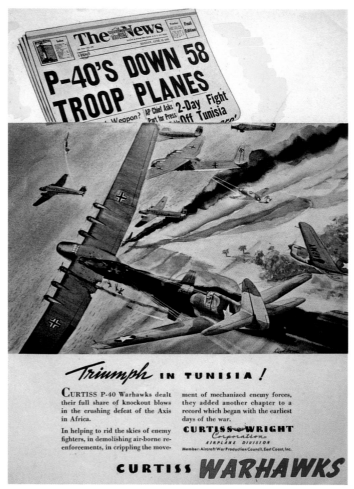

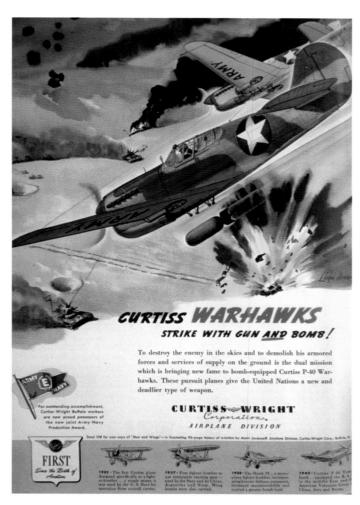

CLAYTON KNIGHT, 1918 (top) and today in his New York studio. Knight, a noted artist, was a World War I pilot

Clayton Knight

YOUR WINGS WILL SERVE YOUR HOME… TOMORROW!

One can understand, when looking at this illustration, the importance of the making of identification prototypes by young Americans in schools and universities. They allowed one to train in the recognition of friendly and enemy planes. The plane seen here is the imposing Boeing 314 Clipper. This student, via his work, is taking part in his country's war effort. The US Navy has rewarded the quality of his work with a certificate. This CK signed composition was no doubt made by Clayton Knight.

The Saturday Evening Post, 2 August 1943.

...

The Navy has awarded a certificate to 13-year-old Joseph Bashore. He has finished all of the 50 wooden ID models. They were made in schools and were used to help aviators train in aircraft recognition. Joseph is seen here with the biggest of his models, the Boeing 314. This photo no doubt inspired the advert's illustrator.

He made very good propaganda adverts for the US Army Air Forces, Crosley, Boots etc., that appeared in the best selling magazines and aviation magazines.

He was also an historian, relating the activities of the 8th Air Force in Great Britain, the 11th Air Force in the Aleutian Islands and the 20th Air Force in the Pacific. He was amongst those invited to see the Japanese surrender on board the battleship Missouri. Clayton Knight dedicated his entire life to painting with passion and talent, the history and progress of aviation.

Kotula Joseph, 1910-1998

Like many young boys, Jo Kotula doodled in the margins of his school books, cowboys, Indians and, of course, planes.

In 1924, whilst still at school, he discovered the aeronautical art of the portrait artist Henri Farre. During the First World War, this artist was sent to the front line to portray the life of the aviators, the allied planes, Spads, Camels and those of the enemy, Fockers and Taubes, engaged in furious combat. This discovery had a great impact on the work of Jo Kotula.

Without having finished high school, he travelled across Kansas, Oklahoma and Texas, returning with a large amount of illustrations that had nothing to do with aviation. It was New York that saw his first successes as an aviation artist and he was in demand for a wealth of subjects. This was period where flying was the stuff of dreams and this explains the great demand. He used all the means available to an artist, and painted in watercolours, gouache, tempera and oils. In 1932 he illustrated the front cover for Model Air Plane News and from this point in time, he began a working relationship with this magazine that would last thirty-eight years. In 1936, he passed his private pilot's licence at Roosevelt Field and bought a small plane, something which did not stop him from renting other aircraft. This experience helped him in the composition of his aeronautical illustrations. To begin with, he knew how to fly a plane....

His interest in aircraft safety led him to looking into the design of an air bag to protect aviators in the event of a crash, something that later proved itself in the automobile industry. He still

continued, nevertheless, to paint and draw and some of his sketches appeared in Air Fact in 1943. Many of his illustrations were futuristic and were published in magazines such as Skyways in December 1942.

In 1939, he sent The Saturday Evening Post a preliminary sketch of his own vision of a four-engine transport plane. To his great surprise, the art director Kenneth Stuart, published it as it was on the front page.

For Collier's during the war, Jo Kotula illustrated articles based on aviation such as, "Mission to Salonika", published on 31 July 1943, "Pickle Lugger", on 4 September 1943 and "Flying through the hell" , on 2 October 1943.

He was part of the team of artists whose interests were looked after by the James Monroe Perkins agency.

He illustrated many adverts with an aviation theme for Westinghouse, Curtiss Electric Propellers, General Aviation and Aeronca. Between 1950 and 1960, he illustrated the boxes of model plane kits for Aurora. He also worked as an illustrator for technical aviation magazines. A co-founder of the ASAA (American Society of Aviation Artists), this friendly and enthusiastic man, dedicated his life with talent and passion, to the promotion and discovery of an important page in the annals of the history of flight.

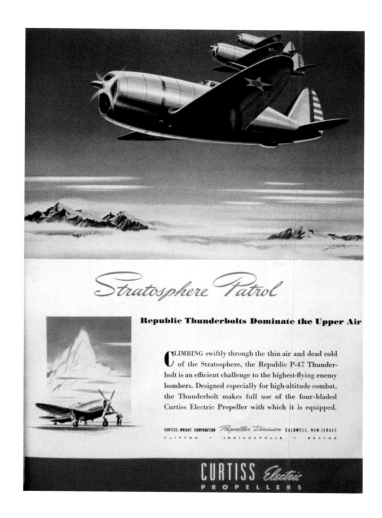

Joseph Kotula

STRATOSPHERE PATROL

For Curtiss Electric Propellers, the artist has portrayed a formation of P-47 aircraft flying at high altitude. The artist expresses perfectly this ice-cold flight over a bank of clouds. The light is particularly well rendered.

The Thunderbolt , designed by Alexander Kartweli, undertook its maiden flight on 6 May 1941, before becoming operational in May 1943 as an escort for B-17 and B-24 formations over Germany. It was also made into a formidable ground-attack aircraft.

Aero Digest, February 1942.

..

BRAWN AND CONTROL MAKE THE POWER TO KAYO TOKYO!

To promote the quality of General Aviation products, the artist chose to portray the famous heroic flight of B-25s that took off from the aircraft carrier Hornet on 18 April 1942 to bomb Tokyo. This symbolic raid helped raise the morale of the American people after the disaster of Pearl Harbor.

Skyways, May 1943.

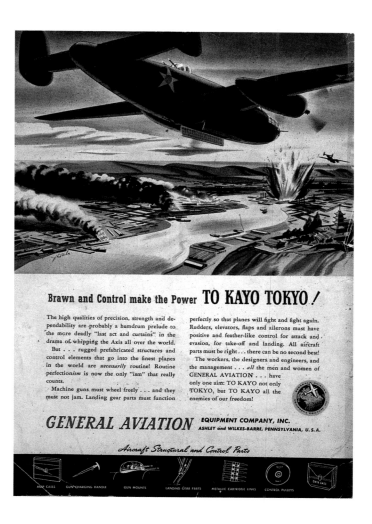

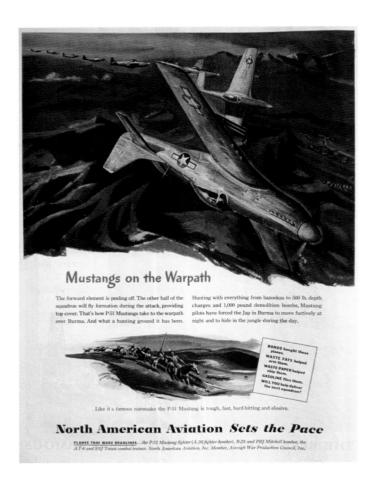

Kramer M. Harold

This artist's advertising illustrations are characterised by the strength and precision that they project. Movement, composition and colour are well observed and the strength of the style makes this artist easily recognisable.

Harold M. Kramer made several excellent, quality adverts for North American Aviation as well as for Douglas. He took part in other advertising campaigns for Pullman and designed, for Eagle Fisher, a black and white series that was published in Newsweek in 1943.

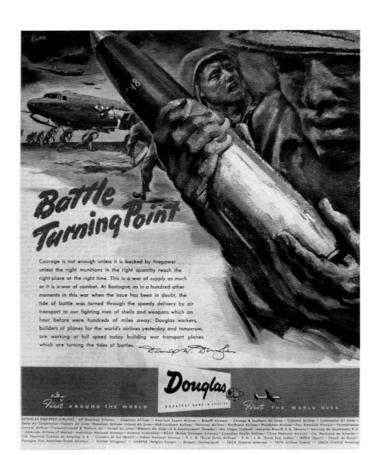

Harold M. Kramer

MUSTANGS ON THE WARPATH

Like a horde of proud Apache warriors on the warpath astride their powerful mounts.... A group of North American P-51 Mustangs, in the same way, bravely attacks Japanese positions somewhere in China.

Life, 8 January 1945.

. .

BATTLE TURNING POINT

In this advert for Douglas, Kramer shows us, with the strength that characterises his style, a crucial moment in the war in Europe during the Battle of the Bulge between 9 - 20 January 1945. The text reads,

" courage is not enough unless it is backed by firepower…"

Published either in Collier's, or The Saturday Evening Post.

This cut out dates from 1945.

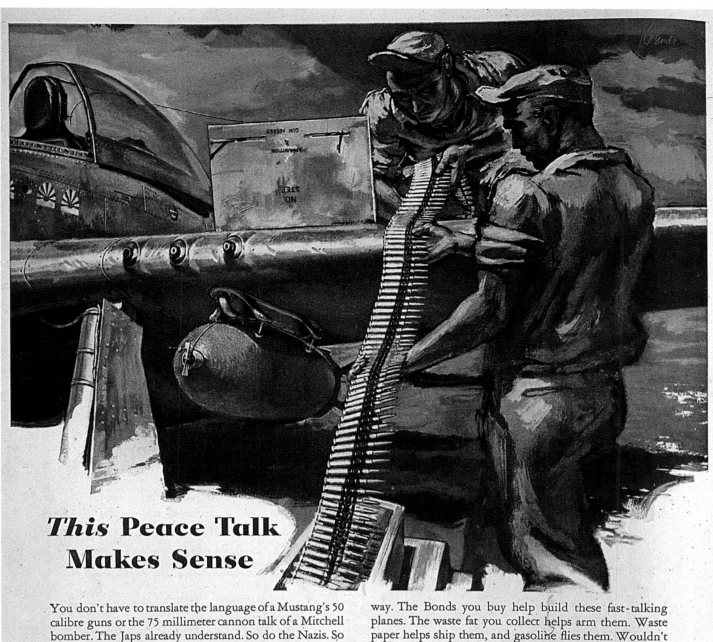

This Peace Talk Makes Sense

You don't have to translate the language of a Mustang's 50 calibre guns or the 75 millimeter cannon talk of a Mitchell bomber. The Japs already understand. So do the Nazis. So let's keep talking, You bet you can help! Think of it this way. The Bonds you buy help build these fast-talking planes. The waste fat you collect helps arm them. Waste paper helps ship them, and gasoline flies them. Wouldn't you like to say a few words of this kind of "peace talk," too?

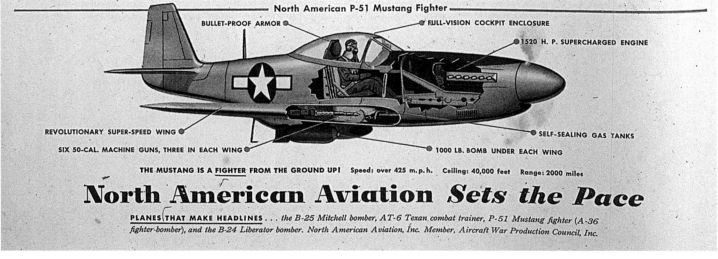

North American P-51 Mustang Fighter

BULLET-PROOF ARMOR • • FULL-VISION COCKPIT ENCLOSURE

• 1520 H. P. SUPERCHARGED ENGINE

REVOLUTIONARY SUPER-SPEED WING •

• SELF-SEALING GAS TANKS

SIX 50-CAL. MACHINE GUNS, THREE IN EACH WING • • 1000 LB. BOMB UNDER EACH WING

THE MUSTANG IS A **FIGHTER** FROM THE GROUND UP! Speed: over 425 m.p.h. Ceiling: 40,000 feet Range: 2000 miles

North American Aviation *Sets the Pace*

PLANES THAT MAKE HEADLINES . . . *the B-25 Mitchell bomber, AT-6 Texan combat trainer, P-51 Mustang fighter (A-36 fighter-bomber), and the B-24 Liberator bomber. North American Aviation, Inc. Member, Aircraft War Production Council, Inc.*

Harold M. Kramer

THIS PEACE TALK MAKES SENSE

This North American advert sings the praises of the Mustang's firepower. In this robust composition, two armourers are rearming a P-51 based in the Pacific. At the bottom of the advert, a semi-cutaway reveals the important parts of the plane. **Life, 4 September 1944.**

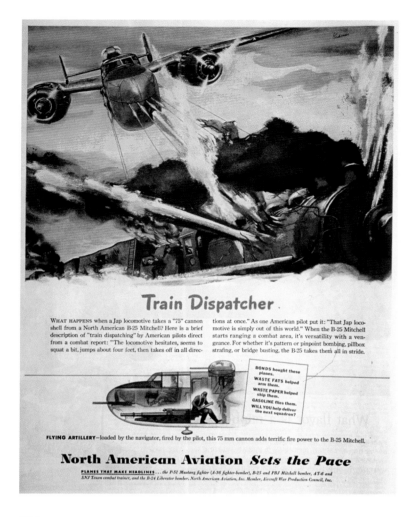

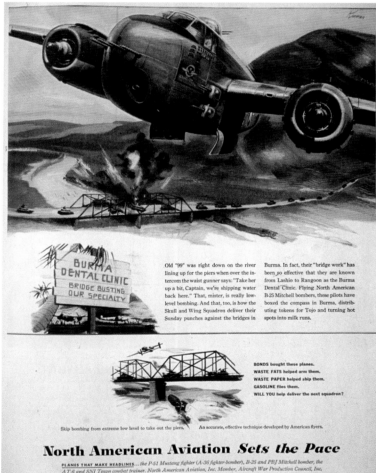

Kurka Anton

Kurka's signature can be found on numerous adverts with an aviation theme. He was part of the team of artists whose interests were looked after by Charles E. Cooper Inc. of New York. He also designed excellent adverts for Good Year, Ethyl Corporation and the Curtiss Airplanes Division of Curtiss Wright.

Harold M. Kramer
TRAIN DISPATCHER

For North American Aviation, Kramer portrays an attack by the powerful B-25 H on a Japanese railway depot. Flying dangerously low, this plane destroyed a train. This action was mentioned in numerous US Army dispatches in the Pacific. A cutaway view of the nose shows the 75 mm cannon installed in this aircraft.

Collier's, 4 November 1944.

. .

NORTH AMERICAN AVIATION SETS THE PACE

In Burma, a B-25 H at low altitude attacks a bridge being crossed by a column of Japanese armour. With this illustration, the artist has chosen an unusual angle with the plane in its flare manoeuvre after having dropped its deadly cargo. North American shows here part of the Mitchell's difficult missions; those carried out at low altitude. The plane is with the 10th AF and the 490th group known as the "Skull Squadron" , recognisable by their death's head nose art. The group was also known as the "Bridge Busters". This is near the end of the war and censorship has been relaxed a little.

Life, 2 May 1945.

. .

(FOLLOWING PAGE)
Anton Kurka
MORE AND MORE ETHYL IS GOING OVERSEAS

Taking the form of an illustrated game with five inserts, Ethyl, a fuel manufacturer, gives the reader to play a questionnaire where one can only answer true or false. For Ethyl, it was all about showing the vital importance of its products in the hard fighting that would lead to victory. The main illustration, with its precise drawing, bears the mark of Kurka.

It portrays the refuelling of a Hellcat on board an aircraft carrier, before it takes off on a mission.

The Saturday Evening Post, 22 April 1944.

MORE AND MORE ETHYL IS GOING OVERSEAS

What do you know about the wartime gasoline situation? Test yourself! Are these statements

TRUE OR FALSE ?

This quiz is tougher than most. Don't expect to answer more than one or two. Correct answers are at the bottom of this page.

1. The Army Air Forces use an average of a million gallons of high octane gasoline daily.
☐ True ☐ False

2. The gasoline requirements of this war are already ten times greater than in World War I.
☐ True ☐ False

3. You could drive from Chicago to Los Angeles on the amount of gasoline it takes to keep a Navy fighter in the air one hour.
☐ True ☐ False

4. Practically all fighting-grade gasoline used by the Army and Navy is Ethyl.
☐ True ☐ False

5. The chief reason why government agencies have placed limits on the quantity and quality of gasoline is to save rubber.
☐ True ☐ False

ETHYL is a *trade mark* name.

ANSWERS:

1. *False.* According to recently released figures, the Army Air Forces used nearly *three million* gallons of high octane gasoline a day during the first two years of the war.

2. *False.* Gasoline needs in the present war are eighty times those of the last war.

3. *True.*

4. *True.* Ethyl fluid is used to improve the antiknock quality of practically all fighting-grade gasoline.

5. *False.* The most important reason government agencies have had to place limits on the quality and quantity of civilian gasoline is to help oil companies meet *military needs.* The petroleum industry is doing a great job, but our Army and Navy require such vast quantities of high-quality gasoline that limits had to be placed on civilian gasoline.

ETHYL CORPORATION
Chrysler Building, New York City

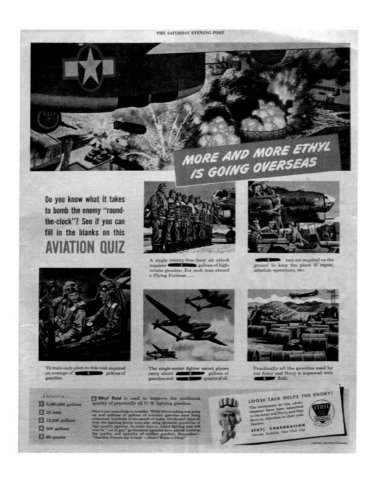

Anton Kurka

MORE AND MORE ETHYL IS GOING OVERSEAS

With this Ethyl advert, the artist has chosen as a theme and main illustration, the formidable and effective attacks launched on the Rumanian refineries at Ploesti by the B-24 Liberators of the 9th Air Force. The illustrated questionnaire looks at the planes' fuel consumption according to various missions. In the small insert at the bottom right hand side, the text says that this game has received the permission of the Army and Navy. Censorship remained on its guard as some information could be of use to the enemy.

The Saturday Evening Post, 12 August 1944.

Leyendecker Joseph Christian, 1874-1951

Born in Montabaur, Germany, he arrived in the United States eight years later and from a very early age showed an interest in painting.

At the age of 16, he obtained his first job with an engraver and after his working hours, studied at the Chicago Art Institute. Later, he travelled to France where he studied at the famous Académie Julian.

Upon returning to the United States and having learnt his profession, this very talented artist had no difficulty in obtaining orders for advertising illustrations and front covers for the big magazines.

In 1899, at the age of 25, he designed his first cover for The Saturday Evening Post and over forty years later the total had reached more than three hundred. During the war he designed very successful adverts, such as those for Goodyear and Timken Roller Bearing Co. This series portrayed famous military personalities such as generals and admirals.

Ludekens Fred, 1900-1982

Ludekens was born in Port Hueneme, California on 13 May 1900, and was part of the third generation of a family of pioneers from the legendary American west. He grew up in British Columbia and in his youth, often travelled to Alaska, a great barren landscape that, without doubt, forged his headstrong and somewhat authoritarian personality. When his high school studies were finished, he became an advertising illustrator without having studied art or any particular techniques, apart from night school classes at the University of California under the guidance of Otis Shepard. This enabled him to improve his style and gave him the necessary foundation.

In 1921, at the California Exhibition, he made a lithograph portraying Cortés in the Mexico valley, for which he won first prize. For the next fifteen years he was a free-lance illustrator based on the West Coast.

In the 1930s, he undertook the occasional illustration for various magazines. In New York he became artistic director, for seven years, with an advertising agency.

During the war, he was the main illustrator of a big series for Nash Kelvinator, a peacetime automobile and fridge manufacturer that, throughout the conflict, made Pratt & Whitney engines, Hamilton Standard propellers and huge flying boats for Vought-Sikorsky. This advertising campaign was organised by the Geyer Cornwell & Newell Inc. agency with Arthur Surin as artistic director. In this long series, Fred Ludekens shows us the materiel and, above all, the men in action with aviation often at the forefront. The drawings of the US Navy aircraft are well portrayed. The historical interest of the adverts lies above all in the atmosphere of the scenes. They show the tension expressed by those involved in these difficult times. Ludekens often holds nothing back in the portrayal of the horrors of all-out war. The saga of these fighting men is well portrayed without becoming a

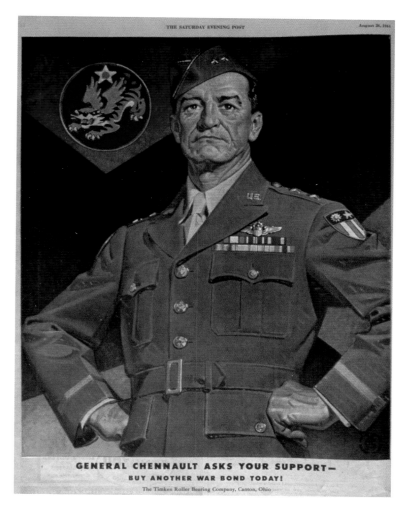

GENERAL CHENNAULT ASKS YOUR SUPPORT—
BUY ANOTHER WAR BOND TODAY!

The Timken Roller Bearing Company, Canton, Ohio

Joseph Christian Leyendecker

Under a menacing red sky, crossed by the shadow of a P-40, the painter-illustrator has made a magnificent portrait of General Chennault in his dress uniform of 14th Air Force commander in China. This formation's insignia, covering the period 1942-1945, is visible in the top left hand corner. This advert was part of a series dedicated to the great generals and admirals for the advertising campaign of Timken Roller Bearing Co.

The Saturday Evening Post, 26 August 1944.

...

The "American Volunteer Group", the first of the "Flying Tigers" photographed in China by Georges Rodger in April 1942.

Life 20 July 1942.

historical panorama and the realistic scenes are perfectly related, but in a very personal way.

Other clients included Cannon Towels and Food Conservation, for whom one of the adverts portrays survivors from a sunken ship on a makeshift raft, catching a seagull in order to survive; a tragic and powerful black and white illustration.

In 1942, he made his first illustration for The Saturday Evening Post, "Tall in Saddle". This was followed by many others. Front covers also bear his signature. He made numerous illustrations concerning the American west, in tribute to his origins. He was co-founder, along with Albert Dorne, another great illustrator, of the famous Westport art school in Connecticut.

During the course of an interview published in the Illustrating book for The Saturday Evening Post by the associate editor of the Post, Ashley Halsey Jr, Fred Ludekens explains how he went about illustrating a story that appeared in the magazine on 4 May 1945. This story talks of a pilot following the crash of his P-51 and is called, "Mademoiselle, I love vous" . We see here the method and seriousness of this illustrator. Of course he begins by reading the story. He then sets the scene, a plane has just belly landed in a field. The pilot escapes unhurt and is standing in front of his plane when a young French, or Belgian woman, hiding a Luger

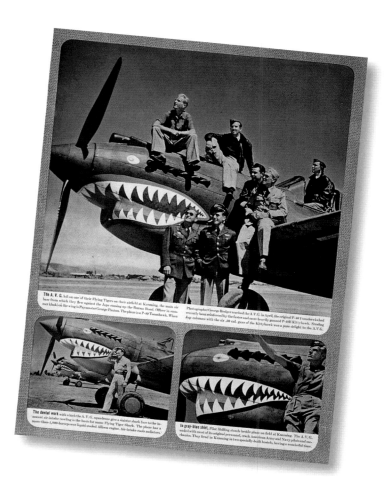

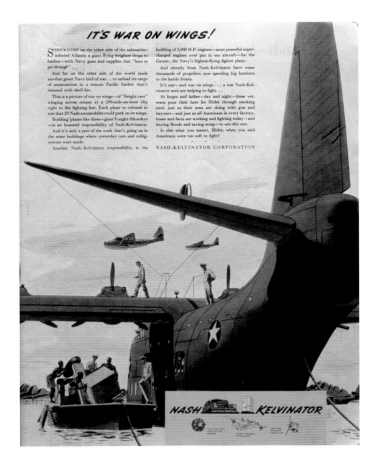

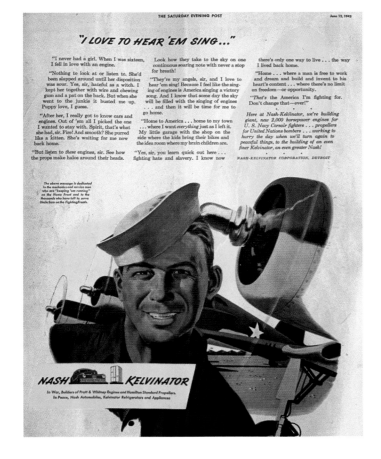

Fred Ludekens
MADEMOISELLE, I LOVE VOUS
. .

IT'S WAR ON WINGS!
On a lake somewhere in Africa, we can see the accurately painted huge transport seaplane, the Vought Sikorsky VS 44A Chance. This aircraft was built by Nash Kelvinator.
Collier's, 12 December 1942.
Art Director: Arthur A. Surin
Client: Nash Kelvinator Corporation
Agency: Geyer Cornell & Newell Inc.
. .

"I LOVE TO HEAR'EM SING…"
This smiling U.S. Navy mechanic seems happy listening to the powerful, regular throb of the Pratt and Whitney engines made by Nash Kelvinator. The latter company placed many adverts in magazines throughout the Second World War, covering the activities of the various army corps.
The Saturday Evening Post, 12 June 1943.

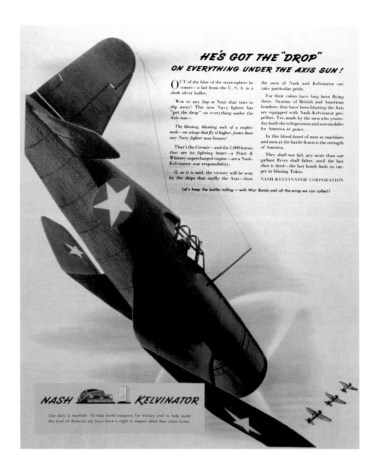

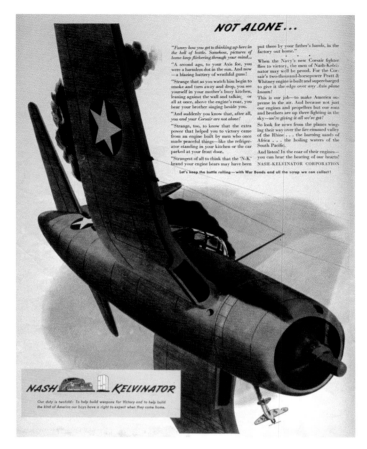

Fred Ludekens

HE'S GOT THE "DROP"

Like an eagle diving towards its prey, a F4 U1 Corsair, with its Wright Cyclone engine roaring, launches a surprise attack on some patrolling Japanese Zeros. This scene, painted for Nash Kelvinator, sums up the action very well.

Fortune, January 1943.

..

NOT ALONE…

Again for Nash Kelvinator, Fred Ludekens has illustrated a well-framed and accurately drawn kill by a F4 U1 Corsair against a Zero. The text of this advert tells of the pride felt by the employees of this firm in their contribution to victory.

Life, 15 February 1943.

..

ALASKAN AQUACADE

For the advertising of Cannon Towel products in a series based on the theme of men at war, Fred Ludekens portrayed aviators in their huts in Alaska. In an atmosphere of great comradeship, a pilot pours an ice bucket over one of his brothers in arms, whilst his apparently relaxing comrades look on in amusement. The hut is particularly well portrayed thanks to numerous details; the pin-ups cut out of magazines, aircraft recognition boards, the glowing brazier filled to the brim . Winter was harsh in this part of the world.

Life, 4 October 1943.

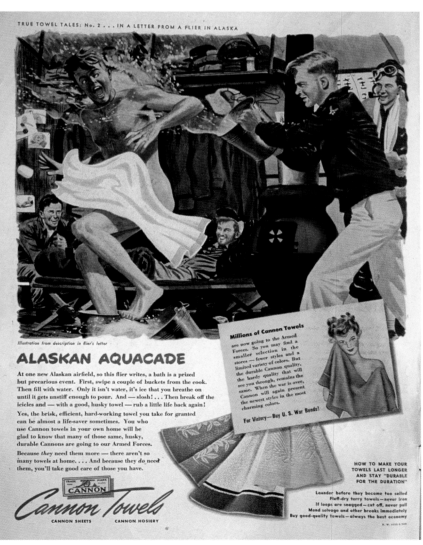

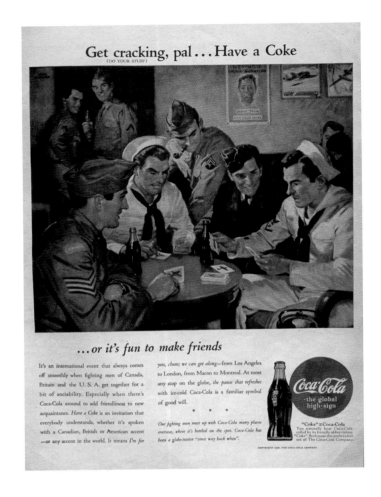

Get cracking, pal... Have a Coke
(DO YOUR STUFF)

...or it's fun to make friends

It's an international event that always comes off smoothly when fighting men of Canada, Britain and the U. S. A. get together for a bit of sociability. Especially when there's Coca-Cola around to add friendliness to new acquaintance. *Have a Coke* is an invitation that everybody understands, whether it's spoken with a Canadian, British or American accent —or any accent in the world. It means *I'm for* you, chum; we can get along—from Los Angeles to London, from Macon to Montreal. At most any stop on the globe, *the pause that refreshes* with ice-cold Coca-Cola is a familiar symbol of good will.

* * *

Our fighting men meet up with Coca-Cola many places overseas, where it's bottled on the spot. Coca-Cola has been a globe-trotter *"since way back when".*

Coca-Cola
-the global
high-sign

"Coke" = Coca-Cola
You naturally hear Coca-Cola called by its friendly abbreviation "Coke". Both mean the quality product of The Coca-Cola Company.

Philip Lyford

GET CRACKING, PAL... HAVE A COKE

At the canteen, allied servicemen play a game of cards using a pack bearing the aircraft recognition outlines. The men are enjoying a friendly moment of relaxation with a well-chilled Coca-Cola. The decors and accessories illustrated by Phil Lyford are sought after by collectors today, as are the plane adverts illustrated by Heaslip and the aircraft recognition playing cards. **Time, 10 September 1945.**

...

Some of the friendly and enemy aircraft recognition playing cards made by Coca-Cola in 1943. .

behind her back, motions to him to move towards her. What will happen ? Next, the atmosphere and the scene where the action takes place has to be created. We are in Europe, near the Channel. It has rained a lot, as shown by the muddy field and overcast sky. illustrated in black and white, in which it will be published, it receives a blue wash to create the atmosphere.

The scene takes place two or three months after D-Day. Should the plane have invasion markings ? Is it olive drab or bar metal ? These were so many questions that could influence the illustration. Also, what is the shape of the cockpit canopy ? Ludekens asked a lot of people before getting in touch with a pilot who had returned from Europe and who gave him the answers to his questions.

"So that's how The Saturday Evening Post illustrators work. We have two or three weeks to send in the illustration after having received the text. From that point on, he tells us, you hold your breath, bite your nails and stay away from the telephone. If the cheque doesn't arrive within three days, the Post is very nice, you make the decision to look for another client."

This account shows a strong temperament, meticulous and precise, but not always easy.

Lyford Philip, 1887-1950

Philip Lyford was born in Worcester, Massachusetts and studied drawing and painting for four years at the Boston Museum of Fine Arts. He was one of Boston's great advertisement illustrators and worked for numerous magazines such as, The Saturday Evening Post, Collier's, Red Book and Country

Gentleman. One brand in particular owes him a great debt; Coca-Cola. The strength of the wartime Coca-Cola adverts lay in the fact that they were hard hitting and well illustrated, with the brand eventually being seen as a moment of relaxation in the midst of hell !

When looking through American magazines, one can measure the degree to which Coca-Cola entered into industry, daily life and all over the world on all fronts wherever the Allies were fighting and in all army corps.

The talents of the great illustrators all contributed to the success of this drink, the drink of victors ! The aviation side of these adverts fell specially to Saul Tepper, Douglas Crockwell, Philip Lyford etc.

Together, all of these wartime advert testify to the strength of a brand in the war effort of the United States.

Osler John S.

Older illustrated numerous adverts for the Oldsmobile Division of General Motor.

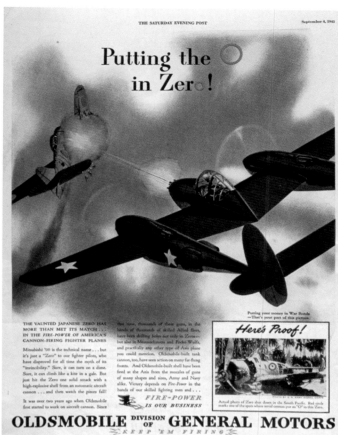

John S. Osler

PUTTING THE O IN ZERO!

A nimble Japanese fighter, the famous Zero, is pulverised by the formidable power of the guns made by the Oldsmobile Division of General Motors positioned in the nose of a P-38 Lightning. According to the manufacturer ''fire-power is our business ''.

The Saturday Evening Post, 4 September 1943.

...

HOW FIRE-POWER SAVES THE LIVES OF AMERICA'S FIGHTING FLIERS

A squadron of B-17 Flying Fortresses flying towards Germany is suddenly attacked by ME 109 fighters.

The escorting long-range P-38 Lightning fighters, equipped with drop tanks, look after this formation thanks to their powerful Oldsmobile made guns.

Escort fighters began going on raids in January 1943. They were the guardian angels of allied bombers and were known as "little friends" by the crews.

The Saturday Evening Post, 4 September 1943.

Art Director: Wynn Belford

Client: General Motors

Agency: DP Brother Co. Inc.

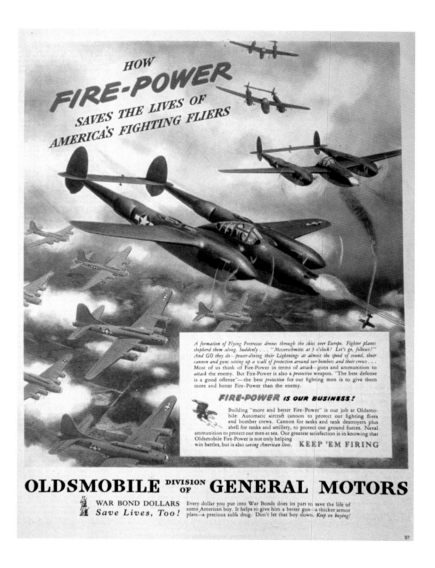

Big as a bomber, fast as a fighter... the first U. S. warplane ever designed especially for night fighting

NORTHROP *BLACK WIDOW* P-61 NIGHT FIGHTER

NORTHROP AIRCRAFT, INC.
NORTHROP FIELD, HAWTHORNE, CALIFORNIA
MEMBER AIRCRAFT WAR PRODUCTION COUNCIL, INC.

This revolutionary new fighter has a "combat urgency" designation. Our Army has now increased by 30% its original order for the Northrop Black Widow ... the P-61 Night Fighter.

This deadly fighter stalks and finds enemy planes in pitch darkness as no other airplane can. It packs enough 20 millimeter cannons and .50 caliber guns to blast apart anything that flies.

Big as it is, the Black Widow is fast as smaller fighters. Yet it can literally hover in the sky when

need be. It takes off quickly, climbs sharply, and has a very slow landing speed for additional safety.

It's powered by twin 2000 horsepower engines. It has plenty of room for its fighting crew of two or three specialists — and long-range fuel tanks.

The remarkable Black Widow is Northrop designed and produced. Into it has gone the far-reaching Northrop know-how in aerodynamic development. Through the war and in the peace ahead, Northrop's proven talents will continue to serve America.

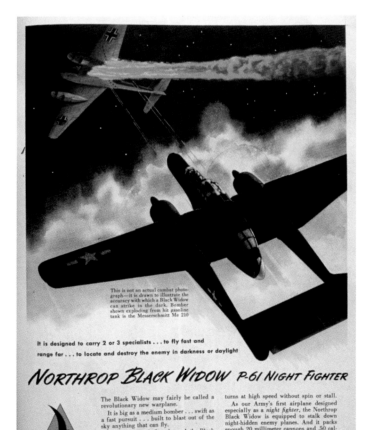

This is not an actual combat photograph—it is drawn to illustrate the accuracy with which a Black Widow can strike in the dark. Bomber shown exploding from hit gasoline tank is the Messerschmitt Me 210

It is designed to carry 2 or 3 specialists ... to fly fast and range far ... to locate and destroy the enemy in darkness or daylight

NORTHROP *BLACK WIDOW* P-61 NIGHT FIGHTER

NORTHROP AIRCRAFT, INC.
NORTHROP FIELD, HAWTHORNE, CALIF.
MEMBER AIRCRAFT WAR PRODUCTION COUNCIL, INC.

The Black Widow may fairly be called a revolutionary new warplane.

It is big as a medium bomber ... swift as a fast pursuit ... built to blast out of the sky anything that can fly.

Yet with all its heft and speed, the Black Widow is nimble as a cat ... it is one of the most maneuverable of all U.S. planes in use today. This superior handling ability comes in large part from the "retractable ailerons" designed into each wing. Retractable ailerons enable the Black Widow to make tighter

turns at high speed without spin or stall.

As our Army's first airplane designed especially as a *night fighter*, the Northrop Black Widow is equipped to stalk down night-hidden enemy planes. And it packs enough 20 millimeter cannons and .50 caliber guns to rip apart anything it locates.

The Black Widow is the most recent evidence of Northrop's talent in aerodynamic development and production. This ability will continue to help the country throughout the war — and in the peace to come.

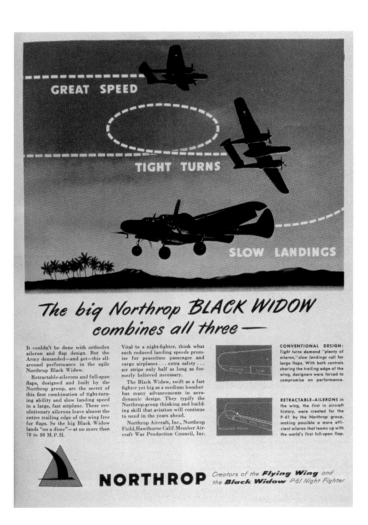

GREAT SPEED

TIGHT TURNS

SLOW LANDINGS

The big Northrop *BLACK WIDOW* combines all three —

It couldn't be done with orthodox aileron and flap design. But the Army demanded—and got—this all-around performance in the agile Northrop Black Widow.

Retractable-ailerons and full-span flaps, designed and built by the Northrop group, are the secret of this first combination of tight-turning ability and slow landing speed in a large, fast airplane. These revolutionary ailerons leave almost the entire trailing edge of the wing free for flaps. So the big Black Widow lands "on a dime"—at no more than 70 to 80 M.P.H.

Vital to a night-fighter, think what such reduced landing speeds promise for peacetime passenger and cargo airplanes ... extra safety ... air strips only half as long as formerly believed necessary.

The Black Widow, swift as a fast fighter yet big as a medium bomber has many advancements in aerodynamic design. They typify the Northrop-group thinking and building skill that aviation will continue to need in the years ahead.

Northrop Aircraft, Inc., Northrop Field, Hawthorne Calif. Member Aircraft War Production Council, Inc.

CONVENTIONAL DESIGN: Tight turns demand "plenty of aileron," slow landings call for large flaps. With both controls sharing the trailing edge of the wing, designers were forced to compromise on performance.

RETRACTABLE-AILERONS in the wing, the first in aircraft history, were created for the P-61 by the Northrop group, making possible a more efficient aileron that teams up with the world's first full-span flaps.

NORTHROP *Creators of the Flying Wing and the Black Widow P-61 Night Fighter*

Owles Alfred, 1894-1978

Owles was born in Nottingham, England, a town where he studied at the School of Art. During the First World War, he served as a photographer with the RAF. He undertook a large series for Northrop, promoting the P-61 Black Widow, that was published in aviation magazines at the start of 1945.

Prohaska Ray, 1901-1981

Proshaka was born in Molo, Yugoslavia. At the age of eight, he arrived in the United States where later, he studied at the School of Fine Arts of San Francisco. In 1929, he moved to New York where he obtained his first order. One of his clients was Whitman's Chocolate. He exhibited his paintings and won a large number of awards. He was president of the Society of Illustrators between 1959 and 1960.

(PREVIOUS PAGE)

Alfred Owles

NORTHROP BLACK WIDOW

Night falls on an American base at the end of 1944, somewhere in the Pacific. We see here a new, powerful, twin-boom, black painted plane, the P-61 Black Widow, an aircraft designed by J.K. Northrop, which, after having made its maiden flight on 26 May 1942, became operational in Great Britain around May 1944.

Northrop could be considered as being one of the creators of the planes of the 21st century.

This advert states that it is "big as a bomber, fast as a fighter". It was especially made for night fighting and proved itself to be a formidable weapon.

Flying, January 1945.

...

This advert states that, "it is designed to carry 2 or 3 specialists...to fly fast and range far... to locate and destroy the enemy in darkness or daylight".

The illustration shows with amazing accuracy, a P-61 at night, shooting down a Me-210. This formidable, powerfully armed night-fighter, was equipped with a very sophisticated radar which enabled it to identify and destroy targets on the ground: trains, convoys...

Flying, February 1945.

...

THE BIG NORTHROP BLACK WIDOW COMBINES ALL THREE

This Northrop Aircraft Inc. advert talks of the Black Widow's three qualities: a very high speed, the ability to make very tight turns thanks to its retractable spoiler flaps placed in the wings, the first of their type, and its low landing speed.

Flying, April 1945.

...

Ray Prohaska

EASTER SUNDAY, APRIL 25th

An Air Forces lieutenant gives his dazzling wife a box of Whitman's chocolates. A gentle and delicious thought, illustrated here with talent.

The Saturday Evening Post, 10 April 1943.

Ray Proshaka
LOVE STORY

A box of chocolates is always a welcome present. A Navy lieutenant disembarks from a DC-3. This advert promoted the quality of Whitman's chocolates, a company that was celebrating its 100th anniversary at the time (1842-1942). **Life, 5 October 1942.**

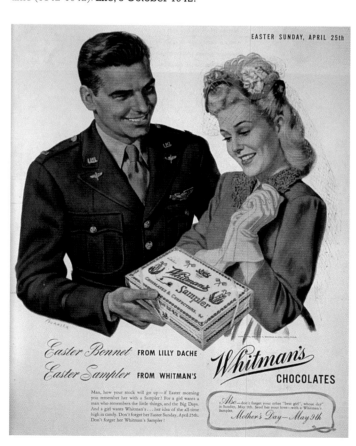

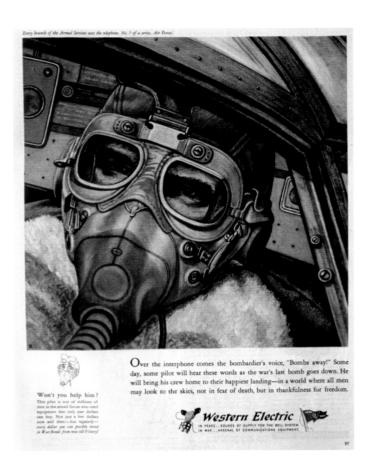

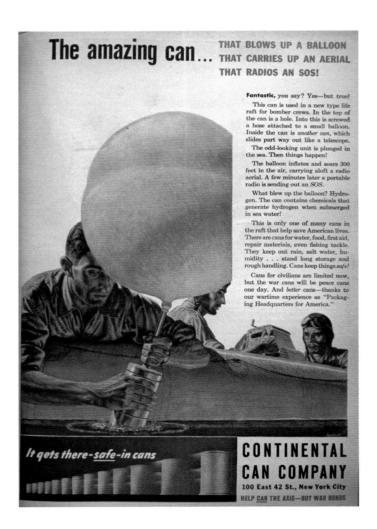

Rabut Paul, 1914-1983

Born in New York on 6 April 1914, he grew up in a family surrounded by numerous animals such as a salamander, a Persian cat and two tortoises. Throughout his life he showed a great interest and unconditional love for animals. His first artistic works were characterised by a desire to portray the large open spaces of the United States. These were used as finely drawn India ink bookplates.

As a boy scout, he excelled in techniques that allowed him to make a rope with the most complicated knots. Like a lot of Americans, he worked as paper boy, covering many miles each day to make a little pocket money. Upon finishing his secondary education at the age of 16 at the time of the Great Depression, he was forced to take on many odd jobs. During this difficult period he did not let events get him down and studied in the evenings at the College of the City of New York and later, entered into the Academy of Design where he had Jules Gotlieb and Harvey Dunn as teachers.

Passionately interested in primitive civilisations, Pre-Columbian art and the peoples of Oceania, he studied more closely the Indian culture of the north-west of the United States. Indeed his knowledge made him an expert with enthusiasts and specialised galleries. He was himself a fervent collector of items in these domains.

During the war, he made numerous adverts for various companies and some of his cleints included, Stromberg Carlson,

Paul Rabut

For the Air Forces, Western Electric wanted to highlight the quality of the communications products that it made. This close up illustration by Paul Rabut shows a bomber pilot at high altitude, wearing his oxygen mask. In his headphones, he hears the bomb aimer telling him that the bombs have been dropped over the target. Mission accomplished. All that remains now is the often-difficult return leg over hostile territory.

Life, 18 September 1943.

Art Director: Charles Hagn

Client: Western Electric Co.

Agency: Newell Emmet Co.

..

THE AMAZING CAN...

The survivors of a shot-down bomber in their dinghy somewhere in the Pacific. These aviators will have to send a distress signal and give their position so that a Catalina seaplane can come and pick them up.

This operation is made possible by a surprising little container made by Continental Can Co. containing a gas that will allow them to inflate a balloon to raise an aerial and at last sent an SOS.

Newsweek, 20 September 1943.

Art Director: Harold Olsen

Client: Continental Can Co.

Agency: Batten, Barton, Durstine & Osborn Inc.

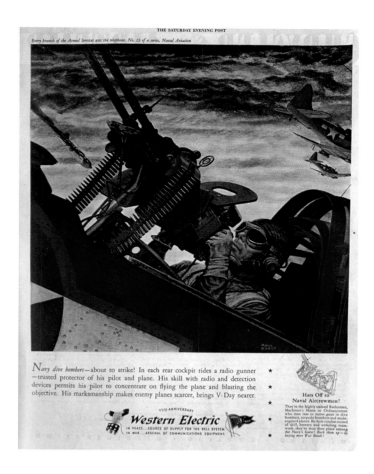

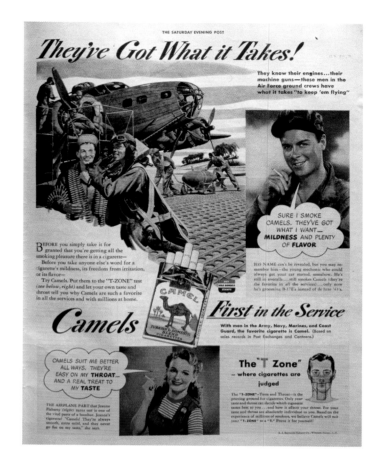

They're Got What it Takes!

Telephone MFG Co., Camel, Continental Can Co. and USS Steel. We owe him a remarkable advertising series for Western Electric where he portrays, via very realistic illustrations, the radio and telephone communications within the various army corps, made for the Newell Emmett Company agency. He worked for agencies such as McCann Erickson, Young Rubicam Inc., William Esty Co. Inc., Batten Barton and Durstine Osburn Inc. He was part of the Rahl Studio team that employed highly talented artists.

For illustrations ordered by magazine editors and advertising agencies, Paul Rabut drew numerous pencil or charcoal sketches, allowing him to create varied compositions and find the best scene. He looked for all the information necessary to make a successful project. The definitive work was also made in tempera on a white gloss board. In 1942 he received the Art Director Medal and in 1945, the Award for Distinctive Merit. In 1945, he worked for The Saturday Evening Post for a series called The Red House.

Working just as easily in black and white as well as colour, Rabut made numerous exhibitions. Some of his work is visible at the US Medical Museum in Washington.

Paul Rabut

Western Electric chose the US Navy for this advert as they made for the latter, headphones and cables for flying helmets.

The illustrator has used all of his talent to portray a formation of Douglas SBD Dauntless dive-bombers under attack by Japanese fighters. The close-up shows the machine-gunner-wireless operator in action. This aircraft was designed by E.M. Heinemann and made its maiden flight in 1940.

The Saturday Evening Post, 23 September 1944.

. .

THEY'VE GOT WHAT IT TAKES!

After a successful mission, the ground crew rearms a B-17 Flying Fortress on a Pacific base. The pilot offers a Camel cigarette to the armourer before a new raid. In a photo, a mechanic tells of his liking for the quality and taste of this brand of cigarettes. At this time, opening a packet of cigarettes gave off the smell of honey, something that no longer exists today. Another photo shows a young female factory worker enjoying her Camel.

The wartime Camel adverts were a great success due to the quality of the paintings, photos and comic strips. It also had a noticeable impact on the population. Each advert bears a fighting spirit where friendship is not excluded and where aviation is often honoured.

In the Pacific, the B-17 Flying Fortresses of the 5th Air Force carried out many raids between August 1942 and September 1943. They were replaced by the longer range B-24 Liberator.

Life, 31 May 1943.

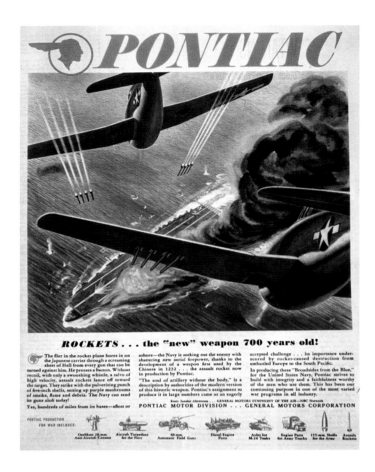

ROCKETS . . . the "new" weapon 700 years old!

PONTIAC MOTOR DIVISION . . . GENERAL MOTORS CORPORATION

Wider Horizons

GET IT DONE–
WITH WAR BONDS

Jerry's number comes up on a stainless steel chute

Walter DuBois Richards

ROCKETS…

(This new 700 year old weapon).For Pontiac, the illustrator has portrayed a rocket attack lead by Navy Hellcats against a Japanese aircraft carrier towards the end of the war. The artist has portrayed the fighting in his very personal and realistic style, in other words, down to the smallest detail. The scene takes place somewhere in the Pacific only a few months away from the end of the war.

Collier's, 19 May 1945.

...

WIDER HORIZONS

Air Command transport planes land all over the world, creating and supplying allied bases. Here, the crew of a DC-3 makes friends with the chiefs of an African country. This advert was made for Bendix, a company which specialised in precision aviation instruments .

The Saturday Evening Post, 14 June 1944.

...

JERRY'S NUMBER COMES UP ON A STAINLESS STEEL CHUTE

For the promotion of Armco steel products, Walter Richards portrayed the machine-gunners of a B-17 in action. These men occupied dangerous positions as they were very exposed to attacks by enemy fighters. There were high losses amongst the crews, despite the fact that they had an armoured plate in front of them that gave only a degree of protection against enemy fire.

The Saturday Evening Post, 8 January 1944.

Richards Walter DuBois, 1907-

Born in Penfield, Ohio, he studied at the Cleveland School of Art. His first works were undertaken at the famous Sun Blom studio in Chicago.

Later, he worked at the Tranquillini Studio in Cleveland, alongside Stevan Dohanos. Next, Walter Richards left for New York where he joined the team of Charles E. Cooper Inc. Then, he became a free-lance illustrator for the big magazines. With Look, he worked on a series on American wartime heroes, that dealt with an exploit that took place during difficult fighting.

He participated in numerous advertising campaigns for companies such as, Pontiac Motor Division (General Motors), Armco, Eureka, Magnav, Jack Heints Inc., Consolidated Vultee Aircraft, Cadillac, J. Laskin & Sons Corp., Thomson Products Inc., Anheuser Busch Inc., General Electric (Mazda Lamps), Stetson and The Public Health Committee of the Papercup and Container Institute.

Throughout his life he continued his artistic research. He showed a particular interest in watercolour techniques. His black and white advertising illustrations are skilfully executed in various tones that give his works particular depth. He was an active member of several associations such as the American Water Color Society and the Society of Illustrators. His work was rewarded with several awards.

Riggs Robert, 1896-1970

A native of Decatur, Illinois, he studied for two years at James Miliken University in the same state, before studying for a further year at the Art Student in New York.

During the First World War, he spent two years in the American army, with part of this time spent in France, and in particular Paris, a veritable melting pot of art where, after the Armistice, he remained in order to study art at the famous Académie Julian. When he finished his Parisian studies, he returned to the United States and worked for several years for the N.W. Ayer Son Advertising Agency, then for many others.

He illustrated the remarkable adverts for Vultee Aircraft Inc., Pan American Airways System (Art Director Club Medal), Goodyear Aircraft, International Salt Company Inc., Reynolds Metal, Curtiss Publishing Company and the Continental Can Company. He also worked as an illustrator for The Saturday

Robert Riggs

Vultee Aircraft Inc. wisely called upon the artist Robert Riggs to undertake, via an illustration, the promotion of its training aircraft, the BT-13. At a training base, a group of trainee pilots and their instructor watch with enthusiasm as one of their comrades takes off. The text states that the war will be won on the airfields where the company's planes train the young pilots for combat.

Fortune, August 1942.

Art Director: Franklin D. Baker /Client : Vultee Aircraft Inc.

Agency: Ruth Rauff-Ryian Inc.

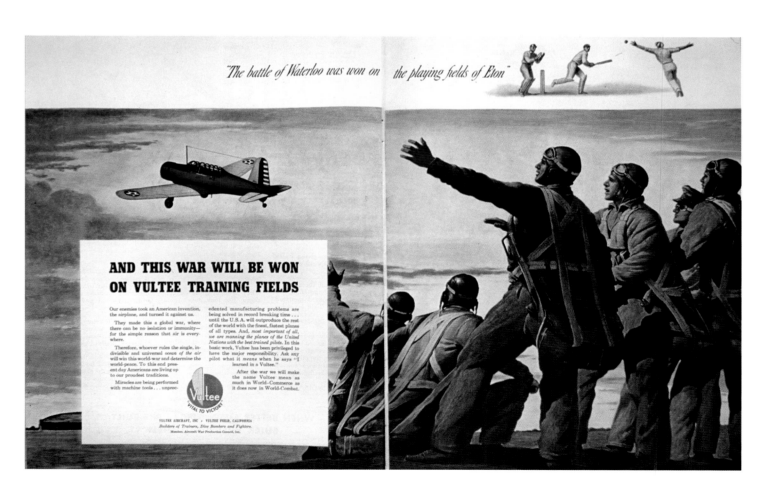

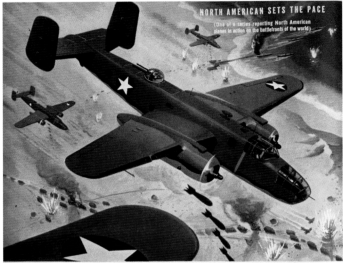

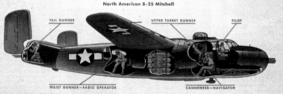

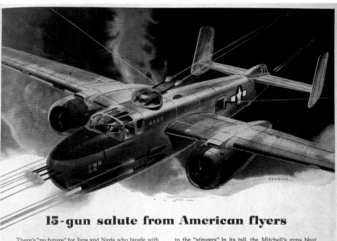

Evening Post, The American Weekly, Country Gentleman Magazine.

During his travels, Robert Riggs was a ceaseless collector of Indian, Thai and African antiques; his studio was like a veritable museum. As for reptiles, the interest that he showed in them was almost devotional and a terrarium was placed next to his work table. An excellent lithographer, he engraved stone with talent, resulting in very personal and powerful works based on the circus and boxing amongst others. Today, his work can be found in numerous museums such as the Brooklyn Library of Congress and the Dallas Museum of Fine Art.

This multi-talented artist was a remarkable painter, engraver and illustrator, leaving a large amount of art that bears the mark of his strong character.

Ryan Tom, 1922-

Born in Springfield, Illinois, he studied graphic art under Franck Reilly at the Art Students League in New York.

During the war, he participated in the series of adverts that promoted the various versions of the B-25 Mitchell for North American Aviation.

Between 1950 and 1962, he specialised in painting the American west. Then, starting in 1961, he painted Western scenes for calendars.

In 1975, he received an award for a painting portraying a cook and his wagon in the American west

Tom Ryan
NORTH AMERICAN PLANES MAKE NEWS AROUND THE WORLD
North American Aviation planes made headlines all over the world with their exploits. This advertising series of six illustrations portrayed these exploits. The Mitchell, designed by R.H. Rice, made its maiden flight on 19 August 1940.
This advert shows us some B-25 C on the Mediterranean front, relentlessly attacking Rommel's troops.
Each month brought new improved versions of the B-25 and P-51 made by this company.
Life, 22 April 1943.
..

15-GUN SALUTE FROM AMERICAN FLYERS
In a sky darkened by columns of smoke sent up by B-25 H attacks on enemy positions, the illustrator Tom Ryan portrays the devastating firepower of this plane. The text states that there is no future for the Axis powers and that the Japs and Nazis will be crushed.
Below, we can see this flying arsenal. The crews called the Mitchell "The Baby Fortress ". This North American Aviation advert is typical of the promotional campaign by this constructor, celebrating the qualities and technology of these fighting aircraft.
Life, 8 May 1944.

Sickles Noel, 1911-1982

Sickles was born in Chillicothe, Ohio. His career began when he met Milton Caniff at the illustration service of the Columbus newspaper, the Ohio State Journal. The young Noel Sickles showed him his drawings. Caniff was taken aback by the quality and diversity of his work. Sickles began working with this newspaper and the two men became great friends.

During the crash of 1929, Caniff and Sickles were fired. They then set up their own advertisement illustration studio and, thanks to hard work, the venture was quite successful. They worked on adverts for Frigidaire General Motors and political campaigns. In 1934, Caniff received an order from the Associated Press Features Service 19 October 1934 saw the appearance of Terry and the Pirates in the Sunday News. During this period, Sickles worked at Cincinnati for RKO, a job which he hated. In 1935, he took over the drawing of Scorchy Smith, which he stopped the following year in order to concentrate on his favourite theme, advertising illustrations. During the war, he worked a lot for Life and Look, as well as the war and naval ministries that contracted him to produce many illustrations. He worked on top-secret manuals for the defence ministry and also adverts published in the big weekly or monthly magazines. Amongst the latter was a series for Rheem MGF Co for the J. Walter Thompson Co agency, The Coca-Cola Company, the D'Arcy Advertising Company, a very beautiful series for the Air Transport Association, for the Erwin Wasey & Co Inc. agency, as well as propaganda adverts for the US Army.

The talent of Noel Sickles is characterised by his spontaneity, skill and choice of most unusual angles, the light, movement and precision of details and the perfect composition of his drawings in the chosen setting. He worked like a veritable film director, using the low angle shot, the wide angle and the close-up. He did not make preparatory sketches. After thinking about the subject, he got straight on with it, using the drawing pen, brush and Indian ink; adding the colour inks afterwards. His skill was

Noel Sickles

AIR TRANSPORT CHANGES « SOS » TO SUB ON SCHEDULE

The submarine USS Perca is undergoing repairs at a dockyard. It suffered serious damage during a mission in the Pacific. Work was almost finished when an incident took place. A part was needed urgently from a far off factory. However, the schedule must be kept to. A Lockheed 18 Lodestar brings in the part. Noel Sickles brilliantly illustrated this advert for The Airlines of the United States.

The Saturday Evening Post, 24 April 1943.

. .

SOMEWHERE WEST OF SUEZ

At an airbase somewhere in Egypt, the sky is filled with the relentless throb of transport aircraft engines, whilst take offs and landings carry on at a rapid rate.

This advert for The Airlines of the United States shows two air traffic controllers watching the arrival of a DC-3.

Life, 5 April 1943.

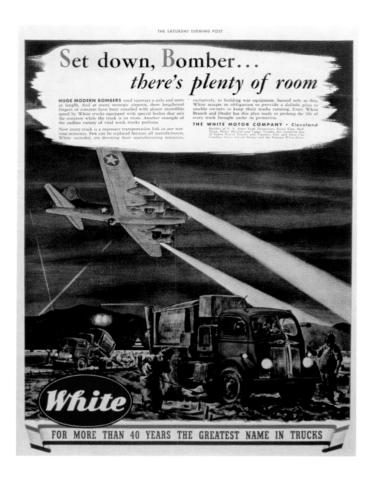

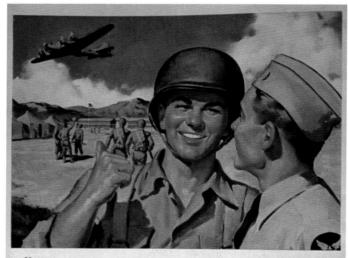

impressive. After the war, he illustrated numerous subjects inspired by the history of the United States for The Saturday Evening Post, This Week End and Reader's Digest.

Sickles was posthumously elected to the Society of Illustrators.

Skemp Robert O., 1910-1984

This artist was born in Scotland, Pennsylvania. After having studied drawing and painting at the Art Student League in New York and Europe, he began, in the 1940s, his career as an illustrator in Chicago. During the war, he took part in advertising campaigns inspired by aviation that were published in big magazines such as, Life, The Saturday Evening Post, Collier's. We should mention, Studebaker, International Trucks, White, International Harvester, The Milwaukee Road etc. In the 1950s, he painted many portraits, in particular that of the famous J. Paul Getty.

He loved the sea and was an enthusiastic yachtsman, painting the first merchant ships. His work can be found in museums and private collections and he received many awards. A member of several societies, he led the American Society of Marine before dying in a car accident whilst driving to his summer residence at East Hampton. He was 73 years old.

Soltesz Frank

This artist lived in New York during the war. He worked in industrial advertising and magazine illustrations, primarily using watercolours. He was on the books of the Gilbert Tompkins agency. His work was published in aviation magazines. He illustrated a big series for Wright Aircraft Engines and Curtiss Electric Propellers.

"Seabee" Balaban and his father helped build many a Studebaker in peacetime

And they're comrades in craftsmanship still

Robert O. Skemp

"SEABEE" BALABAN...

For the advertising of Studebaker products, R. Skemp paid tribute to the Seabees. They were part of the Navy and carried out many tasks such as clearing wrecks off beaches, making runways and setting up camps. The artist has portrayed Seabee Balaban working on setting up a B-17 base in the Pacific at the beginning of the war. At the same time, his father was making Flying Fortress engines in the United States.

Life, 23 October 1944.

...

Frank Soltesz

"OLD HELLCAT"...

Curtiss Electric Propellers chose the Martin B-26 Marauder to promote the quality of its four-blade propellers, as this plane was the first to use them. The company has portrayed a 12th Air Force B-26 "Hellcat" operating on the Mediterranean front. This plane has been on many missions and suffered a lot of damage, something which did not stop it from getting back to base. With this composition, Soltez pays tribute to this plane and its crews.

Flying, November 1943.

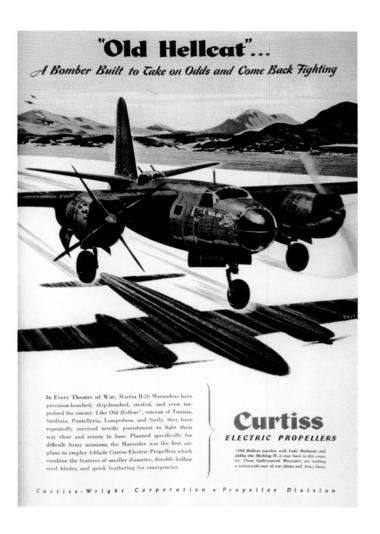

"Old Hellcat"...
A Bomber Built to Take on Odds and Come Back Fighting

Curtiss
ELECTRIC PROPELLERS

Benjamin Albert Stahl

YOUR SON MAY BE OUR BOSS

The Bell Aircraft advertising campaign took the form of a veritable saga to the glory of the P-39 Airacobra, drawn with talent and precision. This advert takes us into a training base somewhere in the United States. The cadets have completed their training and receive their wings from the commander of the school. They are now ready to confront great adversity.

Life, 2 November 1942.

...

IT'S OKAY, MOM

This advert portrays a small village in the United States. On her porch, a mother of a young pilot watches a formation of P-39s training at low altitude.

She wants to believe that "everything is ok" . Everything was done to ensure the safety of the pilots and crews, with armour plating, firepower and so on. This increased their chances of reaching base safe and sound. Some Bell Aircraft adverts used the theme of human relations and the family at war.

Flying, October 1943.

Stahl Benjamin Albert, 1910-1987

It was Ben Stahl's grandmother that got him interested in art. As a young boy growing up in Chicago, his grandmother took him to museums such as the Chicago Art Institute and the Field Art Gallery, something which no doubt set off an artistic leaning that lay dormant in Ben's mind.

At the age of seventeen, he became an errand boy and apprentice in an artists' studio, something that allowed him to learn the basics of his profession. Five years later, he joined, as an artist, one of Chicago's great art studios.

In 1937, one of his illustrations was noticed by the editors of The Saturday Evening Post, an advert based on the sea, and which started his career as an illustrator. He worked for almost every magazine, notably for The Saturday Evening Post, illustrating numerous articles, or Woman Home Companion...

During the war, he participated in many advertising campaigns and worked for Caterpillar, Tractor Co-Peoria, General Motors, Packard, Coca-Cola, American Railroads, Borg, Warner and so on.

For Bell Aircraft, upon the demand of the Addison Vars Company agency, he illustrated a long series, impressive in its quality, rigour and diversity, portraying the remarkably well drawn P-39 Airacobra, as well as other compositions portraying products made by this company.

Ben Stahl was at ease with all subjects and which he treated in a very personal way, be it in the outline and softness of a woman's face, the feelings, and expressions of a face depending on the

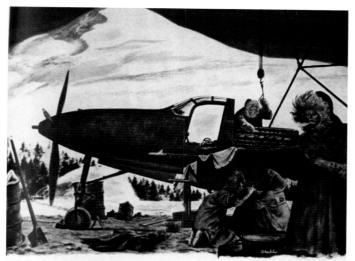

GI's ... by proxy

SUDDEN DEATH... made in U.S.A.

Benjamin Albert Stahl

GI'S… BY PROXY

In the icy air of Alaska and in tough weather conditions, a warmly dressed maintenance crew work on a P-39. With this detailed composition, Ben Stahl portrays perfectly the ice-cold conditions and the atmosphere of the airfield. The P-39s transited by Alaska on their way to reinforce the Soviet air forces. Flown by Russian pilots, this plane scored many kills. **Flying, September 1944.**

...

SUDDEN DEATH… MADE IN U.S.A.

A small flight of P-39s makes a surprise attack on a Japanese airstrip built in the jungle. The firepower of the Airacobra is devastating....This plane, with its modern design for the time, was not a great fighter. On the other hand, with its propeller cone mounted 37 mm cannon, it made a formidable ground attack aircraft. **Flying, June 1943.**

...

PIED PIPER OF THE PACIFIC

This advert is based on real events. In New Guinea, in the Pacific, a formation of P-39s came to the rescue of C-47 transports under attack by Japanese fighters. Lieutenant Clifton H. Troxell shot down a Zero during this dogfight and became an ace of the 8th FG of the 5th Air Force having scored five kills. The article tells of, and authenticates this incident. The P-39 was designed by RJ Woods and Ol Woodson, making its maiden flight in 1939. Along with the P-40, it was involved in the tough, early fighting.
Fortune, May 1943.

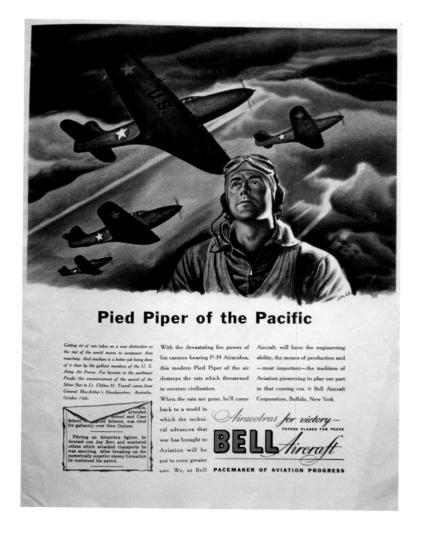

Pied Piper of the Pacific

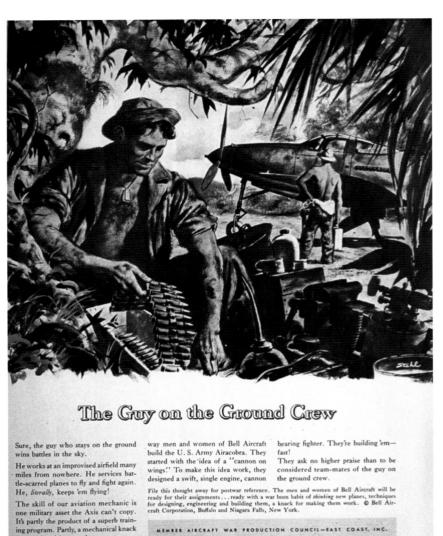

The Guy on the Ground Crew

Sure, the guy who stays on the ground wins battles in the sky.

He works at an improvised airfield many miles from nowhere. He services battle-scarred planes to fly and fight again. He, *literally*, keeps 'em flying!

The skill of our aviation mechanic is one military asset the Axis can't copy. It's partly the product of a superb training program. Partly, a mechanical knack for making things work.

We like to think that there's something of this typically American genius in the

BUY WAR BONDS AND SPEED VICTORY

way men and women of Bell Aircraft build the U. S. Army Airacobra. They started with the idea of a "cannon on wings." To make this idea work, they designed a swift, single engine, cannon

File this thought away for postwar reference. The men and women of Bell Aircraft will be ready for their assignments . . . ready with a war born habit of *thinking* new planes, techniques for designing, engineering and building them, a knack for making them work. © Bell Aircraft Corporation, Buffalo and Niagara Falls, New York.

bearing fighter. They're building 'em— fast!

They ask no higher praise than to be considered team-mates of the guy on the ground crew.

MEMBER AIRCRAFT WAR PRODUCTION COUNCIL—EAST COAST, INC.

Niagara Frontier Division, Buffalo and Niagara Falls, N. Y.
Ordnance Division, Burlington, Vt.
Georgia Division, Marietta, Ga.

BELL *AIRCRAFT*

PACEMAKER OF AVIATION PROGRESS

Benjamin Albert Stahl

THE GUY OF THE GROUND CREW

A roughly made airstrip lost in the jungle somewhere in the Pacific. Working in great heat and harassed by mosquitoes, work conditions are very tough for the men and the means in which to carry it out reduced. The ground crew prepare an Airacobra for a new mission. This scene shows the difficult beginnings of the Air Force early on in 1942.

In this illustration, Ben Stahl perfectly captures the atmosphere. His view is that of a war correspondent paying tribute to the men and the hardwearing materiel in these difficult conditions. Each link in the chain is of the utmost importance in the success of these missions. It is a lesson in courage and energy.

Flying, March 1944.

setting and situation of the portrayed characters. The detail of an interior were portrayed with precision, as was also the case with other items, machinery of all sorts and scenery. In some compositions, one can feel the influence of the great Degas.

He worked by making several pencil sketches, which were then shown to the customer before the work was finished in tempera.

In 1947, he built the studio of his dreams where he worked under the gaze of his wife and his boxer dog Zhandov. He made a television series called, "Journey into Art with Ben Stahl" .

This self taught artist was a reputed teacher at the Chicago Academy of Fine Arts and at the American Academy of Art of Chicago. He was a member of the Famous Artists School in Westport, Connecticut. In 1979, he was elected to the Society of Illustrators.

Tepper Saul, 1899-1987

Born in New York on Christmas day, he spent his whole life in this great metropolis where he first studied drawing and painting techniques in several specialist schools.

At the Grand Central School of Art, he was taught by Harvey Dunn, the famous painter-illustrator. He then began working in a studio that made fashion catalogues, designing lettering and texts, a tedious job that required a great deal of precision. He next set himself up as an illustrator. During his career, he illustrated numerous articles for big magazines. He made a no less important contribution to advertising, working for clients such as Mobil Oil, Texaco, Packard, General Motors, General Electric (Mazda Lamps). For Coca-Cola, he illustrated several adverts that portrayed the friendship between allied aviators.

Saul Tepper was an artist with a precise stroke, his touches of colour give a particular strength to his compositions and a perfect realism. He admirably used harmonies of colours, shade and light. He loved painting pretty women, perfectly capturing their charm and beauty. Each detail was dealt with in a serious manner and he would make enquiries with the right people until he found out what he needed. He made numerous preparatory sketches and worked with models or photos in order to capture the pose and exact movement needed to obtain the required result. He received many awards. For several years he was an excellent teacher and held remarkable conferences at the Pratt Institute, the New York Art Directors Club and the Society of Illustrators. He also had a parallel career as a musician. He wrote many songs that were sung by great artists such as Nat King Cole, Ella Fitzgerald, Glenn Miller and Harry James. He was a life member of the Society of Illustrators.

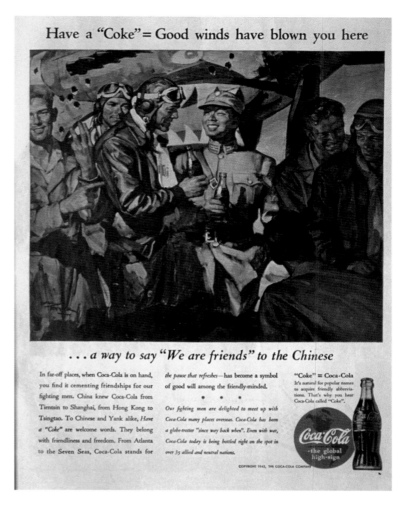

Saul Tepper

HAVE A"COKE"= GOOD WINDS HAVE BLOWN YOU HERE

Back from a dangerous mission, American Flying Tigers pliots and their Chinese friends drink Coca-Cola, standing in front of a P-40 decorated with the famous shark mouth. The way they stand, the emotion and the look on their faces perfectly illustrates this legendary group of men who left their mark on aviation history during the war.

Collier's, 6 November 1943.

..

HAVE A"COKE"= PUKKA GEN

Having only just climbed down from their bomber after a raid, a British crew savours an ice-cold Coca-Cola, the symbol of inter-allied friendship.

Life, 1 May 1944.

The Saturday Evening Post, 29 April 1944.

"*We are friends*"

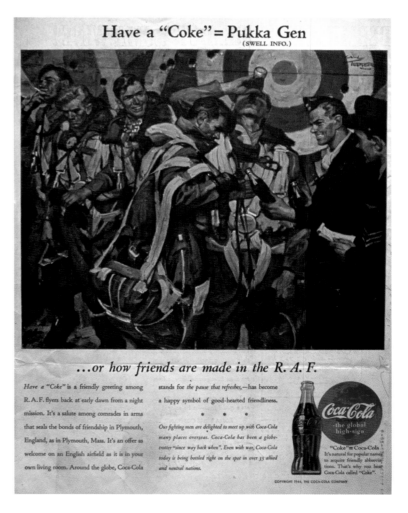

Saul Tepper

"HELLO CHINA… HAVE A COKE"

Oil on canvas 51,5 x 102,5 cm, used for the advert.

Coca-Cola collection.

John Vickery

CHINA SAVED A CENTURY

This two-page Pan American World Airways advert portrays a Clipper seaplane in Hong Kong harbour in 1937.

The text tells of the creation of this airline. This route was not used after the attack on Pearl Harbor. The scene is realistically illustrated.

Life, 18 October 1943.

Art Director: Paul F. Bernardier Jr.

Client: Pan American Airways

Agency: J. Walter Thompson Co.

...

IN THE VANGUARD OF INVASION

This John Vickery advertising illustration uses the theme of a landing on the Mediterranean front, allowing the portrayal of planes and armoured vehicles equipped with Allison engines, the design of which saw the active participation of Cadillac.

Life, 5 May 1944.

Tomaso Rico, 1899-1985

Tomaso was born in Chicago and after several years of musical studies, he played the piano in a small dance orchestra, whose drummer was Dean Cornwell, the future great artist, was at the outset of his career. At eighteen years old, he changed direction and studied at the Chicago Art Institute where he chose illustrating. One of his teachers would be Dean Cornwell who influenced his style. Rico Tomaso sold his first illustration to Collier's. In 1944, True ordered a series of front covers portraying the American fighting men in the various army corps. The first of these was published on 2 August 1944. He also illustrated articles for The Saturday Evening Post. During the war, his signature appeared in advertising campaigns for Nash Kelvinator, Gilbert Paper Company and Texaco. He was also a great portrait artist and his work was exhibited in New York.

Utz Thornton, 1914-

Born in Memphis, Tennessee, he studied in various art schools including the American School of Art in Chicago, a city in which he lived during the war. He worked for many magazines, such as Cosmopolitan, Mc Call's, The Ladies Home Journal, Red Book and Good Housekeeping.

His first illustration was ordered by The Saturday Evening Post and he made adverts for the Northern Pump Co and Johnson's Wax for Home and Industry.

He would usually draw many preparatory sketches and photograph models in the required pose before obtaining the finished project. He worked for aviation as part of the Society of Illustrations Air Forces Art Program.

He also painted portraits of famous people such as the Carter family and Princess Grace of Monaco. He was a member of various societies.

Vickery John, 1906-

A native of Victoria in Australia, he began by studying at the National Gallery of Art School in Melbourne, before working later on for advertising in Chicago

His signature can be found on a great many adverts. During the Second World War, he lived in New York, where his agent, James Monroe Perkins did also with other highly talented artists on his books such as Glen Grohe, John Atherton and Melbourne Brindle.

He had no speciality as an illustrator and revealed himself to be skilled in all sorts of subjects. He was especially skilled at drawing aircraft. He worked for Bell Aircraft Corporation, Cadillac, Pan American World Airways, Spark Plug Company, Aeronca Air Craft Corporation and American Railroads.

Whitmore Coby, 1913-1988

Whitmore was born in Dayton, Ohio, and first studied at the Dayton Art Institute, then in Chicago where he served his apprenticeship at the studio of Haddon Sundblom and Edwin Henry. He went to night school at the Chicago Art Institute and, after his studies, worked for the Chicago Herald Examiner and

PILOTS LOVE PRETTY NOSES

Betty Beach is a United Airlines airhostess who welcomes passengers on board. Her lovely little nose is much admired by the pilots of this airline. She owes her smiling face and perfect make-up to Du Barry beauty products. **Life, 3 January 1944.**

the Charles Jensen Studio at Cincinnati. He then went to New York and began a long working relationship with Charles E. Cooper Studio. He worked for the big magazines such as, Mc Call's, The Ladies Home Journal, The Saturday Evening Post, Red Book, Cosmopolitan, Good Housekeeping and Woman Day.

A lot of foreign magazines bought the rights to his illustrations and published them.

He put his talent to work making adverts for Cadillac, Ralston, Purina Company and so on. For the Du Barry range of beauty products, he made an excellent wartime series, with some of the adverts having an aviation theme. He liked elegant women and racing cars. His wife and son, as well as professional models, often inspired his illustrations. He liked simple decors in his illustrations, but did not neglect to add carefully highlighted detailing.

He exhibited at the New York Art Directors Show as well as in Philadelphia and Chicago, winning awards and acclaim. He was a member of the Society of Illustrators.

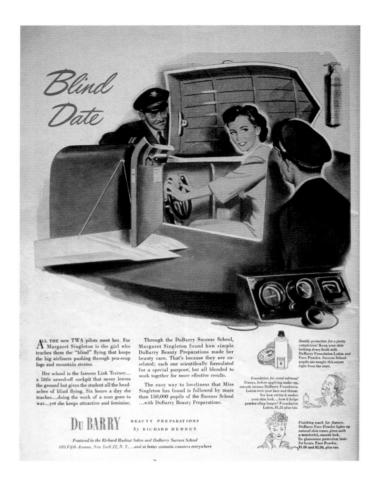

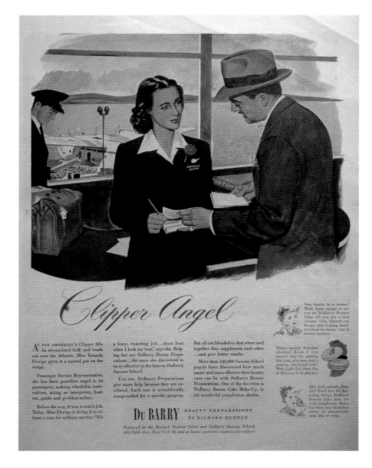

Coby Whitmore

BLIND DATE

TWA pilots train on the Link Trainer for flying without visibility. Their charming instructor is Margaret Singleton, an elegant young woman who uses Du Barry products.

This advert is illustrated with a nice composition.

Life, 25 September 1944.

..

CLIPPER ANGEL

Mrs Yolanda Floripe works for Pan Am : she gives information on the Boeing Clipper seaplanes. This elegant woman owes the glow of her skin to Du Barry beauty products.

Life, 7 September 1944.

..

(RIGHT)

Ren Wicks

Wicks Ren, 1911-1998

Rendel Galloway Wicks was born in Syracuse, New York, where from a very young age he caught the art bug. Indeed, he was eight years old when he decided that he wanted to become an artist. This lead him to study at the Art Center College of Design and the Kann Institute in Los Angeles. When not at school, he worked for an art studio and soon began to skilfully use all of the techniques available to artists: oils, pastels, watercolours and gouache, brilliantly going from one to the other.

During the war, he illustrated training manuals for the P-38 Lightning, A-28, A-29 and Hudson, planes made by Lockheed. For the latter, he designed magnificent adverts that were published by Life, The Saturday Evening Post, Collier's, National Geographic and Flying. By looking at these adverts, we can follow the evolution of the aircraft made by the company based at Burbank in California.

The realism of these compositions of this series make them startlingly truthful, the choice of angles and framing are absolutely perfect. He also worked for Douglas and Adel. Amongst his clients were Walt Disney and Howard Hughes for whom he made the remarkable poster for Outlaw featuring Jane Russell as well as fabulous aerial views of various towns. In the decades of the 50s and 60s, he illustrated for The Saturday Evening Post.

As a talented painter of feminine beauty he worked for Esquire, making very beautiful adverts for bathing costume

makers and.... for the aircraft manufacturer Convair. These were published in the big magazines.

His work covered a great number of topics as he also painted numerous portraits, notably those of J.F. Kennedy and Richard Nixon. He worked for NASA, USAAF, and the American postal services, creating the United States bi-centenary stamp. He also illustrated an aviation themed series for William Piper and Sikorsky. He was a member of numerous societies and was one of the founders of the American Society of Aviation Artists, created in the 1980s.

Ren Wicks is part of the family of great American painter-illustrators whose talent has left its mark on our time.

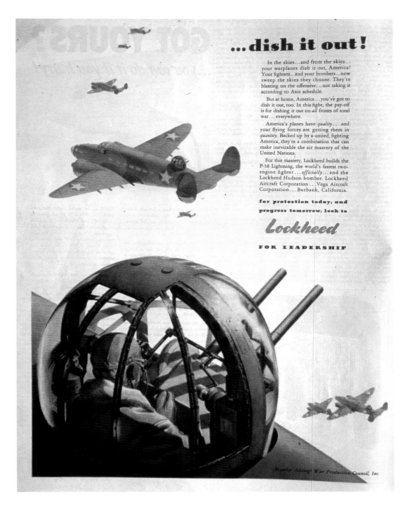

Ren Wicks

...DISH IT OUT!

A formation of Hudsons heads towards its target. This remarkable composition by Ren Wicks, naturally advertises the qualities of these Lockheed made aircraft.

The Hudson was a medium bomber, a coastal reconnaissance aircraft or used for training, and was much used by the British. It bravely participated in the evacuation at Dunkirk, attacking German troops. In September 1941, it was the first plane to force the surrender of a German U-Boat. It was also used for secret missions for the French Resistance. It was called "Old Boomerang" by the British, according to the advert, as it always came back to base.

Collier's, 14 November 1942.

END OF REHEARSAL....

A test pilot is going to try out a new production Lightning. Ren Wicks shows him from an unusual angle. This advert is particularly well made. The plane, designed by H.L. Hibard, had difficult beginnings before becoming one of the most impressive planes of the Second World War. The second prototype, the YP 38, was successfully tested on 17 September 1940. It undertook its first missions in North Africa in 1942.

Life, 8 June 1942.

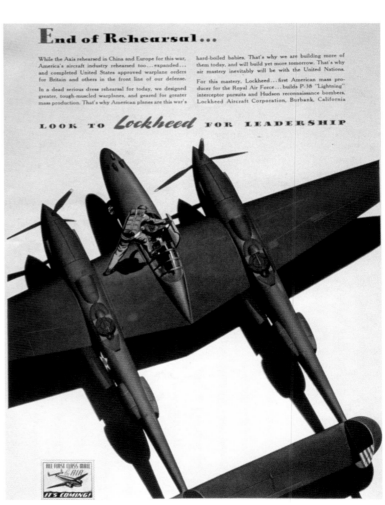

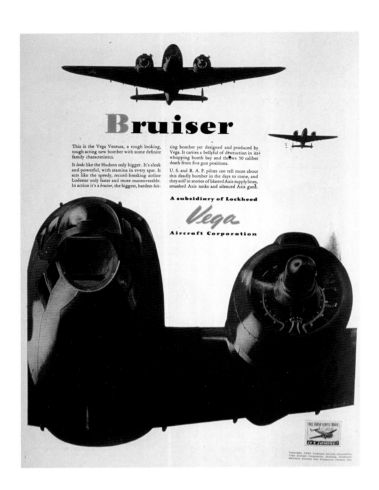

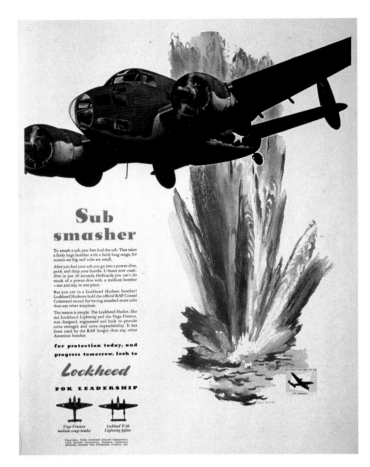

Ren Wicks

BRUISER

This remarkable composition shows the aggressiveness and toughness of the Lockheed Vega. **Flying, April 1943.**

...

SUB SMASHER

Skimming the waves of the Atlantic, a Coastal Command Hudson drops its depth charges in the hope of destroying a U-Boat. The advert sings the praises of this Lockheed built aircraft that was in the fight from the very beginning. It was adopted and successfully used by the British in the first months of the war.

Flying, May 1943.

...

INTRODUCING THE NAVY'S FIRST LAND-BASED BOMBER

A flight of wave skimming Venturas launch a surprise torpedo attack against a heavy cruiser whose outline suggests that it is a Japanese vessel. Ren Wicks has chosen to portray these events from a very good angle. The planes are very well drawn. The atmosphere of this successful attack shows the quality and power of these Vega made aircraft. Vega was part of Lockheed Aircraft.

Flying, October 1943.

...

SO IT'S A FIGHT THEY WANT...

This remarkable advert by Ren Wicks portrays a full frontal view of a P-38 and its powerful armament. The illustration is well executed down to the

smallest detail. It is made to strike both the eye and the imagination. Experienced pilots that flew this aircraft scored many kills. In the Pacific, Major Richard I. Bong obtained (40 kills) and Major Thomas B. MacGuire (38 kills) ; In Great Britain, Jenkins (16 kills), Thomas White (22 kills)... Hunted down by Lightnings during the battle of Normandy, German convoys suffered heavy losses. The German troops nicknamed them the "twin-tailed devils" (Der gabelschanz teufel), a name that was well justified !

Life, 13 July 1942.

...

BE PROUD, AMERICA

Using a low angle view, Ren Wicks portrays a pilot on the wing of his Lightning, proudly watching a flight of P-38s as they fly over him.

Flying, August 1942.

...

WHAT DO YOU MEAN MEDIUM BOMBER!

A flight of Lockheed Vegas dives steeply towards an enemy industrial zone. The quality of the drawing, the plane, choice of angle, the composition and movement are breathtaking. One can feel the sensations and tension of the pilot flying this plane.

Ren Wicks seizes perfectly this moment of flight.

Rear cover page of Flying, June 1943,

The Saturday Evening Post, 12 June 1943.

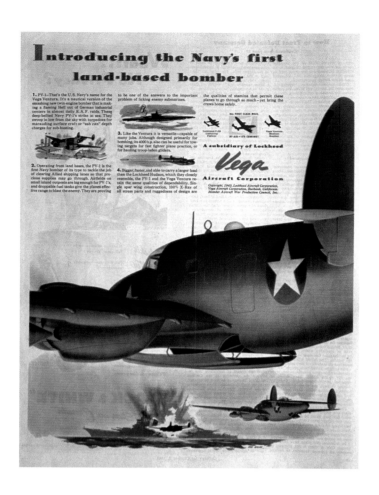

Introducing the Navy's first land-based bomber

1. PV-1—That's the U.S. Navy's name for the Vega Ventura. It's a nautical version of the smashing two-engine bomber that is making a flaming Hell out of German industrial centers in almost daily R.A.F. raids. These deep-bellied Navy PV-1's strike at sea. They swoop in low from the sky with torpedoes for marauding surface craft or "sub can" depth charges for sub-busting.

2. Operating from land bases, the PV-1 is the first Navy bomber of its type to tackle the job of clearing Allied shipping lanes so that precious supplies may go through. Airfields on small island outposts are big enough for PV-1's, and droppable fuel tanks give the planes effective range to blast the enemy. They are proving to be one of the answers to the important problem of licking enemy submarines.

3. Like the Ventura it is versatile—capable of many jobs. Although designed primarily for bombing, its 4000 h.p. also can be useful for towing targets for fast fighter plane practice, or for hauling troop-laden gliders.

4. Bigger, faster, and able to carry a larger load than the Lockheed Hudson, which they closely resemble, the PV-1 and the Vega Ventura retain the same qualities of dependability. Single spar wing construction, 100% X-Ray of all stress parts and ruggedness of design are the qualities of stamina that permit these planes to go through as much—yet bring the crews home safely.

A subsidiary of Lockheed

Vega
Aircraft Corporation

Copyright, 1943, Lockheed Aircraft Corporation,
Vega Aircraft Corporation, Burbank, California.
Member Aircraft War Production Council, Inc.

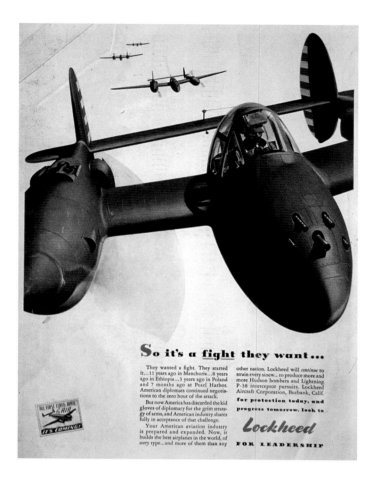

So it's a fight they want...

They wanted a fight. They started it...11 years ago in Manchuria...8 years ago in Ethiopia...3 years ago in Poland and 7 months ago at Pearl Harbor. American diplomats continued negotiations to the zero hour of the attack.

But now America has discarded the kid gloves of diplomacy for the grim strategy of arms, and American industry shares fully in acceptance of that challenge.

Your American aviation industry is prepared and expanded. Now, it builds the best airplanes in the world, of *every* type...and more of them than any other nation. Lockheed will *continue* to strain every sinew...to produce more and more Hudson bombers and Lightning P-38 interceptor pursuits. Lockheed Aircraft Corporation, Burbank, Calif.

for protection today, and progress tomorrow, look to

Lockheed
FOR LEADERSHIP

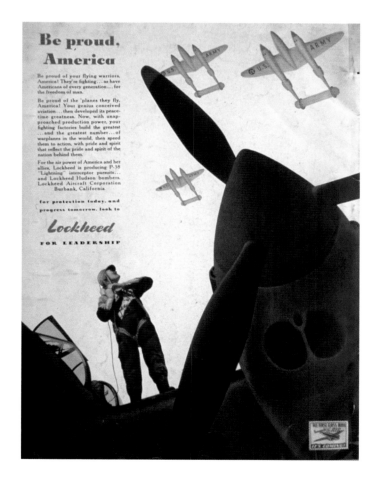

Be proud, America

Be proud of your flying warriors, America! They're fighting...as have Americans of every generation...for the freedom of man.

Be proud of the 'planes they fly, America! Your genius conceived aviation...then developed its peacetime greatness. Now, with unapproached production power, your fighting factories build the greatest ...and the greatest number...of warplanes in the world, then speed them to action, with pride and spirit that reflect the pride and spirit of the nation behind them.

For the air power of America and her allies, Lockheed is producing P-38 "Lightning" interceptor pursuits... and Lockheed Hudson bombers. Lockheed Aircraft Corporation, Burbank, California.

for protection today, and progress tomorrow, look to

Lockheed
FOR LEADERSHIP

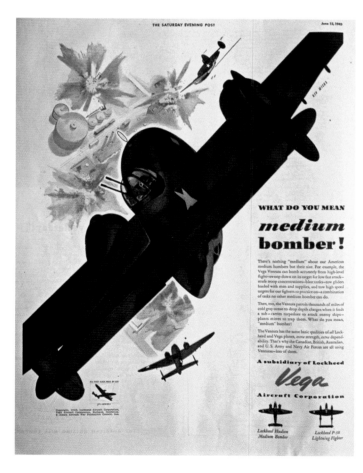

WHAT DO YOU MEAN
medium bomber!

There's nothing "medium" about our American medium bombers but their size. For example, the Vega Ventura can bomb accurately from high-level flight—swoop down on its target for low flat crackstrafe troop concentrations—blast tanks—tow gliders loaded with men and supplies, and now high-speed targets for our fighters to practice on—a combination of tasks no other medium bomber can do.

Then, too, the Ventura patrols thousands of miles of cold gray ocean to drop depth charges when it finds a sub—carries torpedoes to attack enemy ships—planes mines to trap them. What do you mean, "medium" bomber!

The Ventura has the same basic qualities of all Lockheed and Vega planes, extra strength, extra dependability. That's why the Canadian, British, Australian, and U.S. Army and Navy Air Forces are all using Venturas—lots of them.

A subsidiary of Lockheed

Vega
Aircraft Corporation

Lockheed Hudson Medium Bomber *Lockheed P-38 Lightning Fighter*

Reunion in America

. . . that's one thing we're working and fighting for!

Christmas furlough, 1943 . . . a little fellow he's never seen . . . such a lot of living to be crowded into precious days, then off again.

Ask this man, *any* man, what he's fighting for.

Ask Joe, who's done "bomb-sight-seeing" over Berlin; or Tom, who found good hunting among the cold rocks on Attu; or Pete, who can tell of bullet-spitting trees on Guadalcanal; or Al, who took his South Seas cruise in a rubber raft. They know the answers.

Conquest? . . . a New Order? No, it's much bigger—much simpler—than that.

It's families and homes and hobbies. It's jobs that can grow with a man's ambitions. It's the right to think, to vote, to worship as a man chooses. It's the heart of America.

It's what the thousands of men and women of North American Aviation are fighting for too—fighting for by turning out ever-more and ever-better Mitchell bombers, Mustang

fighters, Texan combat trainers . . . planes to make the job of our fighting men easier, safer . . . to bring the men home sooner.

Home—not for Christmas furlough—but for a reunion in America that will have no ending.

North American Aviation, Inc., designers and builders of B-25 Mitchell bomber, AT-6 Texan combat trainer and the P-51 Mustang fighter (A-36 fighter-bomber). Member of the Aircraft War Production Council, Inc.

North American Aviation *Sets the Pace!*

REUNION IN AMERICA

A family reunion and a joyous occasion when on leave. This theme is often used in the adverts of this period. The title, "…that's one thing we're working and fighting for!", gives meaning to this advert by *Michel Cady* for North American Aviation. **Collier's, 25 December 1943.**

✪ CHAPTER 12

A few adverts by unidentified illustrators, a certain talent

Sometimes, whilst searching in archives, one comes across a dilemma; some works of art do not bear the signature of the artist or any other sign that would allow the identification of their creator.

Indeed, artists' styles can be similar and because of this, it would be a risk to take a guess at a name and I did not want to do such a thing in fear of perhaps betraying an artist. Nevertheless, I could not just leave out certain admirable pages. That is why, therefore, I decided to show them as they were. This is a way of paying tribute, via unknown talented artists, to all the illustrators who, excuse the pun, illustrated themselves with distinction during the Second World War.

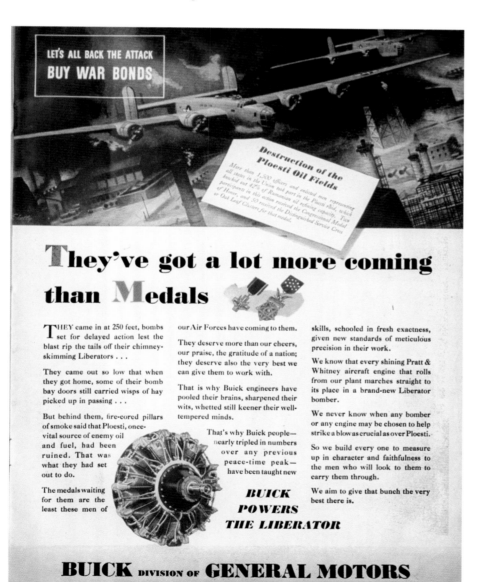

THEY'VE GOT A LOT MORE COMING THAN MEDALS

This illustration for the Buick Division of General Motors, the manufacturer of B-24 bomber engines, uses the theme of the raid on the Ploesti oil refineries in Romania, the most important source of fuel for the Germans. The first raid took place on 1 August 1943. In all, 162 8th and 9th Air Force Liberators took off from Libya. Flying at low altitude, they reached their targets, but suffered heavy losses of approximately 30%. This important strategic raid is accurately painted from a USAAF photo.

Life, 24 April 1944.

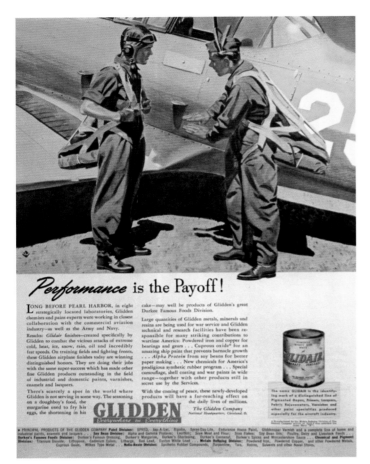

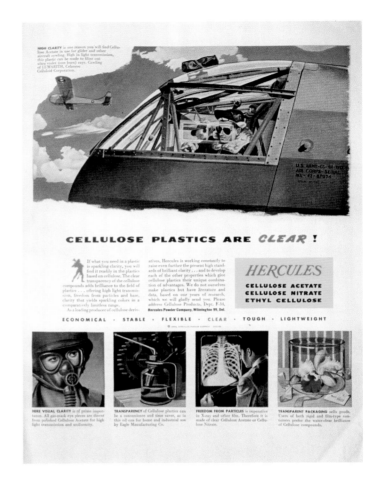

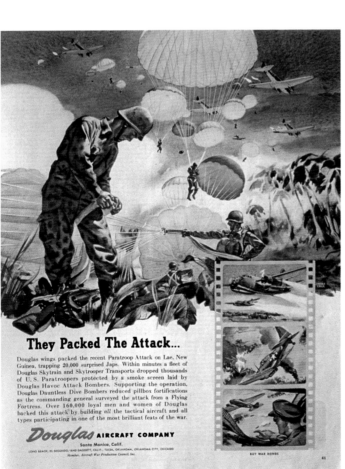

PERFORMANCE IS THE PAYOFF!

Well before the war, the Glidden Company made paint for both civilian and military aircraft. After Pearl Harbor, its researchers came up with products that could withstand the most extreme climates. To show the quality of their products, the artist has chosen to portray a trainee pilot in front of a T6, listening to the advice of his instructor. He will become a skilled and competent pilot, just like the researchers of this company, always looking to improve their products. The talented illustrator has signed his work with a W and would appear to be *Lynd Ward*.

Fortune, June 1944.

...

CELLULOSE PLASTICS ARE CLEAR!

For Hercules, a manufacturer of transparent plastics for aircraft windows, the non-identified artist has chosen the Waco glider "Adrian" CG4A, a famous aircraft that had carried airborne troops and materiel on D-Day. Several illustrations show the various uses.

Fortune, March 1944.

...

THEY PACKED THE ATTACK…

In this advert, designed to show the quality of its products, Douglas Aircraft Company chose to take us to Lae, in Papua New Guinea in the Pacific. The main illustration, a water colour signed by James Cole, shows landing paratroopers taking up their positions. Also shown are planes made by this company, the C-47 Skytrain, Havoc and A24. It should be known that a general directed the attack from a B-17 Flying Fortress and

also that no less than 160,000 men and women were involved in making these aircraft.

Fortune, February 1944.

. .

''TOGETHER, WE'RE BUILDING BRIDGES ACROSS THE SEVEN SEAS''
Bendix, a manufacturer of aircraft instruments and various other aviation products, chose an Air Force transport pilot to highlight its products. The illustration would appear to be by *Walter Richards.*
.Life, 15 February 1943.

Sets the Pace!

PILOTS OF 24 NATIONS TRAIN IN ''TEXANS''
This North American Aviation advert shows the most famous training aircraft used by the pilots of twenty-four countries. This twin-seater was designed by R.H. Rice and flew in its first version in 1937. The BC 1A was designated the AT6 Texan model NA 59 in 1939. By writing to this company, one could receive for free a poster of this advert. The artist is unknown. Later, this plane became a formidable attack aircraft during the Algerian conflict.

Look, 10 August 1943.

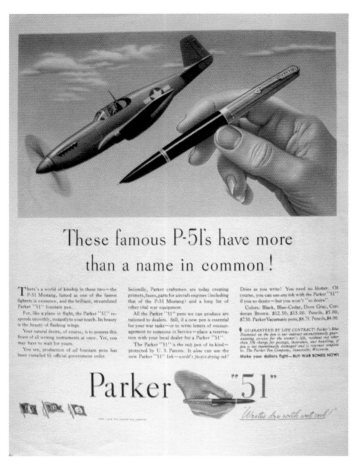

STAR OF HOPE FOR AMERICAN MOTHERS
This North America Aviation advert uses the theme of a mother's feelings for her son, a P-51 pilot. She need not worry as the quality of the plane and the expertise of this company guarantees her son all the hope of returning safely home on the day of victory.
This illustration is by *Reynold Jones*.
Air News, May 1944.

..

THESE FAMOUS P-51'S HAVE MORE THAN A NAME IN COMMON!
Sharing the same name, the advert sings the praises of the remarkable P-51 Mustang and the famous Parker 51 pen. However, the illustrator remains unidentified.
Fortune, June 1944.

TALENT—WITH WINGS!

TALENT–WITH WINGS!
Goodyear, the famous tyre manufacturer, participated in the construction of the Corsair F4 U and fourteen other types of aircraft in its aviation department. The company chose an interesting theme for this well painted composition: the Corsair leaving the factory shortly before its test flights. The artist is unknown.
Collier's, 25 November 1944.

..

LOOK WHAT YOU GET WHEN AMERICANS GET TOGETHER
This advert, painted in a lyrical style, shows the first version of the Goodyear made F-4 U Corsair. It also portrays some of the power of the United States naval air forces.
Following a difficult period of trials on aircraft carriers, this aircraft only really became operational at the end of 1944 on this type of vessel. However, based in the Pacific in 1943, it quickly became a legend flown by Marines and Navy pilots.
Life, 12 April 1943.

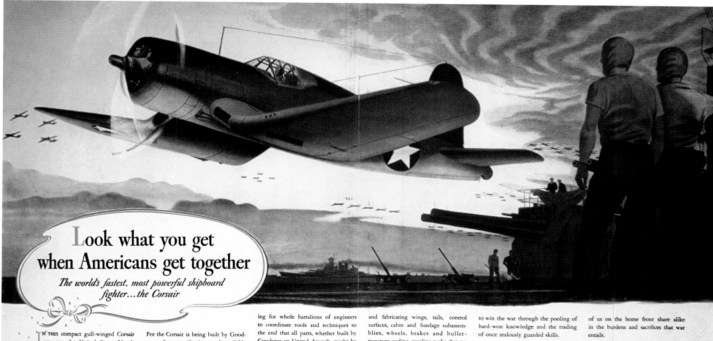

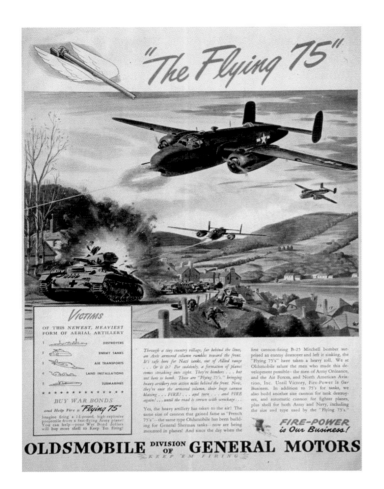

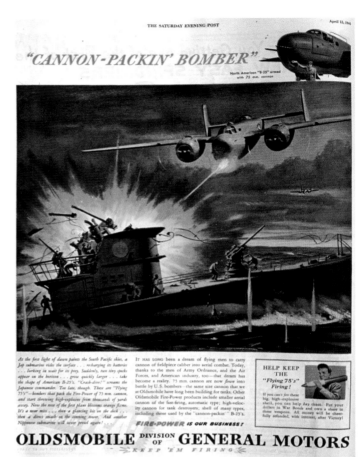

"THE FLYING 75"

This advert made for the armaments maker Oldsmobile Division of General Motors, portrays one of the actions carried out by the Air Force on a daily basis. A column of German armour moves through an imaginary European village. Low-level B-25 H aircraft suddenly appear, attacking and destroying the convoy with their 75 mm cannon. A small insert shows the type of targets that this flying artillery could destroy.

Life, 13 March 1944.

...

"CANNON-PACKIN' BOMBER"

In dawn's first light in the South Pacific, a Japanese submarine surfaces to charge its batteries. Suddenly, two B-25 H appear, giving the sub no time to dive. It is attacked by cannon and destroyed in this rapid attack. This advert obviously sings the praises of the firepower of the Oldsmobile Division of General Motors made cannons.

The Saturday Evening Post, 15 April 1944.

...

THE BLACK WIDOW... SNARES AN AXIS "FLY"!

A German JU-88 flies unworried over its target by night. Suddenly, a P-61 Black Widow appears out of the darkness, firing with all its machine-guns and pulverising the intruder.

Life, 13 November 1944.

HERE COME THE SKY ROCKETS!

These are the final months of the war in Europe. The Germans try to counter-attack in their own country. However, the rocket equipped P-47 D aircraft attack and destroy the convoys. These weapons were made in great secrecy by the Oldsmobile Division of General Motors whose motto was "Fire-power is our business".

Collier's, 9 December 1945.

...

GLIDER TRAINS BRING IN THE FIRE-POWER!

This advertising illustration for the Oldsmobile Division of General Motors uses the them of the airborne troops landing in Normandy. This is one of the rare adverts based on these events. In the sky, C-47 Skytrains tow WACO gliders, whilst on the ground, troops pull a Howitzer out of a glider.

The Saturday Evening Post, 1944.

...

... FASTER FIREPOWER BRINGS THEM BACK

The bonds of friendship uniting aviators and maintenance personnel are accurately and powerfully portrayed by the illustrator in this advert for Hughes Aircraft Company.

It uses the theme of the return of a B-17, badly damaged during a tough raid.

Flying, June 1945.

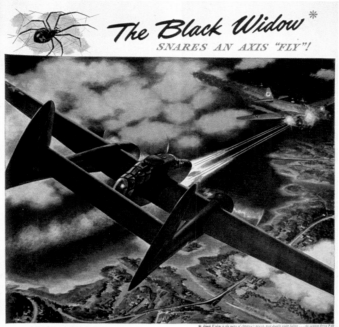

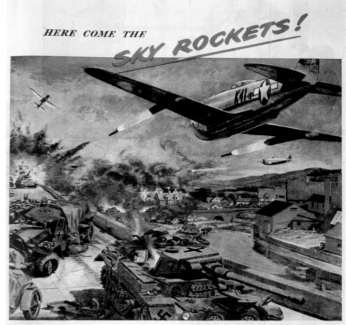

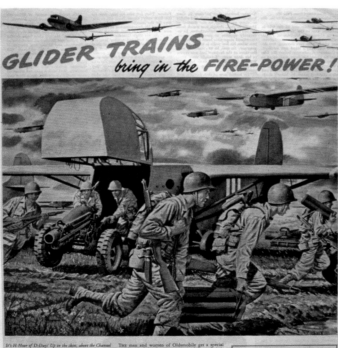

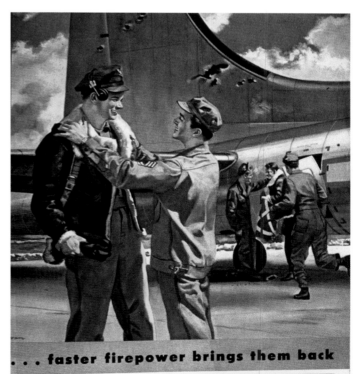

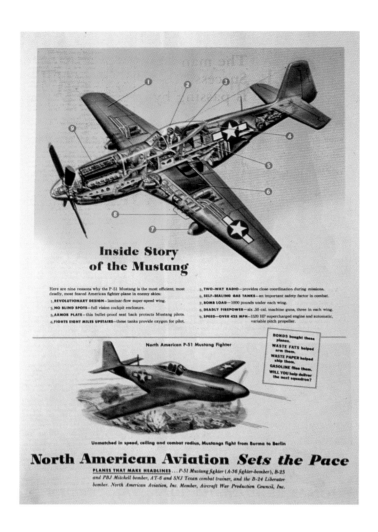

INSIDE STORY OF THE MUSTANG

This superb cutaway of a North American Aviation P-51 Mustang clearly shows the most important areas and parts of an aircraft that was considered as being the Cadillac of the skies by its pilots. Also, the advert highlights the skill and efficiency of a close-knit team at all levels of production. This illustration would appear to be the work of *R. Brown*. **Collier's, 7 October 1944.**

MITCHELL BOMBERS FIND GOOD HUNTING IN NEW GUINEA

On the New Guinea front in the Pacific, squadrons of 5th Air Force B-25 Mitchells constantly harass Japanese targets: ports, supply convoys, airfields and so on. This North American Aviation advert puts the onus on the qualities of this medium bomber in the very places where these missions take place.

This composition is by *William Macrae Gillies*, an artist whose signature appears on adverts for Ryan Aeronautical Company. **The Saturday Evening Post, 17 April 1943.**

… PRAISED TO THE STRATOSPHERE!

The famous Johnnie Walker Black Label brand of whiskey was enjoyed by passengers on the comfortable Clipper flying boats during the long inter-continental flights. **Fortune, May 1943, Collier's, 22 May 1943.**

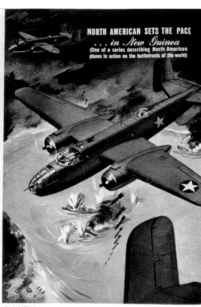

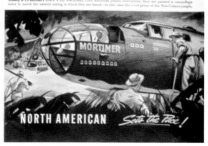

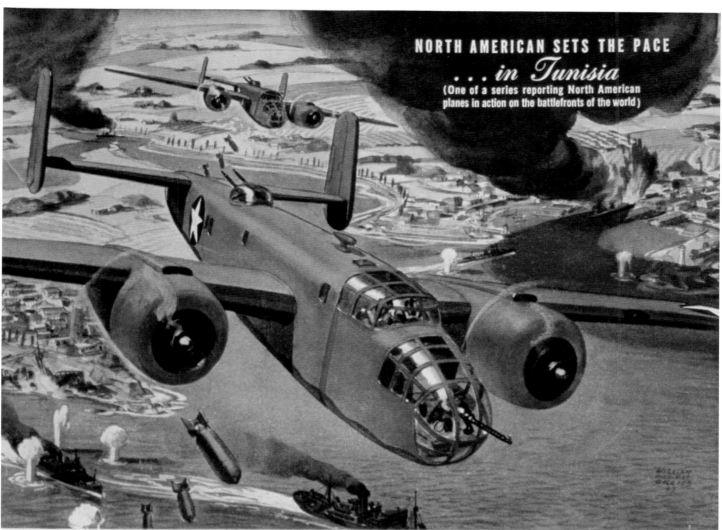

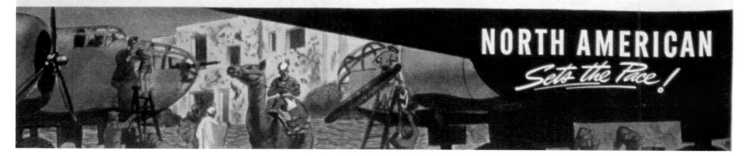
"B-25 MITCHELL BOMBERS BREAK HITLER'S GRIP IN AFRICA"

Taking off from a North African airfield, a squadron of B-25 Mitchells attacks the port of Sousse on the Tunisian coast, destroying enemy forces and supplies.

This advert is part of a series and is based on actual events experienced by the crews of these bombers made by North American Aviation.

Collier's, 15 March 1943.

⭐ IN CONCLUSION

For many contemporaries deprived of liberty and maybe blasé, the mention of these times of solidarity between men often come from different parts of the world, animated by high sentiments, cause nothing more than an ironic smile. At the cost of their life, they gave nevertheless a meaning to ours. In France, authors like Jacques Mortane, René Chambe and Joseph Kessel have dedicated many enthusiastic pages to these heroes, something which, as it happens, they did not see themselves as. This did not stop them from attracting the affection and admiration of a large public, especially when they appeared at air shows. And what about Mermoz, Saint-Exupéry, Guillaumet and many other passionate, endearing and admirable characters. How can one avoid dreaming when looking at the still flushed faces of Hélène Boucher, Maryse Bastié or Amy Johnson after carrying out some aerobatics. Their exploits were talked of in newspapers and newsreels, or by school teachers where the pupils would listen in a silence where you could have heard a pin drop. They were immortalised by artists such as Géo Ham, Brenet and Paul Lengelé. They thrilled the young and better still, gave them something to look up to, where examples of courage, friendship and solidarity were commonplace. Although the collective conscience still honours some of these names, it is, on the other hand, not so grateful towards war heroes, the pilots and crews who gave their lives for their country and for France.

Today they are unfairly disregarded or even forgotten. They were filled with a spirit of self sacrifice that lead them to give their utmost, even if it meant giving the supreme sacrifice. These heroes, who are for the most part unknown, no longer interest the media and this is a great pity. They could have been, when peace returned, the bonds of a more closely bonded world, with a dynamism that would lead to a new age of fraternity. A Utopia no doubt ? These trips into the pages of history prove that these men and women were many, but also modest. They were not looking for effect and were happy to have carried out their duty; the latter also being something that has fallen

Jo Kotula in his studio in 1994.
He was the founder of the A.S.A.A., (American Society of Aviation Artists).

from grace in our day. Luckily, they have not completely disappeared as a handful of enthusiasts, respectful of history can still find them in film archives and some document rich museums, libraries, antique dealers and flea markets, where, with a little patience, one can pull from the dusty past, period magazines and books. Luckily also, there are still groups of honest researchers, although they are few in number and isolated, that contribute to keeping this period alive, without really being listened to or heard. However, what remains are the accounts of those who lived through these events, photos, films, texts that can be constantly discovered and rediscovered.

Behind the glorious mirror of these magnificent illustrations, one should never forget the men who made them and those who were their models in every sense of the term. When you find yourself in the magnificent Normandy countryside or when you see the big military cemetery at Colleville-sur-mer overlooking Omaha Beach, a place to reflect and show respect, spare a thought for these young men, your elders. Many of them were barely eighteen years of age. Remember that they came from the far flung corners of the United States to liberate Europe and, in principle, make a world of peace.

A few years after a hard won victory, after the enthusiasm of the Liberation, how could we, the French, daub the walls with "US go home " ? But that was another war, another moment of human madness, another story.

As for myself, I have not forgotten this period where the atrocities and barbarism of some, were opposed by the courage, solidarity and sense of sacrifice of others and which finally prevailed in the midst of great joy.

I remember that Navy officer of Indian origin, a family friend who took me for rides in his jeep and who gave me magazines and candy, a deeply humane man and a university teacher in civilian life. No, I have not forgotten.

Let's keep a small place in our memories to honour these men and women, the actors of this heroic fresco.

ANNEXES

General interest magazines

LIFE	CLICK
SATURDAY EVENING POST	PIC
COLLIER'S	LOOK
COSMOPOLITAN	LIBERTY
Mc CALL'S	THIS WEEK
THE LADIE'S HOME JOURNAL	HOLIDAY
WOMAN'S HOME COMPANION	GOOD HOUSEKEEPING
VOGUE	ARGOZY
WOMAN'S DAY	CAVALIER
HARPER'S BAZAAR	THE AMERICA LEGION
VANITY FAIR	FORTUNE
TODAY'S WOMAN	TOWN & COUNTRY
ESQUIRE	AMERICAN HERITAGE
RED BOOK	Mc CLURE
BLUE BOOK	TIME
TRUE	NEWS WEEK
THE AMERICAN HOME	THE NEW YORKER
THE AMERICAN MAGAZINE	CORONET
THE NATIONAL PICTURE MONTHLY	THE NATIONAL GEOGRAPHIC MAG.
PICTORAL REVIEW	THE AMERICAN WEEKLY

Aviation magazines

AERODIGEST	AVIATION
AIR AGE	FLYING
AIR FORCE	FLYING ACE
AIR NEWS	SKYWAYS
AIR TECH	THE SPORTSMAN PILOT AT WAR
AIR TRAILS	WESTERN FLYING
AIRCRAFT AGE	

Aeronautical constructors magazines

BELLRINGER	MARTIN STAR
CURTISS FLY LEAF	PLANE TALK
DOUGLAS REVIEW	SKYLINE
NORTH AMERICAN AVIATION	WINGS

List of illustrators known to have covered aeronautical subjects

BARCLAY Mac Lelland, 1891-1943
BAUMGARTNER Warren, 1894-1963
BEALL Cecil Calvert, 1892-1967
BEAUMONT Arthur, 1890-1978
BINGHAM James R., 1917-1971
BRINDLE Melbourne, 1906-1995
BROWN Reynold, 1917-1991
CLYMER John, 1907-1989
COGGINS Jack, 1911-2006
CORNWELL Dean, 1892-1960
CROCKWELL Douglas, 1904-1968
DAVIS Wayne Lambert, 1904-1988
DORNE Albert, 1901-1965
FALTER John Philip, 1910-1982
FREEMAN Fred L., 1906-1988
GANNAM John, 1907-1965
GICHA
GODWIN Frank, 1889-1959
GOULD John F., 1906-1996
GROHE Glen, 1912-1956
HEASLIP William, 1898-1970
HOWE Lloyd
KNIGHT Clayton, 1891-1969
KOTULA Joseph, 1910-1998
KRAMER M. Harold
KURKA Anton
LEYENDECKER Joseph Christian, 1874-1951
LUDEKENS Fred, 1900-1982
LYFORD Phil, 1887-1950
OSLER John S.
OWLES Alfred, 1894-1978
PROHASKA Ray, 1901-1981
RABUT Paul, 1914-1983
RICHARDS Walter DuBois, 1907-
RIGGS Robert, 1896-1970
RYAN Tom, 1922-
SICKLES Noel, 1911-1982
SKEMP Robert O., 1910-1984
SOLTESZ Frank
STAHL Benjamin Albert, 1910-1987
TEPPER Saul, 1899-1987
TOMASO Rico, 1899-1985
UTZ Thornton, 1914-
VICQUERY John, 1906-
WHITMORE Coby, 1913-1988
WICKS Ren, 1911-1998

Brands and their agencies

AAF (Army Air Forces): propaganda

AIR TRANSPORT ASSOCIATION: air carriers association, agency Erwin-Wassey Co

ALCOA ALUMINUM: metal

ALLISON: aircraft engines

AMERICAN AIRLINES: air carrier

ARMCO: weapons

ARMSTRONG CORK COMPANY: household products

BELL AIRCRAFT: aeronautical construction , agency Addison Vars Company Inc.

BELMONT-RADIO: radio and radar

BENDIX AVIATION CORPORATION: aeronautical instruments

BORG-WARNER : various aircraft parts

BUICK (Division of General Motors): vehicles

CADILLAC: vehicles

CAMEL: cigarettes, agency William Esty Co. Inc.

CANNON TOWELS: towels

CHESTERFIELD: cigarettes, agency Newell Emmet Company

COCA-COLA: drink, agency D'Arcy Advertising Company

CONTINENTAL CAN COMPANY: packaging, agency Batten, Barton Durstine & Osborn Inc.

CROSLEY: radios

CURTISS ELECTRIC PROPELLERS: propellers manufacturer

CURTISS WRIGHT: aircraft manufacturer

DOUGLAS: aeronautical constructor

DU BARRY (Beauty preparation by Richard Hudnut): beauty products

ETHYL CORPORATION: petroleum products

FISHER (Division of General Motors): flying instruments, tanks, trucks

FOUR ROSES: alcoholic beverage, agency Young-Rubicam Inc.

GENERAL AVIATION: aeronautical construction , instruments, aviation products

GENERAL ELECTRIC: armament systems, aircraft gas turbines, radio receivers and transmitters

GLIDDEN: paints

GOOD YEAR: tires, aeronautical construction, agency Arthur Kudner Inc.

GRAPEFRUIT JUICE: drink

GRUEN WATCH: watches

GRUMMAN: aeronautical construction

HERCULES SOCONY-VACUUM: oil, engines

HUGHES AIRCRAFT COMPANY: aeronautical construction, armament

INTERNATIONAL HARVESTER: bulldozers, tractors

JANTZEN: bathing suits

JOHNNIE WALKER: whiskies

KODAK: photos

LOCKHEED: aeronautical construction

MARTIN AIRCRAFT: aeronautical construction

MAXWELL: coffee, instant coffee

MILKY WAY: candy bars

NASH KELVINATOR: aircraft engines, vehicles, refrigerators, agency Geyer, Cornell & Newell

NAVAL AVIATION (NAVY): propaganda

NORTH AMERICAN AVIATION Inc.: aeronautical construction

NORTHROP: aeronautical constructor

OLDSMOBILE (Division of General Motors): armament, agency DP Brother Co. Inc.

PAN AMERICAN WORLD AIRWAYS: air carrier, agency J. Walter Thompson Co

PARKER « 51 »: fountain pens

PONTIAC: various vehicles

RCA (Radio Corporation of America): radio accessories and equipment

SHELL: petroleum products, agency J. Walter Thompson

STUDE BAKER: vehicles

TEXACO: petroleum products

THE AIRLINES OF THE UNITED STATES: air carrier

THOMPSON-PRODUCTS Inc.: various aircraft parts

TWA: air carrier

UNITED STATES STEEL: metals

VULTEE AIRCRAFT: aeronautical construction , agency Ruthrauff-Ryian

WAX (Johnson's WAX): household products

WESTERN ELECTRIC COMPANY: radios, agency Newell Emmett Company

WHITE (Trucks): trucks

WHITMAN'S CHOCOLATES: chocolate

WINGS FOR THE EAGLE (Warner Bros): propaganda

WYETH: pharmaceutical products, agency John F. Murray and Compton Advertising Inc.

Acknowledgements

To my wife Jade who encouraged and helped me to finish this long and difficult, but oh so fascinating study.

Warm thanks to;

In the U.S.A.
- Jean-Luc Beghin
- Steve Remington, Collectair, Santa Barbara, CA
- Bill and Joan Hannan
- Louise Brown and her son Franz Brown
- Ernest R. McDowell
- Bill and Betty Sellier
- Jo Kotula
- Ren Wicks
- Walter and Roger Reed (Illustration House inc., New York)
- Peronce Brown (Society of Illustrators, New York)
- Peter Maresca
- Fred L. Charlton

In France
- Jean-Michel Daniel
- André Leguen
- Eddie L. Rosier
- Francis Maratier
- Alain Pelletier
- Bernard Macaire
- Yves Tariel
- Claude Moliterni
- Éric Leguebe
- Bernard Thévenet
- Claude Lecronier
- Jacqueline Tissandier

Thanks to all the firms, constructors, advertisement agencies, who ordered these adverts from all the artists who I discovered with great emotion throughout the course of my research.

Thanks also to :
- Gilles Conte
- Gil Bourdeaux
- Grégory Pons
- Jean-Louis Dussoulier

Bibliography

Magazines

The choice of press adverts is the fruit of a compilation of approximately 700 magazines published between 1941 and August 1945.
Life - The Saturday Evening Post - Collier's - Liberty - Cosmopolitan - Time - Newsweek - The American - Look - Esquire - Fortune - Flying - Skyways - Aero Digest - Air News - Air Trails - The Sportman Pilot (At War).

Books
- 22nd Annual of Advertising Art - Watson Guptil, 1943.
- 23rd Annual of Advertising Art - Watson Guptil, 1944.
- Illustrating for the Saturday Evening Post - Ashley Halsey Arlington House, 1951.
- Forty Illustrators and How They Work - Ernest W. Watson Watson Guptil Publications Inc. New York, 1946.
- The Illustrator in America 1880-1980 - Walter and Roger Reed The Society of Illustrators, 1989.
- The ads that won the war - Derek Nelson - Motor Books International, 1992.
- Flight to every where - Ivan Dmitri - Whittsey House Mc Graw Hill Book Company Inc., New York London, 1944.
- The best from yank the army weekly - Cleveland New York.
- The World Publishing Company,1945.
- Phenix - Revue internationale de la bande dessinée - Spécial aviation 1er trimestre 1968 - n°6.
- Peintures de guerre - J. Ethell - Clarence Simonsen Motorbooks International USA - France - M. D. M.
- Aircraft of the United States - R. A. Saville - Sneath - Penguin Books Harmonds Worth, Middlesex, England, 1945.

Edited by **Gil Bourdeaux**
Design and layout: **Gilles Conte**. Translation: **Lawrence Brown**.

This book has been designed, typed, laid-out and processed by Studio A&C on fully integrated computer equipment. Color separation: Studio A&C.
Printed by Elkar, Spain, European Union. May 2010.

Histoire & Collections
SA au capital de 182 938,82 €
5, avenue de la République
F-75541 Paris Cedex 11 - FRANCE
Tel: +33-1 40 21 18 20 / Fax: +33-1 47 00 51 11
www.histoireetcollections.com

ISBN: 978-2-35250-133-6

Publisher's number: 35250

© Histoire & Collections 2010